THE LIFEBOAT SER ENGLAND

THE SOUTH WEST AND BRISTOL CHANNEL STATION BY STATION

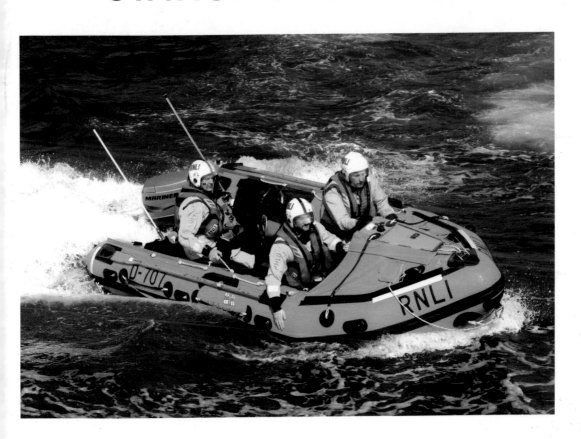

NICHOLAS LEACH

cover Penlee's 17m Severn class lifeboat Ivan Ellen (ON.1265) in Mount's Bay.

page one Port Isaac's D class inflatable Copeland Bell (D-707) on a training exercise. The D class inflatable, introduced in 1963, is the workhorse of the RNLI fleet.

above The lifeboat crew in front of their Atlantic 75 at Weston-super-Mare, outside the station's Knightstone Harbour temporary facility.

First published 2015

ISBN 978 1 4456 4762 3 (print)
ISBN 978 1 4456 4763 0 (ebook)

Amberley Publishing Plc
The Hill
Stroud
Gloucestershire GL5 4EP
www.amberley-books.com

Copyright © Nicholas Leach 2015

Typesetting by Nicholas Leach. All images and photographs by Nicholas Leach unless stated. Printed in the UK.

Acknowledgements

I am very grateful to many people at the lifeboat stations in Cornwall and North Devon that I have visited; all have shown me hospitality and provided much assistance. These include Bob Bulgin at Port Isaac; Martin Cox at Appledore; Paul Richards at Fowey; Patrick Harvey at Penlee; Terry George at Sennen Cove; Chris Cloke at Bude.

At the RNLI, Nathan Williams has been very helpful in supplying photos and images; the Heritage Team, including Hayley Whiting and Joanna Bellis, have facilitated my research; Carol Waterkeyn read a proof of the book and suggested improvements; Amanda Boon provided information about RNLI Lifeguards; and Amy Caldwell and Emma Haines kept me up-to-date with events around the coast. My thanks to all of them.

For supplying photographs I am most grateful to John Harrop, whose rare old postcards provide an insight into the lifeboat service 100 years ago and more in a way no words can; to Jeff Morris, whose outstanding colour slides brought post-war life-saving work to life, and to Tim Stevens and Paul Richards, for making available their own photos for use.

In the text, ON stands for Official Number, the number given to lifeboats built by the RNLI since the 1880s.

Nicholas Leach, Lichfield
November 2015

CONTENTS

Map of lifeboat stations in the South West 4

Part One • England's Lifeboat Heritage 5

Part Two • Lifeboats of the South West Coast of England, station by station 63

Appendices 156

Index 160

Lifeboat stations in the South West

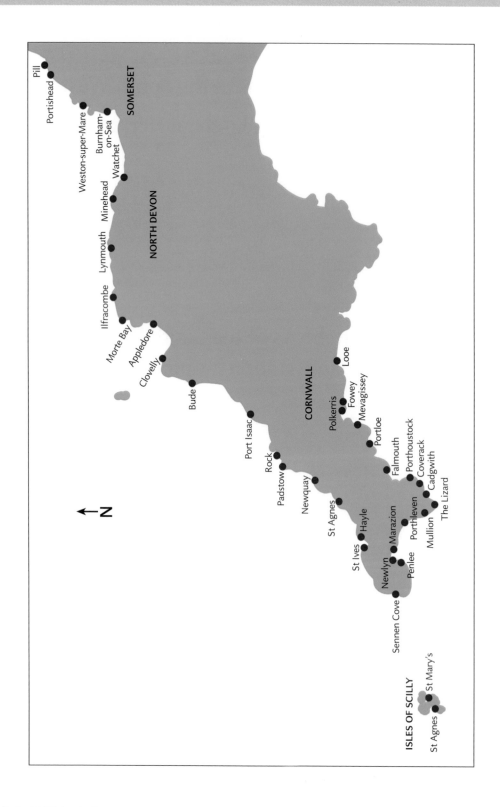

Pill
Portishead
Weston-super-Mare
Burnham-on-Sea
Watchet
Minehead
Lynmouth
Ilfracombe
Morte Bay
Appledore
Clovelly
Bude
Port Isaac
Rock
Padstow
Newquay
St Agnes
Hayle
St Ives
Newlyn
Penlee
Marazion
Porthleven
Mullion
Sennen Cove
Looe
Fowey
Mevagissey
Polkerris
Portloe
Falmouth
Porthoustock
Coverack
Cadgwith
The Lizard
St Mary's
St Agnes

SOMERSET
NORTH DEVON
CORNWALL
ISLES OF SCILLY

←N

Lifeboat Heritage of the South West

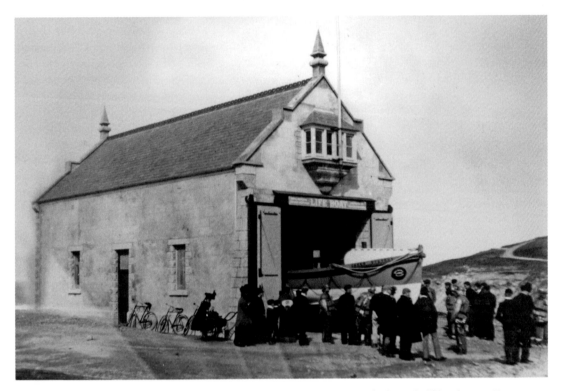

Introduction to Part One

The lifeboat service in the United Kingdom and Ireland is operated by the Royal National Lifeboat Institution (RNLI), which was founded in 1824 and today maintains a network of 235 lifeboat stations around the coasts, plus two trial stations. The charity has a long and proud history of saving lives at sea based on a voluntary ethos and its lifeboats and crews have saved thousands of lives.

Today's lifeboat stations operate fast state-of-the-art all-weather and inshore lifeboats which provide search and rescue cover up to 100 nautical miles out to sea, and reach 90 per cent of total casualties within thirty minutes.

This book looks at the history and current operations of the lifeboat service along the south-west coast of England and the Bristol Channel. It is divided into two parts: the first gives an overview of the history of the lifeboat service with an emphasis on the south-west; the second provides a brief history of each station, past and present, in Cornwall, North Devon and Somerset. Space does not permit all medal-winning and outstanding services to be described, but those that are included are representative of the many courageous life-saving acts performed by the lifeboat men and women on England's south-west coast.

above The lifeboat house at Newquay built in 1899–1900 at Towan Head, with a committee room above the boathall and close to the steep slipway that had been built in 1875 at the headland. The slip, on the western side of Towan Head, afforded a deepwater launch within easy reach of the open sea. A small crowd has gathered to watch the launch of the 35ft self-righter James Stevens No.5 (ON.426), which was on station from 1899 to 1917 and saved twenty-six lives. She was the first lifeboat to use this boathouse and was a common subject for postcard publishers of the day, who particularly liked images of her hitting the water at the foot of the steep slipway or being recovered onto her carriage on the beach and brought back to Towan Head through the town's streets.

Early sea safety measures

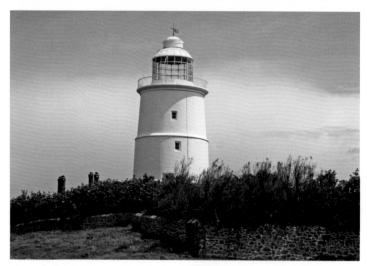

above The lighthouse at St Agnes, on the Isles of Scilly, was built in 1680 and coal-fired until 1790, when it was converted to oil, with copper lamps and twenty-one revolving reflectors. St Agnes was chosen as it is the most westerly of the inhabitable islands of the Isles of Scilly, and is also close to the rocks, tidal flows and currents now known as the Western Rocks. (Paul Richards)

below The first Lizard lighthouse was erected in 1619, and provides a landfall and coastal mark to guide vessels along the English Channel and warn of the hazardous waters off Lizard Point. The current building was completed in 1751, and consisted of two towers, with a cottage built between them.

During the seventeenth and eighteenth centuries the expansion in coastal trade and shipping activities around England's coasts was considerable. The industrial revolution meant increased trade which meant greater movement of goods, and sailing ships were the best way to transport much of the output from the newly expanding industries. Ports such as Penzance, Falmouth, Fowey, Par, Charlestown, Barnstaple and St Ives, are small by twenty-first-century standards and no longer home to commercial traders, but many hosted fleets of small coasting vessels and trading craft. And many of these coasters and traders

would have been working the Bristol Channel, visiting Bristol as well as the ports of South Wales.

Inevitably, life for the coastal traders was difficult, and many came to grief in bad weather. Cornwall's long coastline presents many dangers to the mariner who is either navigating past it or intending to enter one of the its small ports or harbours. The south coast has many inlets, bays, estuaries and natural harbours, whose entrances can often catch out the unwary navigator. The north coast, on the other hand, is characterised by rugged cliffs and rocks which take the full force of the Atlantic ocean in the prevailing westerly wind.

Navigating the Bristol Channel past the cliffs of Exmoor is a particular challenge with the strong tides making it a particularly hazardous area, while few havens on the north Devon and Somerset coasts can be entered in all states of the tide.

Many vessels have been wrecked on the coasts of Cornwall, North Devon and Somerset. In January 1814 the transport ship *Queen*, which had anchored off Falmouth, was wrecked in a violent south-easterly storm on rocks of Trefusis Point. More than 300 people were on board, of whom fewer than 100 survived.

Being open to the prevailing westerly winds, the Bristol Channel was generally easier to enter than to leave in the days of sail, and many ships were caught on the shifting sandbars or negotiating treacherous estuaries of the various rivers that empty into the Channel. Of the many ships that came to grief during the eighteenth century, several Baltic traders and Dutch East Indiamen were wrecked having mistaken Land's End for Cap Finistere.

With ship losses greatly increasing, measures to reduce those losses were sought. This initially involved erecting

THE LIZARD LIGHTHOUSE, CORNWALL G.9857

lighthouses to make navigation easier and safer. As early as the sixteenth century there is evidence of lights being displayed to help guide the mariner in Cornwall. The first major lighthouses to be built were those at Lizard and St Agnes, the former dating from 1619 and the latter from 1680. Subsequently, lights were placed at the most dangerous points on the coast, with leading lights to guide ships into ports.

The number of lighthouses was greatly expanded during the nineteenth century, with many now famous towers erected, such as Hartland Point, Start Point and Longships. The major offshore hazards, such as the Wolf Rock, were marked by lighthouses, as were dangerous headlands, making life easier for the mariner.

However, ships continued to be wrecked, and so the need for some form of boat on shore ready to put out to save vessels in distress became acute.

The first attempts to place lifeboats on Britain's coast were made during the last quarter of the eighteenth century, a time when the nation's industrial growth was gathering momentum. The first recorded lifeboat on the west coast was placed at Formby in the mid-1770s,

by Liverpool Docks Commissioners. On the east coast, the fastest growing port was Newcastle, where the first boat designed and built specifically for life-saving has its origins. It was built by Henry Greathead in 1790 at South Shields, on the south bank of the mouth of the River Tyne, and operated from there for several decades.

The shipowners' and underwriters' growing awareness of ship losses

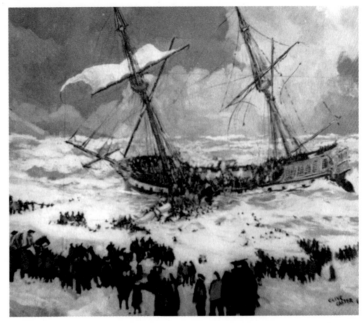

above The wreck of HMS Anson off Looe Bar, Cornwall on 29 December 1807. The previous day she had been driven onto a lee shore by a gale while attempting to return to Falmouth after her anchor cable snapped. The mainmast broke and fell onto the beach and some men managed to get ashore. Estimates of the number of lives lost vary from sixty to 190. Most of the victims were buried in pits dug on unconsecrated ground on the cliffs with no burial rites. A monument to the drowned sailors was erected near the entrance to the harbour of Porthleven. This kind of tragedy was all too common during the eighteenth and nineteenth centuries, with ships coming to grief when caught on a lee shore in bad weather.

left The North Country type lifeboat, with steering oars at both ends, was built by the South Shields boatbuilder Henry Greathead. Only one Greathead-built lifeboat served in the south-west, at Penzance, but was never used for rescues.

The first lifeboats

above An engraving showing the loss of the Welsh brig Diana off Penzance Quay on 9 February 1855. She was one of sixty sailing craft sheltering in Mount's Bay, most of which got to safety when the wind changed, but Diana was driven onto rocks behind the lighthouse pier.

Henry Trengrouse

Henry Trengrouse, a Cornish resident of the area, was the son of a Cornish cabinet maker who, having witnessed the wreck of HMS Anson in 1807, was inspired to start experiments with a line-throwing apparatus. Distressed by the loss of life caused by the difficulties in attaching lines to the wreck, he developed a rocket apparatus to shoot lines across the surf to shipwrecks, and by this means to take off survivors in cradles. This was an early form of the breeches buoy, and Trengrouse's invention was used to save life at sea. An example of his life-saving apparatus is on display at Helston Folk Museum, as is a cannon salvaged from Anson.

prompted greater efforts on their part to reduce dangers to life, ships and trade and, during the first decade of the nineteenth century, Lloyd's insurance agency, in London, set up a fund which promoted the building and operating of lifeboats to counter ship losses. This fund helped to pay for, among others, Cornwall's first lifeboat, which was stationed at Penzance in 1803.

The Penzance boat was one of more than thirty boats built by Greathead in the early 1800s. The Penzance boat was 27ft by 10ft in size and cost 150 guineas, of which Lloyd's contributed £50, while the remainder was made up by locally raised subscriptions. The initial enthusiasm for the project is reflected by the large number of subscribers listed who were in the *Royal Cornwall Gazette* of 29 October 1803.

Although this lifeboat was kept serviceable during the first few years of her existence, she was never used for life-saving. On 22 October 1805, when Cornwall was visited by 'a most tremendous gale', she is stated to have been 'kept in a state of readiness in case

of accident', but was not called upon, although several vessels sheltered at Penzance during this storm. Nothing more is known of this lifeboat until 1812, when she was sold for 20 guineas. Despite the efforts to secure a lifeboat for Penzance, interest in the boat waned to such an extent that it was sold less than ten years after being built.

The reasons for the relative failure of this first lifeboat are a matter of conjecture. Although demand for such a boat was not great in the then relatively quiet trading routes around west Cornwall, the natural hazards of Mount's Bay were enough to justify it. However, the poverty of the county in general would have probably meant that monies needed for its upkeep and operation were scant; indeed, this is supported by a statement made in the *West Briton* newspaper when the lifeboat was for sale. It said: 'Perhaps the Gentlemen of Penzance and its neighbourhood feel themselves so burthened by providing the poor with provisions . . . that they have nothing to spare for redeeming the Life-boat.'

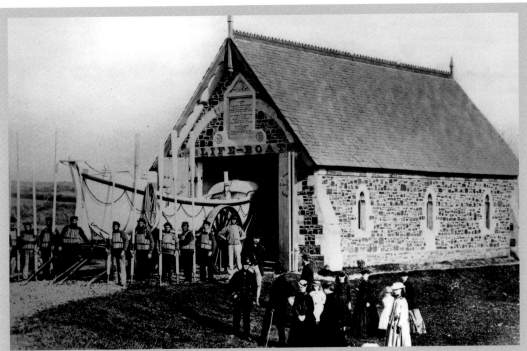

above The lifeboat house built at Bude in 1863 with the first Elizabeth Moore Garden lifeboat, a 33ft self-righter, outside on her carriage. The house was used by all three of the lifeboats named Elizabeth Moore Garden, until the station was closed in 1923.

below The building initially became a garage for removal vans after the lifeboat was withdrawn, but largely retained its external appearance, with the inscription to donors the Garden family intact. It was later converted internally into a holiday home.

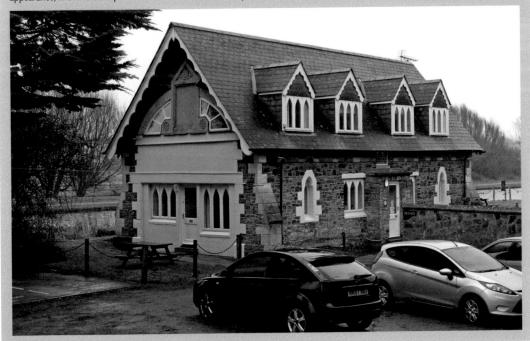

Independent lifeboat initiatives

right The first Padstow lifeboat, named *Mariner's Friend*, was built locally by Tredwen at a cost of £50, and was only 23ft in length. The boat was managed by the Padstow Harbour Association for the Preservation of Life and Property from Shipwreck, which was established on 11 November 1829 with the intention to work towards 'the preservation of life and property from shipwreck, by rendering more effectual assistance to vessels entering the Harbour of Padstow in tempestuous weather'.

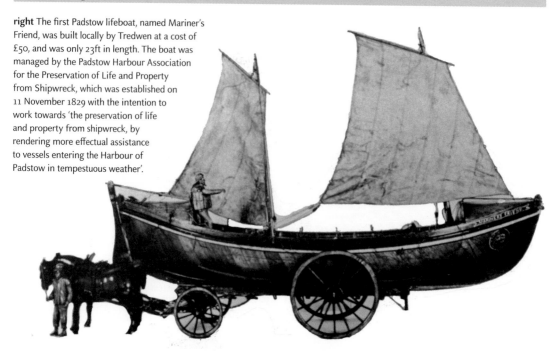

Early rescues

APPLEDORE · 17 December 1833 · The Silver medal was awarded to Thomas Burnard, Honorary Secretary of the North Devon Humane Society, for being the first on board one of the Appledore lifeboats which saved eight from the Liverpool ship Elizabeth, wrecked in a violent storm on Northam Sands

ISLES OF SCILLY · Gig rescues · Before lifeboats had been established, rescues were performed by local people using their own boats. At many of Cornwall's ports, the light, narrow boats built for speed, known as gigs, were used as work boats by local seamen. They were also often used by coastguards or pilots to go to wrecks, particularly on the Isles of Scilly, where many rescues were effected using them. In February 1830 they were used to save twenty-one people from the ship Borodino, which had been driven onto rocks. In 1838 the schooner Victoria, of Exeter, was wrecked in Crow Sound, Isles of Scilly, and three gigs helped to rescue her crew of six.

The Royal National Institution for the Preservation of Life from Shipwreck was founded in 1824, with the aim of providing a lifeboat service on a national basis, described in detail in the following section. However, as the institution was unable to provide lifeboats to every place immediately, local individuals and bodies took responsibility for funding and managing them where they were needed – at those places where vessels were most often at risk and where a crew could readily be obtained.

Between 1803 and the founding of National Institution in 1824 no more lifeboats were built for service in Cornwall, and indeed between 1824 and the 1850s most of the lifeboat initiatives that were put in place came from local communities rather than the national body, although that body did play some part in West Country lifeboat provision.

Following the failure of the lifeboat at Penzance, the next initiatives to provide lifeboats came at Bude,

Appledore, Padstow, Burnham-on-Sea, St Mary's, St Ives and Ilfracombe, as well as another effort to operate a boat at Penzance, one of the area's busiest port. These places were closest to the main shipping routes, and their harbours were small but busy in the days when schooners and barques were numerous and frequent callers.

At Bude, the Admiralty provided a boat in 1817, although details of it are patchy. In 1837 a local committee provided a lifeboat after two vessels were wrecked off Bude on 29 October 1836 after the incident had been brought to the attention of the king, William IV. The monarch then 'most promptly and munificently commanded that a sum of money should be given from the Duke of Cornwall for the purpose of establishing a lifeboat at Bude'.

The lifeboat was of a design similar to Greathead's lifeboats, and was disliked by the crew at Bude. When it capsized during a practice launch in October 1844 with the loss of two men,

any confidence which the crew had in it evaporated. By the early 1850s, long neglected, it was in poor repair.

To cover the dangerous Bideford Bay, which ships traversed to reach the busy ports of Bideford and Barnstaple, lifeboats were stationed at Appledore, where the first arrived in February 1825. An 18ft non-self-righting type named *Volunteer*, she was one of twelve built by Plenty of Newbury for the nascent RNIPLS, and, although small, her sturdy construction stood her in good stead for she served the station for thirty years and saved at least eighty-eight lives.

The boat was managed by the Bideford District Association, a local organisation affiliated to the central body. In 1831 it was taken over by the North Devon Humane Society, which had a stone boathouse built large enough for two lifeboats. In August 1831 the Society applied to the RNIPLS for another boat, and a 26ft craft, built to the design of George Palmer and named *Assistance*, arrived the station on 27 December 1831. In 1848 another lifeboat was built for Appledore, named *Petrel*. The station was operated independently with some success for more than two decades, but by the 1850s, when the North Devon Humane Society experienced financial difficulties, it was taken over by the RNLI.

At Padstow, on the River Camel, which offered a natural haven for ships,

a treacherous entrance caught out many vessels, with the aptly named Doom Bar and Hell Bay being very hazardous, particularly in westerly gales. The first Padstow lifeboat was provided in 1827, named *Mariner's Friend*, and was paid for by a collection made locally, to which the National Institution contributed £10. In November 1829 the Padstow Harbour Association was founded and took over the lifeboat's management, moving it to Hawker's Cove, nearer the mouth of the estuary.

As well as the Plenty-built lifeboat at Appledore, two other Plenty lifeboats

above The lifeboat Volunteer from Appledore going to the aid of Daniel S. Tail on Appledore Bar, making her first approach to the wrecked ship in rough seas during a service on 11 September 1829. (From a painting by Mark Myers, courtesy of the RNLI)

left The lifeboat designed by George Palmer in 1828, as depicted in the report by the 1843 Select Committee on Shipwrecks. Palmer's plan was 'for fitting all Boats so that they may be made secure as Life-boats', and boats built to this plan served at Appledore and Burnham. The boat depicted measured 26ft 8in in length, 6ft 2in in breadth and 2ft 7in depth amidships inside, very similar to the Burnham boat. The boat was described as 'a whale-boat, sharp at both ends, fuller at the bow than at the stern, but flatter in the floor, and with more beam, in proportion to her length, to admit of sufficient space for the crew between the air-cases in the wings.'

Independent lifeboat initiatives

above A contemporary model of the St Ives lifeboat Hope, which was launched on 11 January 1840 having been built locally. Measuring 30ft in length, she was kept in a fish cellar adjoining the coastguard boathouse on the beach, and performed at least one service, on 7 April 1840, when she went to the smack Mary Ann, of Poole, which went ashore in a heavy gale. The lifeboat made two fruitless attempts to reach the vessel and, filled with water, was thrown onto the beach. Eventually two men risked their lives by swimming to the smack and saving those on board it.

served in Cornwall, at Penzance and St Mary's (as described in the following section). And a Palmer type was used at Burnham from 1836, funded by Sir Peregrine Acland, a local landowner, to aid vessels using the river Parret to reach Bridgwater, but details of this boat are lacking.

More is known of the lifeboat built in 1840 at St Ives, another independently-funded boat but unusual to the county in that it was designed locally. The impetus to build a lifeboat came about as a result of two events: a wreck within sight of the port, and a competition organised by the Royal Cornwall Polytechnic Society. The wreck occurred on 24 December 1838, when, in a heavy gale, the schooner *Rival* grounded on one of the harbour piers. Local pilots went out a fishing boat and saved five from the schooner. At the meeting held to make monetary rewards to those involved in this rescue, a discussion took place about 'providing a lifeboat for this port'.

Fortunately for those at the meeting, building a lifeboat for St Ives was feasible thanks to the foresightedness of the Royal Cornwall Polytechnic

Society which, in 1838, held a competition seeking the best model of a lifeboat. Many fanciful suggestions for and designs of rescue boats were put forward, most totally impractical. However, the winning design, by Francis Adams, was neither fanciful nor impractical. Adams, a St Ives boatbuilder, designed his boat with two objectives in mind: first, that it should be highly manoeuvrable when near a wreck, and second, that it should be unsinkable under all circumstances – an optimistic if laudable aim.

His design had two bows so that it could be rowed in either direction without the boat itself being turned round. The rowers effected the change of direction by turning round and facing in the opposite direction. The craft was clinker-built, had extra buoyancy, and was fitted like the local gigs. The favourable reception gained by Adams' design led to the new boat being built by the designer himself. Named *Hope*, it was inaugurated on 11 January 1840, but was largely shunned by the local boatmen for the next decade, and was soon replaced when the RNLI took over the station in 1861.

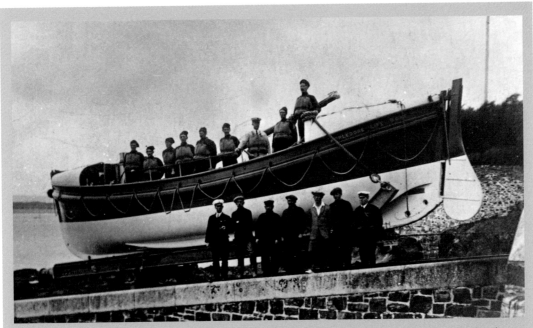

above The first motor lifeboat at Appledore, North Devon, was the 40ft self-righter V.C.S. (ON.675), pictured in 1925 when the station was celebrating its centenary. V.C.S. was powered by a single 45hp Tylor JB.4 four-cylinder petrol engine which gave her a top speed of about seven knots. She served at Appledore from 1922 to 1938, saving fourteen lives in that time. She was launched from a trolley which ran on rails down the slipway; at the end of the rails was a set of buffers and, when the trolley hit these, the boat would be launched through the momentum gained as the trolley went down the slip. This was a rather unusual arrangement used at very few stations, although Sennen Cove operated a trolley on rails during the 1920s.

below Although the location is the same, much has changed in the ninety years since the photo of 1925 was taken. By 2015, the slipway had been widened (although much of the original stonework remained in place), the rails removed and the boathouse rebuilt. The Atlantic 85 ILB, driven by twin 115hp Yamaha outboards, has a speed of approximately thirty-five knots; the ILB has more than five times the power and speed of the station's first motor lifeboat. Driving the tractor is Coxswain Martin Cox.

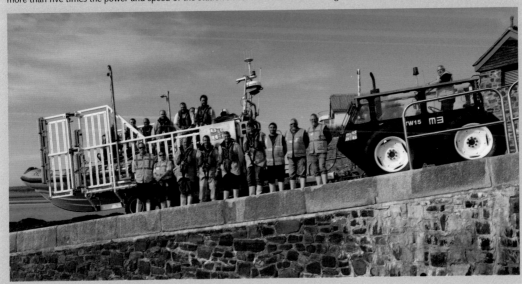

A national organisation

right The first standard lifeboat types used by the RNIPLS were those designed by William Plenty and George Palmer. This diagram shows the Plenty type, which was 18ft or 20ft in length, pulled by six or eight oars, and examples of which served at Appledore, Penzance and St Mary's, with varying degrees of success.

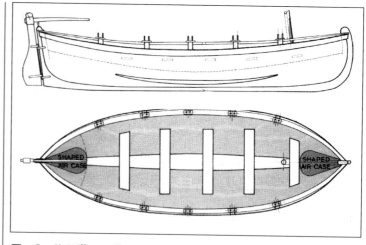

Northumberland Report

The Northumberland Report, which was published in 1851, included details of lifeboat provision around the country, with regional surveys of lifeboat stations, as well as descriptions of the lifeboat models submitted to compete for the prize offered by the Duke of Northumberland for a new lifeboat design. The Report described the situation on England's south-west coasts thus: 'On the south coast, from Dover to Land's End, a distance of 420 miles, there are seven lifeboats, but none at Penzance where most needed. At the Scilly Isles there is one inefficient boat; the same at St Ives and Bude; and a little better at Padstow. So from Falmouth round the Land's End by Trevose Head to Hartland Point, an extent of 150 miles of the most exposed coast in England, there is not a really efficient life-boat. In the Bristol Channel the North Devon Association maintains three life-boats in Bideford Bay. There is a new life-boat at Ilfracombe, and one at Burnham'. So the situation in Cornwall and the Bristol Channel was poor to say the least, and the Report highlighted the need for significant improvements in lifeboat coverage.

In 1823 Sir William Hillary, from Douglas in the Isle of Man, wrote and published 'An Appeal to the British Nation on the Humanity and Policy of forming a National Institution for the Preservation of Lives and Property from Shipwreck'. In this he set out his ideas for the formation of a national body whose sole responsibility would be the preservation of human life from shipwreck. Largely as a result of the exertions of Sir William, the Royal National Institution for the Preservation of Life from Shipwreck (RNIPLS) was founded in London on 4 March 1824.

Initially, the newly formed National Institution was quite successful in fulfilling its aims. One of its earliest ventures was the re-establishment of a lifeboat at Penzance where a 24ft lifeboat, built by William Plenty of Newbury, was sent in 1826. Unfortunately, the boat lasted only two years for reasons that are not clear, but lack of funds and local support probably account for its short life.

Another station established with the assistance of the embryonic National Institution was at St Mary's in the Isles of Scilly, where wrecks were frequent because of the nature of the coastline. In 1837 the Inspecting Commander

of Coastguard on the Isles of Scilly, Captain Charles Steel, collected money for a lifeboat to operate in the islands, sending the £26 19s 6d that he had collected to the National Institution.

At a meeting of the Committee of Management on 21 June 1837, it was agreed to transfer the former Brighton lifeboat, built in 1824, to the Isles of Scilly. The boat arrived in September 1837 and a boathouse was built on the beach at Hugh Town, St Mary's, where a crew could be obtained. However, at 20ft by 6ft 9in, it was too small and not liked by its crew. After only two years at St Mary's, having never been used on service, it was broken up.

Following this first attempt to operate a lifeboat at St Mary's, Captain Steel requested a larger lifeboat from the institution. They sent a boat which, like its predecessor, had also been built by William Plenty, but was 26ft by 8ft 6in, rowing ten oars rather than six. Previously stationed at Plymouth, it had never been used there.

At St Mary's, it was only used once, in January 1841, when it went to the aid of the steam packet *Thames*, which had been wrecked on the Western Rocks in a severe gale. Despite the best efforts of Captain Steel and the volunteers

who manned the boat, as well as the local gigs, the steam packet broke up with the loss of fifty-seven lives. Only one person survived, with eight bodies being recovered by the lifeboat. For his gallantry, the gold medal of the National Institution was awarded to Captain Steel with silver medals going to four of the coastguard men who also went out in the lifeboat.

Improvements were needed to make the lifeboat at St Mary's more effective, yet nothing was done, most likely because of a scarcity of funds available to the National Institution and the lack of a suitably powerful lifeboat design. The lifeboats of the pre-1850 era, which were generally under 30ft in length and relied solely on manpower, struggled to cope with the seas off Scilly, and reaching wrecks on the outer islands in such a small craft would have been almost impossible in bad weather.

Although the National Shipwreck

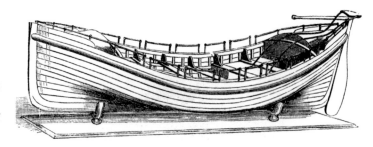

Institution, as the RNIPLS became known, had provided lifeboats in the years immediately after its founding, by the mid-1830s its operations had faltered through lack of funds. Since its inception in 1824, raising money for lifeboats had proved difficult, and annual income gradually dwindled. By 1850, with no public appeals made for over a decade, the level of finance available to the committee of management was at its lowest level.

Matters came to a head following a disaster at the mouth of the River

above Diagram of the self-righting type lifeboat built in 1851 by James Beeching. She was the product of the winning designs submitted for the Northumberland prize and measured 36ft in length. Beeching's design employed a principle of self-righting achieved by a low waist and high air-cases at each end, causing the boat to come upright in the event of a capsize.

below The first lifeboat station established in Cornwall following the RNLI's reform was that at Sennen Cove, to cover the treacherous seas off Land's End. The new boat was a small, light self-righter, to James Peake's design, 25ft 8in in length, 6ft 10in in breadth, and rowing six oars.

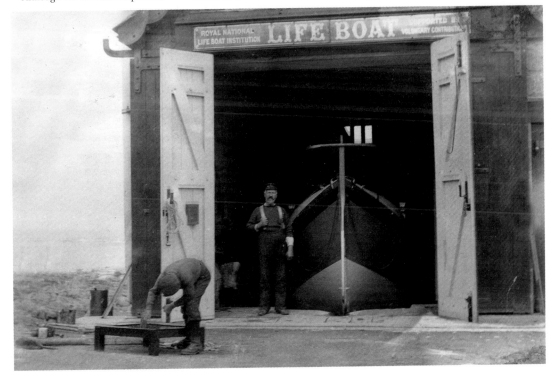

A national organisation

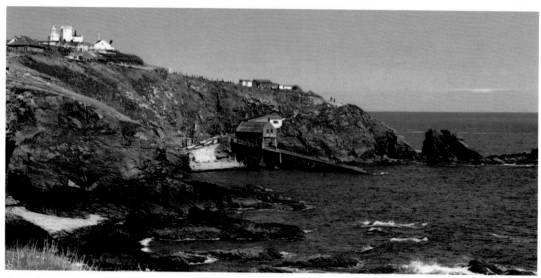

above The historic Lizard Point, where the RNLI operated a lifeboat from 1859. The first lifeboat house was built at the top of the track leading down to Polpeor Cove, so that the boat could be taken elsewhere if required. In 1892 a new house was built, at the foot of the roadway, from which the lifeboat was launched over skids.

below The original lifeboat house at Newquay built in 1860 in Fore Street, near the top of South Quay Hill. It originally housed a 30ft self-righter, subsequently taking boats up to 34ft, and by 1899, when it was vacated by the RNLI, it was inadequate. However, the historic building, one of the oldest lifeboat houses in existence, remains in use as a shop. (Grahame Farr, courtesy of the RNLI)

Tyne in December 1849, when one of the local lifeboats capsized in sight of the land with the loss of twenty out of twenty-four on board, highlighting the need for more efficient lifeboats. But in the 1850s, Richard Lewis and the Duke of Northumberland, then First Lord of the Admiralty, became the institution's Secretary and President respectively, and both played a major part in improving the institution's fortunes.

During the early 1850s, under their guidance a series of reforms were implemented. The service was reorganised and, in 1854, renamed the Royal National Lifeboat Institution (RNLI). The Duke of Northumberland realised that a new design of lifeboat was also essential. After consulting with the institution's chairman and deputy chairman in May 1850, he drew up a prospectus for a national competition to test the ideas of boatbuilders and designers throughout the nation.

Out of 282 plans submitted, the design of the Great Yarmouth boatbuilder James Beeching was deemed the best. Beeching's design was subsequently modified by James Peake, Master Shipwright of the Royal Naval Dockyard at Woolwich, under the instructions of the institution, and the Peake designed self-righter, altered and improved over time, became the standard type throughout the country.

With a new design of lifeboat available and the RNLI on a relatively sound financial footing, the committee of management embarked on a fairly rapid building programme, and established many new stations. The first new station in Cornwall during this expansion was at Sennen Cove, a small hamlet about a mile to the north of Land's End. A lifeboat was placed

here as the direct result of a shipwreck that occurred in November 1851 which, as well as drawing attention to the need for a lifeboat in the area, was also one of the most heroic rescues ever undertaken in Cornwall.

On the morning of 11 November 1851, in thick fog, the brig *New Commercial*, of Whitby, struck the Brisons, a pair of rocks off Cape Cornwall, and broke up. Of the nine crew, only the master and his wife survived, reaching a ledge on the Little Brison rock from where they were seen at daybreak. Attempts were made to reach them, but none succeeded and, by the following morning, hundreds of people thronged the cliffs to watch as no fewer than six vessels attempted to effect a rescue, but none could get close. However, Captain George Davies, Inspecting Commander of the Coastguard, had a nine-pound rocket which, although never been tried here before, was the only option left.

The first line to be fired fell short, but the second reached the rock and the master's wife was first pulled to the boat, but later died of exhaustion; the master was more fortunate and reached another boat, being landed at Sennen. For their

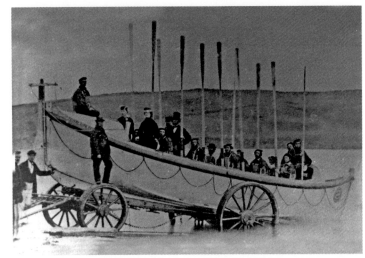

effort made in trying to effect a rescue, Captain Davies and Thomas Randall, Commander of the cutter *Sylvia*, were awarded the RNLI's gold medal.

Following this tragedy, steps were taken to establish a lifeboat station at Sennen. At the Annual General Meeting of the RNLI held on 22 April 1852, it was reported that a boat was ready to be sent there, 'in acknowledgement of the gallant conduct of the Coast Guards and fishermen of that place on the occasion of the wreck of the ship *New Commercial* on the Brisons'.

above The lifeboat station at Polkerris as founded in 1859, one of the earliest to be opened by the RNLI in Cornwall, operating lifeboats to cover St Austell Bay. This is one of the earliest photographs from Polkerris, and probably shows the station's second lifeboat, Rochdale, on her carriage at Par. (Supplied by Paul Richards)

below Line drawing entitled 'Lifeboat Race', which took place in Mount's Bay on 10 September 1867 and involved lifeboats from St Ives, Penzance, Porthleven, Hayle and Mullion. It was held to make the inaugural ceremony of the new Mullion lifeboat Daniel J. Draper, a 33ft self-righter.

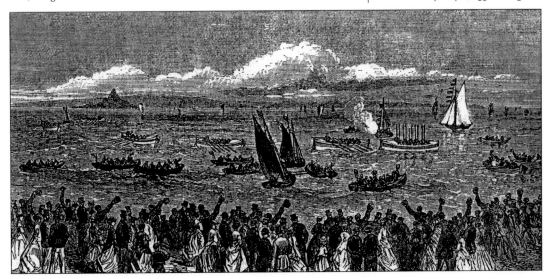

Nineteenth-century lifeboat work

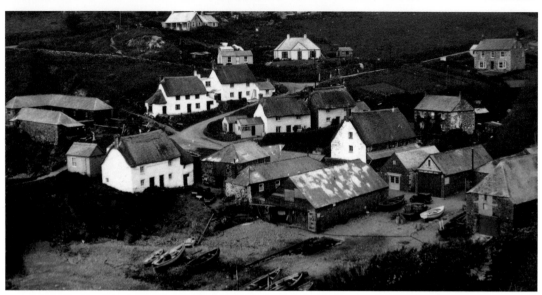

above The small village of Cadgwith, with the lifeboat house centre right. A lifeboat was operated by the RNLI, covering the eastern side of the Lizard peninsula, from 1867 to 1963.

The nineteenth century was a period of great expansion in lifeboat coverage as the RNLI opened many new stations to cover the most dangerous parts of the coast, with the institution benefitting from an improved financial position and having a suitable design of lifeboat available. In addition to the new station at Sennen described above, new lifeboats were also built for Bude, Penzance (both in 1853) and Padstow (in 1856), where lifeboats had been operated before.

Lifeboat coverage was further expanded around the West Country during the late 1850s and into the 1860s when, not only were new lifeboats

provided, but new stations were opened to cover various danger spots. Between 1859 and 1863 four new stations were established, at Polkerris and Lizard (both in 1859), Newquay (in 1860) and Porthleven (in 1863), bringing to eight the number of lifeboats in Cornwall, and by the 1860s the most dangerous hazards had been covered.

The new stations at Polkerris and Lizard were of particular significance as they were the first on Cornwall's south coast. Hitherto, no lifeboat was in operation between Penzance to the west and Teignmouth, in Devon, to the east. Polkerris is a small village at the eastern end of St Austell Bay, in which the two

right The inauguration of the 33ft ten-oared self-righter Jack-A-Jack (ON.225) at Morte Bay on 17 March 1871. She served the station from 1871 to 1892, and was renamed Grace Woodbury in 1872 having been appropriated to the gift of Mr R. Atton, of Taunton. The Morte Bay station, located at Woolacombe, was manned from Ilfracombe, was in operation from 1871 to 1900. (From the files of Grahame Farr, courtesy of the RNLI)

small harbours of Charlestown and Pentewan are situated. Since the 1820s, these harbours attracted an increasing number of vessels, mainly involved with the china-clay industry. The new station was established following the wreck of the schooner *Endeavour*, of Ipswich, off Gribben Head on 6 May 1856, after she had been driven ashore by a gale.

The coastguard failed to reach the schooner in the severe weather so a small boat and ropes, sent from Polkerris, were lowered down the cliffs, and, manned by three men, put out. Watched by a large crowd, the three men struggled in the ferocious conditions to manoeuvre the punt towards the only survivor, but he was successfully brought ashore.

Following this, William Rashleigh, the local landowner, wrote to the RNLI requesting a lifeboat for the area. Selecting the best site for the station proved difficult and the matter was left for three years until further pressure from Rashleigh brought about the establishment of the station. He contributed money and material for the building of a lifeboat house, together with other local gentry, with Polkerris being chosen as the most suitable site as it offered a sheltered launching area. A lifeboat house was built on the beach

and housed a 30ft six-oared self-righter, named *Catherine Rashleigh*.

As with Sennen in 1851 and Polkerris in 1856, the establishment of a lifeboat station at the Lizard also came about following a tragic accident in the area. On 22 January 1859, the steamship *Czar* struck the Vrogue Rock and sunk within half an hour. Some of those on board were rescued by coastguard, but thirteen others lost their lives. This event was brought to the attention of T.J. Agar Robartes, of Lanhydrock, a landlord in the county, who ascertained the practicality of having a lifeboat stationed at or near the Lizard.

As at Polkerris, finding the most suitable site proved problematic, but local opinion favoured Polpeor Cove,

SW lifeboat stations opened 1850–1870

1853 Sennen Cove	1867 Falmouth
1859 Polkerris	1867 Cadgwith
1859 Lizard	1867 Mullion
1860 Newquay	1869 Mevagissey
1863 Porthleven	1869 Porthoustock
1866 Looe	1869 Port Isaac
1866 Hayle	1869 Lynmouth

The RNLI expanded lifeboat provision during the 1850s and 1860s; in addition to the above stations, which were newly opened, the RNLI took over independent stations at Appledore (1855), Padstow (in 1856), St Ives (1861), and Ilfracombe and Burnham (both in 1866).

below The Penzance lifeboat Richard Lewis, a standard 32ft self-righter, returning from service to the barque North Britton, of Southampton, on 6 December 1868, from which eight people were saved.

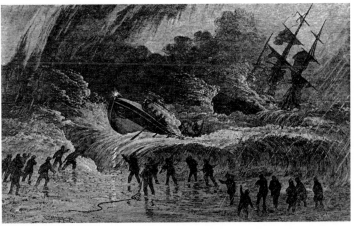

Nineteenth-century lifeboat work

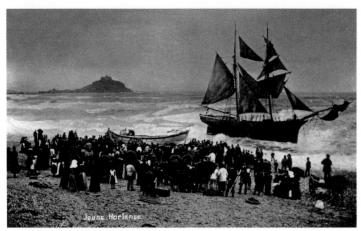

above The wreck of the French brigantine Jeune Hortense at Penzance on 17 May 1888, with the lifeboat Dora (ON.49) being prepared to go to her aid. The vessel stranded 300 yards offshore and the rescue was watched by a crowd of locals, while photographer John Gibson took a series of images, which have subsequently been widely used, of the event. (From an old postcard supplied by John Harrop)

below St Mary's lifeboat Henry Dundas (ON.313) going to the aid of the the ship Horsa, of Liverpool, on 4 April 1893, from which she landed three. (From an old postcard supplied by John Harrop)

at the southern tip of the Lizard, which was centrally placed enabling a lifeboat to most easily reach either side of the peninsula. Agar Robartes and his mother funded the establishment, providing both lifeboat and boathouse, and in November 1859 the new 30ft six-oared self-righter Anna Maria arrived. The total cost of the new station was £269. However, despite the fine intentions of Agar Robartes in getting the station established, its first lifeboat met with a tragic end. During a

routine exercise on 2 January 1866, she was wrecked with the loss of three of her crew. She was quickly replaced by another boat of similar size and design.

By the time Lizard's second lifeboat had been placed on station, frequent wrecks showed that further lifeboats were needed on the east and west of the Lizard peninsula. New stations were therefore opened in 1867 at Mullion on the western side and Cadgwith on the eastern side. Both places afforded sheltered launching sites with adequate crew available to man the lifeboats.

The success of the RNLI in establishing lifeboat stations after the reforms of the 1850s was down to a combination of factors, with one of the most significant being the introduction of the self-righting design of lifeboat, based on Beeching's prize-winning design of 1851. All of the stations opened in Cornwall and Devon in the 1850s and 1860s received this design of lifeboat. In fact, all the West Country lifeboat stations operated a boat of this type at one time or another.

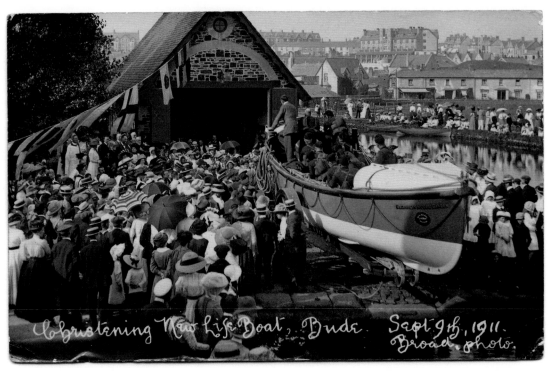

Christening New Life Boat, Bude. Sept 9th, 1911. Broad. photo.

The second half of the nineteenth century was the heyday of the self-righting lifeboat. The design had been perfected since its conception in 1851 so that by the 1880s it was almost the only type of lifeboat in use. Self-righters were primarily rowing boats, usually 34ft or 35ft in length, with a limited range. As a result many stations were operated, with lifeboats sometimes grouped close together, so that which was best placed in the conditions prevailing at the time of a shipwreck would go to the casualty.

The situation at Appledore, where lifeboats were placed at both the north and south entrances to the river, was not unusual, and a similar situation existed at the Lizard, where not only were flank stations opened either site

above The christening ceremony of Elizabeth Moore Garden (ON.616) at Bude on 9 September 1911. The boat, a 35ft self-righter and the third so named to be provided by the family of the late Mr R.T. Garden, London, was christened by Mrs Waddon Martyn. She was the latest design, with four water ballast tanks and eleven relieving tubes, proving to be 'a very splendid craft under all conditons'.

below left The Porthleven lifeboat John Francis White (ON.444), a 35ft self-righter, launching into the harbour down the slipway, watched by crowds lining the quay.

below The 36ft ten-oared self-righter Arab (ON.472) served at Padstow from 1901 to 1931, replacing a boat of the same name that was wrecked on service in April 1900. (Images this page from old postcards supplied by John Harrop)

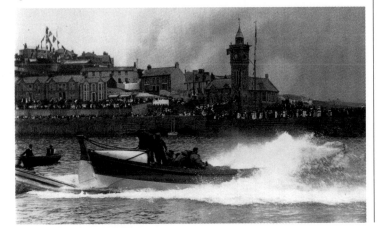

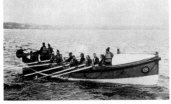

Nineteenth-century lifeboat work

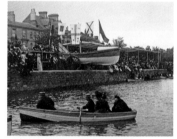

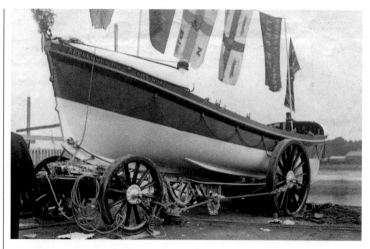

above/right The 36ft ten-oared self-righting lifeboat Robert and Catherine (ON.632) on Barnstaple Quay for her inauguration on 29 May 1912. She served at Braunton Burrows, an offshoot of the Appledore station, from 1912 to 1919. (Grahame Farr, courtesy of the RNLI; from an old postcard supplied by John Harrop)

below A fine photograph of the St Ives lifeboat Exeter, a standard 34ft ten-oared self-righter on station from 1886 to 1899, on her carriage outside the lifeboat house. Her crew have donned their cork lifejackets for the photograph.

of Lizard Point, but in the 1880s it was deemed necessary to place a second boat at the station.

Two lifeboats were also operated at Padstow for more than sixty years from 1901, when a large sailing lifeboat was sent to the station for long-range work attending casualties out to sea. Another boat was supplied for work closer inshore and around the Camel estuary.

Because they were light enough to be carriage-launched, and because sailing against the wind in a vessel relying solely on manpower was slow and exhausting work, these lifeboats would sometimes be taken further afield to a site from where a launch would enable the casualty to be reached more easily. At Padstow, an unusual and unique development involved a carriage being

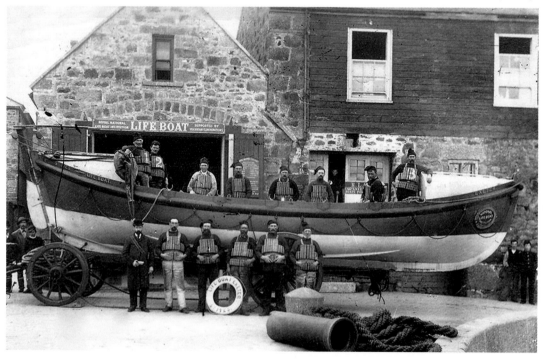

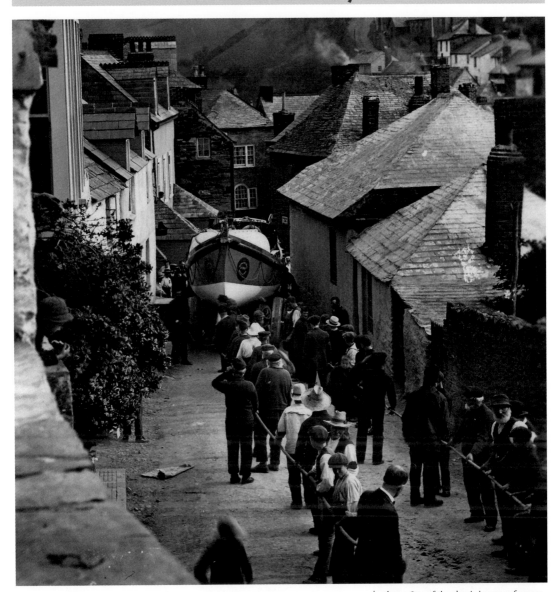

kept in a small house built in 1883 on high ground above the town, and this was used for moving the lifeboat to one of the beaches around Padstow other than those usually used.

Between 1865 and 1885, a further fourteen stations were established in the West Country. On the south coast, new stations were opened at Looe (1866); Falmouth, Cadgwith and Mullion (all 1867); Mevagissey and

Porthoustock (both 1869); Portloe (1870); and the No.2 station at Lizard (1885). On the north coast lifeboats were placed at Hayle (1866) and Port Isaac (1869). A second station was opened in the Isles of Scilly, at St Agnes, in 1890 to assist vessels wrecked on the Western Rocks, the most dangerous part of the Isles of Scilly, but the local community was so small it was often difficult to obtain a full crew.

above One of the classic images of rescue work in the era of the sailing and pulling lifeboats is that of the Port Isaac lifeboats being hauled through the village's narrow streets back to the boathouse at the top of the hill. Helpers would pull the lifeboat through the street up a hill, and over the years ropes cut into the buildings leaving notches. The boat pictured is the 34ft ten-oared self-righter Richard and Sarah (ON.334), the third boat so named to serve the station. (From an old postcard supplied by John Harrop)

Nineteenth-century lifeboat work

above Launch of the Newquay lifeboat James Stevens No.5 (ON.426) down the steep slipway at Towan Head. The slipway was one of the steepest in the country. (From a postcard in the author's collection)

below Weston-super-Mare lifeboat Colonel Stock (ON.488), a 38ft Watson sailing type, launching down the slipway at Weston, which was built in 1902-3 and was one of the longest. (From an old postcard supplied by John Harrop)

In the Bristol Channel, lifeboats were placed at Burnham-on-Sea in 1866, Lynmouth in 1869 and at Clovelly in 1870, while continual efforts were made to improve the coverage of Barnstaple Bay with lifeboats being placed at Appledore, Braunton and Northam Burrows at various times in what was a complicated set up that frequently changed. Further stations were opened at Morte Bay (1871), Watchet (1875) and Weston-super-Mare (1882).

The station at Lynmouth operated a standard 30ft self-righter when opened in 1869, having been established following the wreck of the ship *Home*, bound from Bristol for Quebec, on 22 August 1868. Of the nineteen on board, seventeen were saved by various means and not without difficulty by local inhabitants, but two were lost, highlighting a gap in lifeboat coverage.

The first lifeboat, *Henry*, remained on station until April 1887, when she was replaced by a larger 34ft self-righter, *Louisa* (ON.54), which was involved in one of the most famous rescues in the history of the lifeboat service. During the evening of 12 January 1899 the three-masted ship *Forrest Hall*, carrying thirteen crew and five apprentices, got into difficulty off Porlock Weir in a severe gale and was now dragging her anchor. Launching the lifeboat at Lynmouth and rowing round to Porlock Wier would be impossible in the

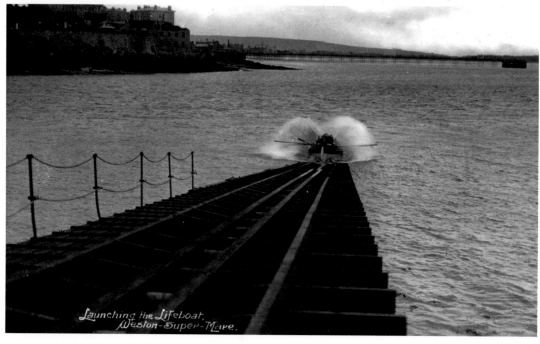

Launching the Lifeboat. Weston-Super-Mare.

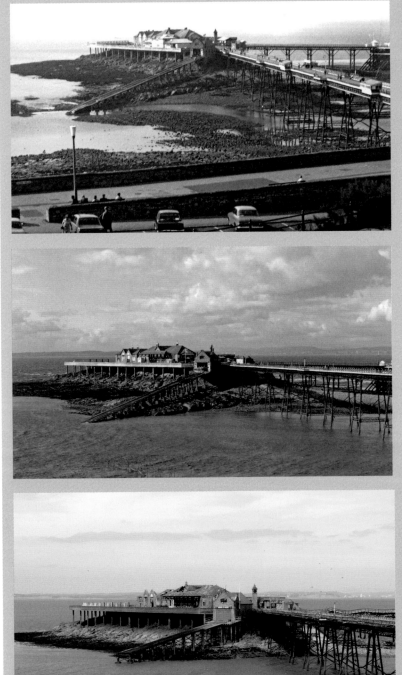

top The lifeboat house and slipway built in 1902-3 on the south-eastern side of Birnbeck Island for the 38ft Watson sailing lifeboat *Colonel Stock* (ON.488), which was on station from 1903 to 1933. The building was funded by the late Mrs Anna Sophia Stock, who also funded the lifeboat. The slipway was 368ft long, making it one of the longest in use at RNLI lifeboat stations. This picture dates from September 1971 when the boathouse was used for two inshore lifeboats, one of which was the 18ft 6in McLachlan type A-504.

middle Birnbeck Island, linked to the mainland by a pier designed by Eugenius Birch and opened in 1867, is the best place from which to operate a lifeboat at Weston as it provides access to deep water at all tides, giving the lifeboats access to the main channels when called upon, and two lifeboat houses have been built on the island.

bottom Pictured in April 2015 after the RNLI had abandoned their site on the Island and moved operations to a temporary base at Knightstone Harbour, the boathouse had deteriorated and the slipway had been out of use for a number of years, after launching by tractor and carriage had been employed. The pier, in private ownership and not maintained for many years, had become too dangerous for lifeboat crews to use, and this precipitated the RNLI's withdrawal. The buildings on the island have long since fallen into disrepair, while the pier, which has gradually been collapsing, has been closed since 1994.

Nineteenth-century lifeboat work

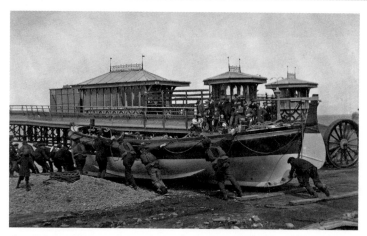

above Minehead lifeboat Arthur Lionel (ON.626), a 35ft twelve-oared Liverpool type non-self-righter, being hauled across the beach to be launched. Built in 1912 for service in Jersey, she served at Minehead from 1930 to 1939, and was the station's last sailing lifeboat. (From an old postcard supplied by John Harrop)

below The 35ft self-righter Queen Victoria (ON.468) being launched at Porthoustock, a small village on Cornwall's south coast. Manhandling the four-ton lifeboat over the beach required considerable effort on the part of numerous shore helpers. (From an old postcard supplied by John Harrop)

prevailing conditions. So Coxswain Jack Crocombe proposed to take the boat by road to Porlock's sheltered harbour, thirteen miles down the coast, and launch from there.

What followed has become known as the 'Overland Launch', and involved taking the boat on her carriage, which weighed in total about ten tons, over the one-in-four Countisbury Hill out of Lynmouth, a tremendous feat accomplished by twenty horses and 100 men, and down the other side. The road, which at its highest point

is 1,423ft above sea level, had to be widened in places to allow the lifeboat to pass. But the lifeboat got to the top after more than ten miles of wild Exmoor tracks had been crossed. The descent of Porlock Hill was equally dangerous, with horses and men pulling the ropes to prevent the carriage from running out of control.

The lifeboat eventually reached Porlock Weir at 6.30 a.m. and was launched to *Forrest Hall*. Although cold, wet, hungry and exhausted, the crew rowed for over an hour in heavy seas to reach the stricken vessel and managed to save the eighteen men on board. This epic rescue has lived long in the memory, and the overland journey was recreated in January 1999 to mark the centenary of the event.

Following the *Forrest Hall* rescue, a new lifeboat station was opened at Minehead to cover the gap highlighted by the incident. A 35ft Liverpool type, named *George Leicester* (ON.477), was sent to the new station, which became operational in December 1901. Minehead was the second new station

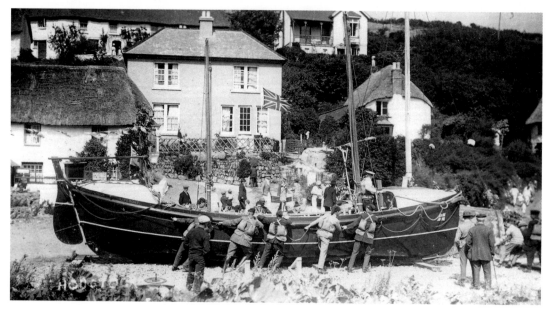

Nineteenth-century lifeboat work

in the West Country to be established in 1901. The other was at Coverack, needed following shipwrecks on the Manacles in 1898 and 1899. A house and slipway were built in the small harbour, which enabled the lifeboat to be launched quickly and easily, and a 35ft Liverpool type boat, similar to that at Minehead, was placed in service. The Liverpool type had a greater range than the pulling self-righters.

During the years up to the outbreak of the First World War one of the most significant shipwrecks in the RNLI's history occurred wen the steamer *Suevic* was caught in a storm off the Cornish coast in March 1907, and ran aground among the rocks of Maenheere Reef, a quarter of a mile off the Lizard with 524 passengers on board.

Lifeboats from Cadgwith, Coverack, The Lizard and Porthleven were called out and their crews – a total of about sixty lifeboatmen – rowed back and forth for sixteen hours to rescue the

passengers and crew. The numerous journeys were undertaken in dense fog and heavy seas and resulted in 456 men, women and children from the stricken liner being brought to safety, and, amazingly, not a single life was lost. Six people were awarded silver medals by the RNLI, including two Suevic crew members and two members of the Cadgwith lifeboat crew, Edwin Rutter and the Rev Harry Vyvyan.

left Watchet lifeboat being taken up Cleeve Hill for a practice launch at Blue Anchor, two miles away, in the 1920s. The boat pictured is the station's last lifeboat, the 35ft self-righter Sarah Pilkington (ON.473), which served the station from 1919 to 1944. (From an old postcard supplied by John Harrop)

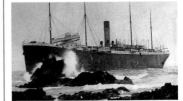

above The saving of 456 people from the steamer Suevic in 1907 set the record for the largest number of people saved in a single operation in RNLI history – a record that still stands today. (By courtesy of the RNLI)

below Launch of Coverack lifeboat Constance Melanie (ON.458), a 35ft Liverpool type non-self-righter which served the station from January 1901 to 1934. She was the first lifeboat to serve the station, and saved ninety-four lives. (From an old postcard supplied by John Harrop)

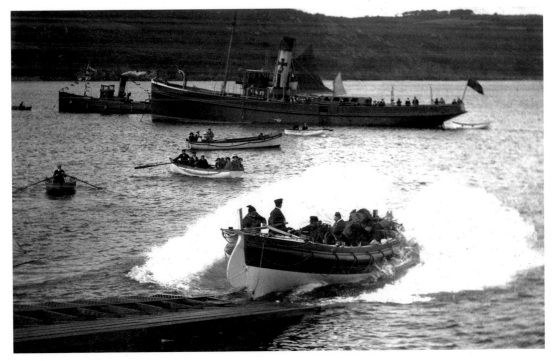

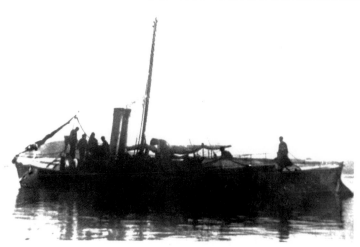

above The steam lifeboat James Stevens No.4 (ON.421) was twin funnelled and powered by twin screws. She was the only such craft to serve in the West Country, where a paucity of suitable harbours restricted the use of steam lifeboats. (By courtesy of Padstow RNLI)

below The three survivors of the James Stevens No.4 disaster of 1900: Ernest Tippet, Thomas Grant and Orson French. (By courtesy of the RNLI)

below right The steam lifeboat James Stevens No.4, barely recognisable, after being wrecked with the loss of eight of her crew in the Padstow disaster of April 1899. One onlooker commented that she resembled 'nothing so much as a battered tin can'. (By courtesy of the RNLI)

The first powered lifeboats which the RNLI employed were steam-driven craft that entered service in the 1890s. Nineteenth-century lifeboat designers initially thought a steam-powered lifeboat impractical due to the severe conditions under which lifeboats often operate. However, although designing and building a steam lifeboat presented designers with many difficulties, advances in engineering techniques during the latter half of the century meant that building a steam-powered lifeboat became a possibility.

By 1890 it was a reality when the first steam lifeboat, *Duke of Northumberland* (ON.231), was launched from her builder's yard on the Thames for her first trial trip. During the next decade, the RNLI

had a further five steam lifeboats built for service around the British Isles. These impressive vessels were all over 50ft in length and could cover a much greater area than any pulling or sailing lifeboat. However, their size restricted the number of places where they could be stationed; they had to be kept afloat, but few places had sheltered moorings.

In the West Country, Padstow was deemed the only place from where such a vessel could operate and one was sent there in February 1899. Named *James Stevens No.4* (ON.421), she was 56ft 6in in length and was one of two similar craft built in 1899 at Cowes by J.S. White. She was only the second lifeboat to be built that was driven by a propeller; her sister ship, *James Stevens No.3* (ON.420), was the first. Sadly, *James Stevens No.4* served at Padstow for less than a year, until April 1900, when she was tragically wrecked.

The disaster that befell Padstow's steam lifeboat was one of the worst in the RNLI's history, for not only did the steam lifeboat capsize but the station's pulling lifeboat *Arab* (ON.51), a 34ft self-righter, was also wrecked going to the same vessel. Both lifeboats put out on 11 April 1900 to the ketch *Peace and Plenty*, of Lowestoft, which had anchored at the harbour mouth having fished during the day. By

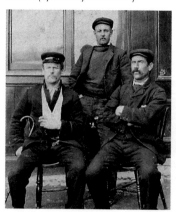

nightfall, she began to drag her anchors, and eventually went ashore. The Trebetherick Life Brigade managed to bring four men to safety, and another jumped overboard and made it ashore, but three others were drowned.

Meanwhile, *Arab* had launched and her crew searched for an hour. Unable to find anybody, they returned to Padstow, but, as they headed back, a very heavy sea struck the boat, unseating the crew and carrying away nine of the ten oars. The crew threw the anchor overboard, and burnt a distress flare. They managed to beach the boat using the spare oars, and the crew were then able to scramble ashore, uninjured.

Meanwhile, *James Stevens No.4* was putting out. As her draught was too great for a direct crossing of the sands in the estuary, a course was set for deeper water. However, before managing to turn towards the casualty, she was caught by a huge sea which

lifted her stern out of the water, spun her broadside to the waves and turned her over. The seven crew in the cockpit were thrown clear, but the four in the engine room tending the boilers were trapped. The three men washed off the boat came ashore and were revived, but the other four were drowned. The lifeboat herself was thrown into a small cave in the rocks at Hell Bay.

Despite the tragic loss of *James Stevens No.4*, a powered lifeboat was still deemed necessary for the challenging conditions in and around Padstow. So, the RNLI developed a unique combination of a steam tug, which was purpose-built by the institution, working with a large pulling lifeboat. Commercially operated steam tugs were used in life-saving at other major ports, notably Ramsgate, where the lifeboat would be towed to the scene of a wreck. However, as no such tug was available at Padstow, the RNLI

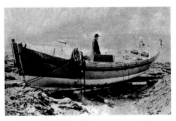

above The wreck of the Padstow pulling lifeboat Arab (ON.51) near the harbour entrance, April 1900. (Courtesy of Padstow RNLI)

below The steam tug Helen Peele (ON.478) in Padstow harbour. The 95ft 6in twin-screw vessel was designed by George Lennox Watson and represented a unique departure in lifeboat design.

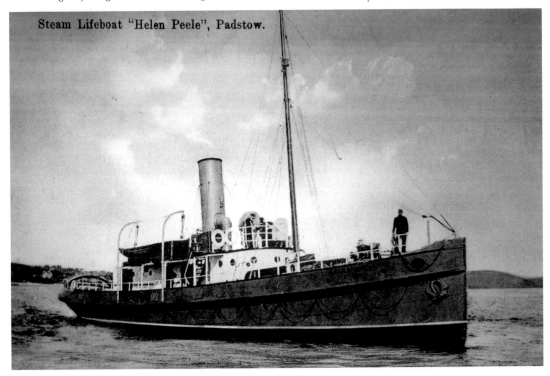

Steam Lifeboat "Helen Peele", Padstow.

The first powered lifeboats

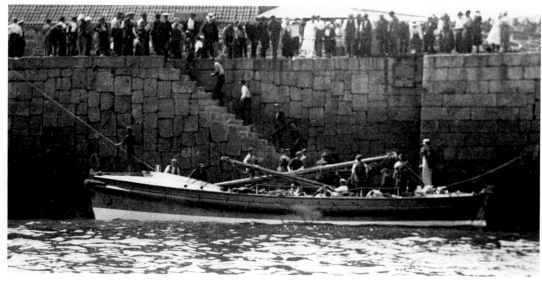

above The new 45ft Watson motor lifeboat Elsie (ON.648) landing forty men from the steamship Western Front, of Seattle, at St Mary's, Isles of Scilly on 11 July 1921. Elsie, one of the first Watson motor lifeboats, was single-engined and so carried a full set of sails in case the motor failed, but the sails were rarely used. (Grahame Farr, courtesy of the RNLI)

right Elsie on service to the drifter Lord Haldane, of Lowestoft, and her crew of nine on 20 March 1929. Elsie served at St Mary's from 1919 to 1930, saving eighty-eight lives during theat time. (Grahame Farr, courtesy of the RNLI)

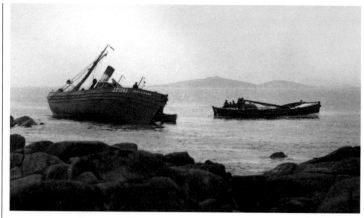

below The pulling and sailing lifeboat Edmund Harvey (ON.475) at Padstow was one of the largest lifeboats of that type to be built by the RNLI. She was intended for use primarily under sail, and usually worked in conjunction with the steam tug Helen Peele. (Courtesy of the RNLI)

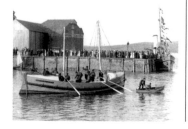

built one to their own specification. Named *Helen Peele* (ON.478), she was 95ft 6in long, steel-hulled, and had two compound engines producing 400hp and driving twin screws, developing a very satisfactory speed of over ten knots. The 42ft twelve-oared self-righter *Edmund Harvey* (ON.475) was used in conjunction with *Helen Peele* and these two boats undertook much life-saving work, operating together successfully for twenty years at Padstow.

Apart from the disaster at Padstow, steam lifeboats served the RNLI well, although only six were built. But they were overtaken in the early years of the twentieth century by the internal combustion engine which, when applied to lifeboats, represented a significant advance, being able to go where pulling lifeboats could not, and cover a far larger area.

Petrol-driven engines were first developed during the second half of the nineteenth century, and by the 1900s motor power was being applied to sea rescue work. The first lifeboat with an engine was *J. McConnel Hussey* (ON.343), a pulling lifeboat built in 1893, fitted with 10hp engine in 1904. Although there were many problems to be solved to operate an engine

The first powered lifeboats

on board a lifeboat sucessfully, once these technical difficulties had been overcome, lifeboats powered by the internal combustion engine pointed the way ahead for the RNLI.

Initially lifeboats already in service were converted with the fitting of an engine, but in 1908 the first lifeboat built with an engine was completed. Further developments with engines were delayed by the war of 1914–18, but once hostilities had ended the RNLI made up for lost time with an ambitious building programme.

The first motor lifeboat in Cornwall arrived at the Lizard in 1918, where the crews had to frequently contend with heavy seas. The boat was a 1912-built

38ft self-righter named *Sir Fitzroy Clayton* (ON.628), which was fitted with a single 35hp Tylor petrol engine. Like most immediate post-war lifeboats, she was based on old designs of pulling and sailing lifeboats, but fitted with a single petrol engine of relatively modest power and sometimes questionable reliability.

In this boat, however, the Lizard crew gained valuable experience while their own motor lifeboat, *Frederick H. Pilley* (ON.657), was under construction at Cowes. This new boat, also a 38ft self-righter, arrived at the Lizard in November 1920 and served the station until 1934, and is credited with saving 130 lives during that time. She was

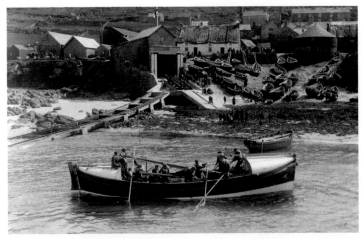

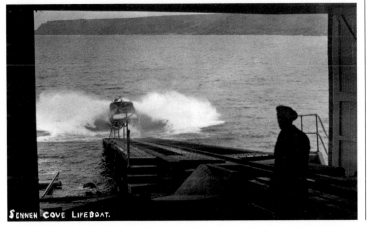

SENNEN COVE LIFEBOAT.

left The first motor lifeboat at Sennen Cove was the 40ft self-righter The Newbons (ON.674), pictured arriving on station in May 1922. The bow of her predecessor, Ann Newbon, can just be seen beside the boathouse. The launching trolley has been placed at the head of the short slipway ready for the new boat to be recovered, while a crowd of well-wishers and local supporters have turned out to see the new boat at first hand. (From an old postcard supplied by John Harrop)

left The Newbons (ON.674) being launched down the long slipway after the railway lines and trolley, in place when the boat first arrived, had been replaced. The remains of the rail tracks can just be made out at the far left. During this period the RNLI experimented with various unusual methods of launching, but at the majority of stations slipway launching was the preferred solution to getting the boat afloat. (From an old postcard supplied by John Harrop)

The first powered lifeboats

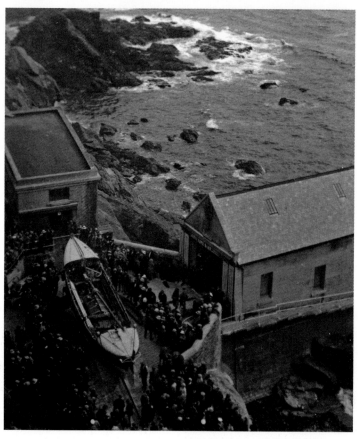

above The Lizard motor lifeboat Frederick H. Pilley (ON.657) returning from service to the White Star Line's liner Bardic, which was wrecked on the Maenheere Reef on 31 August 1924. The lifeboat saved ninety-three persons from the casualty, in relatively benign conditions. The liner was later refloated with the help of salvage tugs and towed to Falmouth. In this photo, looking down on the scene at Lizard Point with the lifeboat on the turntable, the engine casing on Frederick H. Pilley is clearly visible. (Grahame Farr, courtesy of the RNLI)

right The 40ft self-righting motor lifeboat V.C.S. (ON.675) was stationed at Appledore from 1922 to 1938. She is pictured in 1929 hosting a visit by the mayor of Bideford, Maine, in the river off Bideford. (Grahame Farr, courtesy of the RNLI)

named *Elsie* (ON.648), was a 45ft Watson motor type powered by a 60hp Tylor engine, while also equipped with eight oars and a modest sailing rig should the engine fail.

The 45ft Watson was a larger and more powerful type better suited to the Atlantic swell, and another boat of this type was sent to Penlee in December 1922. Named *The Brothers* (ON.671), she was similar to the St Mary's boat and spent nine years at Penlee before being transferred to Falmouth in April 1931, becoming the first motor lifeboat there.

By the time *The Brothers* was in situ at the Penlee Point boathouse, new motor lifeboats had arrived at both Sennen Cove and Appledore. Named *The Newbons* (ON.674) and *V.C.S.* (ON.675) respectively, they were self-righting types measuring 40ft by 10ft 6in and were effectively sister vessels, built at the Cowes yard of J.S. White. They arrived at their stations in early May 1922, and both were initially launched from trolleys down slipways; a tunnel to protect the propeller during recovery was incorporated into the hull.

In December 1928 Fowey became the next West Country station to receive a motor lifeboat, when the 45ft 6in Watson *C.D.E.C.* (ON.712), also built by J.S. White, entered service.

fitted with a single 45hp Tylor JB4 petrol engine, which gave her a top speed of just over seven knots.

The next motor lifeboat in the West Country went to St Mary's on the Isles of Scilly in October 1919. This boat,

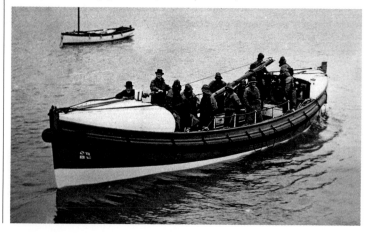

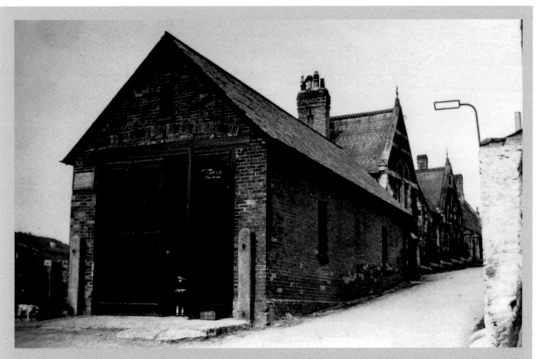

above The original lifeboat house on the hill leading down to the east side of the port was used from 1869 to 1927, and is pictured in April 1929 after the station had closed. (Grahame Farr, courtesy of the RNLI)

below Almost exactly eighty-six years later, in March 2015, the building retains its basic shape but has been rendered in white and been completely renovated internally as a souvenir shop, having previously been occupied by the village post office.

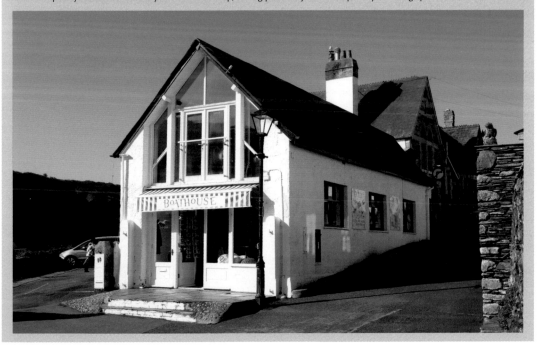

Motor lifeboats take over

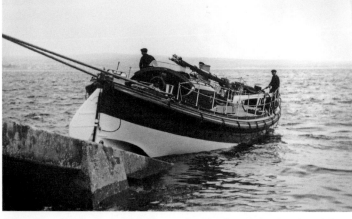

By the end of the Second World War, the ten lifeboat stations in Cornwall were all operating motor lifeboats: Fowey, Falmouth, Coverack, Cadgwith, Lizard, Penlee, Sennen Cove, St Mary's, St Ives and Padstow, as were the three in North Devon (Clovelly, Appledore and Ilfracombe) and the two in Somerset (Weston and Minehead).

St Mary's and Penlee had received 45ft Watsons immediately after the end of the First World War, with further Watsons going to Fowey

(1928), Falmouth (1931) and Appledore (1938). The Watsons, with good overall stability, were popular with the crews, although they were not self-righting. And as the RNLI gained greater experience in the operation of motor lifeboats, and more reliable engines were developed, larger boats were designed, with Watson boats of 45ft 6in being introduced.

Motor lifeboats were stationed at places where they could be manned and launched most efficiently. As they could

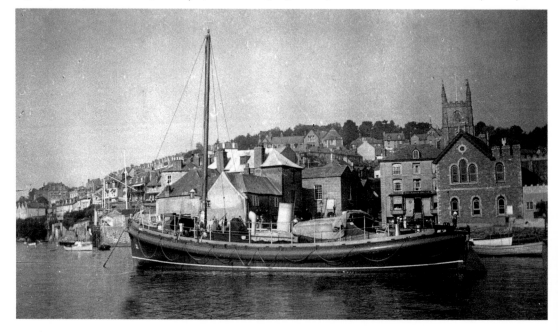

Motor lifeboats take over

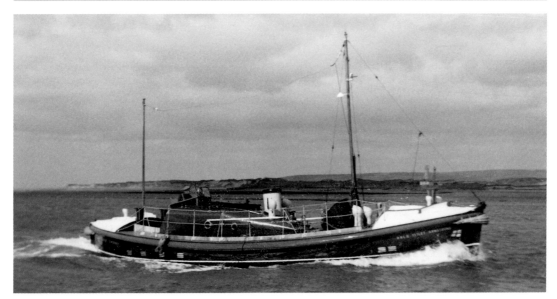

cover a greater area than their pulling counterparts, many of the stations established during the nineteenth century using the standard self-righter were closed when a neighbouring station received a motor lifeboat. Although this led to a reduction in the number of stations, motor lifeboats could actually cover a greater area.

Falmouth received a motor lifeboat in 1931, a year after the station at Mevagissey was closed. The station at Polkerris was transferred to nearby Fowey, the preferred location for a lifeboat to cover St Austell Bay. A motor lifeboat could leave the estuary at Fowey in all weathers, something a pulling lifeboat could not achieve. After St Mary's received a motor lifeboat in 1919, the other station on the Isles of Scilly, St Agnes, was closed. With two motor lifeboats operating from Padstow by the early 1930s, the Port Isaac lifeboat was withdrawn in 1933.

During the 1930s motor lifeboats were placed along the Bristol Channel, starting with Weston-super-Mare in 1933, and followed by Ilfracombe, Clovelly (both 1936) and Minehead

(1939). This led to the closure of the stations at Burnham-on-Sea, Lynmouth and Watchet, although the latter two remained operation until the 1940s.

As well as the larger Watson motor boats of 40ft or more in length, smaller, lighter types were developed for carriage and slipway launching. Two 35ft 6in classes were built: the Liverpool non-self-righter and the self-righter. During the 1930s they served at Coverack, St Ives, Padstow No.2, Clovelly and Weston-super-Mare. With the introduction of these two types, a design of motor lifeboat suitable for every station had been developed.

above The 46ft Watson motor Violet Armstrong (ON.815) pictured in 1957 running engine trials off Appledore. She arrived at Appledore in 1938 and, because of the dangerous bar at Appledore where the rivers Torridge and Taw meet, had a modified deck layout to suit local conditions. This was unusual and meant she was one of only two lifeboats built to this modified specification.

below The single-engined 35ft 6in Liverpool motor lifeboat Fifi and Charles (ON.765) on the slipway at Weston-super-Mare, where she served from 1933 to 1962, saving eighty-three lives. Other boats of this design that served in the West Country were stationed at Coverack (1934) and Newquay (1940). (Grahame Farr)

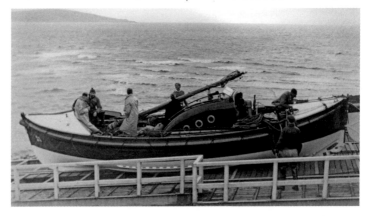

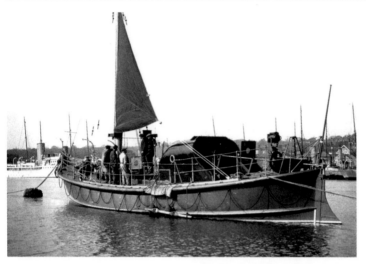

above The Padstow lifeboat Princess Mary (ON.715) was one of four large twin-engined Barnett motor lifeboats built in the 1920s. She was the last of the four, and measured 61ft by 15ft, making her the largest motor lifeboat ever built. She served the North Cornwall station from May 1929 to July 1952.

below The inaugural launch of the 32ft Surf motor lifeboat at Mindhead, Kate Greatorex (ON.816), on 26 July 1939. She was unusual in that the power from the twin 12hp engines provided propulsion through Gill jet units rather than conventional propellers, which was an early form of water jet. (Grahame Farr, courtesy of the RNLI)

During the inter-war years motor lifeboats gradually took over. In December 1918 more than thirty lifeboats were in RNLI service along the coasts of Cornwall, North Devon and Somerset, including the steam tug at Padstow and two lifeboats at Appledore. There were no motor lifeboats, and so many pulling lifeboats were needed to cover the coast as their range was governed basically by the crews' efforts and stamina.

However, the introduction of the motor lifeboat resulted in a reduction in lifeboat numbers. So in December 1938, just before the outbreak of the Second World War, only nineteen lifeboats were needed to cover the same coastline. Although pulling lifeboats remained at Porthoustock and Cadgwith in Cornwall, Lynmouth in Devon and Watchet in Somerset, these were soon withdrawn and the stations closed as the RNLI completed the task of motorising the fleet.

Among the notable technical advances during the inter-war years was the introduction of a motor lifeboat larger than anything built hitherto. The 60ft lifeboat, designed by James Barnett, the RNLI's Consulting Naval Engineer, employed twin engines and twin propellers, eliminating the need for the auxiliary sails. Only four of the large 60ft Barnett motor lifeboats were built, one of which, *Princess Mary*, was stationed at Padstow in May 1929 and did excellent service there until 1952.

The small 32ft Surf lifeboats represented the other end of the scale to the large Barnett, but this type, deemed suitable for these stations where the boat was launched from a carriage, saw service at Ilfracombe and Minehead. The Ilfracombe boat, *Rosabella* (ON.779), was the first of the Surf type boats, of which ten were built between 1935 and 1941.

Although the small motor lifeboats gave good service, they were more vulnerable to the heavy Atlantic seas often encountered off the Cornish coast, and this was demonstrated by the tragedies that overtook the St Ives station in the late 1930s. In the space of twelve months two lifeboats and twelve lives were tragically lost from the Cornish station in events unparalleled in RNLI history.

The first accident occurred on 31 January 1938 when the 35ft 6in self-righting motor lifeboat *Caroline Parsons* (ON.763), manned by a crew of nine, went to the aid of the steamer *Alba*. In very heavy seas, twenty-three men were taken off the casualty but, as the lifeboat was leaving the scene, she was hit broadside on by a huge wave and capsized. The lifeboat righted herself, but was driven onto the rocks. The crew got ashore with the aid of the life-saving apparatus but the rescued men were not so fortunate and five died.

Following this fatal mishap, a similar lifeboat, *John and Sarah Eliza Stych* (ON.743), was sent to St Ives from the Padstow No.2 station as a replacement. Sadly, she was to serve for less than a year before being lost in another

The 1930s and wartime years

left The steamer Alba, of Panama, built in the United States, after being wrecked at St Ives in January 1938. Her crew of twenty-three were rescued by the St Ives lifeboat, but the lifeboat capsized and three of the rescued men were drowned as a result. The remainder of the steamer's crew and the crew of the lifeboat got back into the lifeboat again, which had righted herself, and she was washed ashore. (Courtesy of the RNLI)

left The small 35ft 6in self-righting motor lifeboat John and Sarah Eliza Stych (ON.743) being launched into the harbour at St Ives in July 1938. She was built in 1931 and powered by single 35hp Weyburn petrol engine. She was sent to St Ives from Padstow as a temporary measure following the capsize of the station boat in January 1938. (Courtesy of the RNLI)

below John and Sarah Eliza Stych ashore near Godrevy on 23 January 1939 after capsizing while searching for a vessel reported in distress, with the loss of seven St Ives lifeboatmen. (From an old photo in the author's collection)

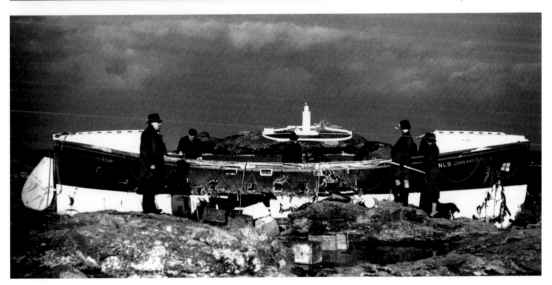

The 1930s and wartime years

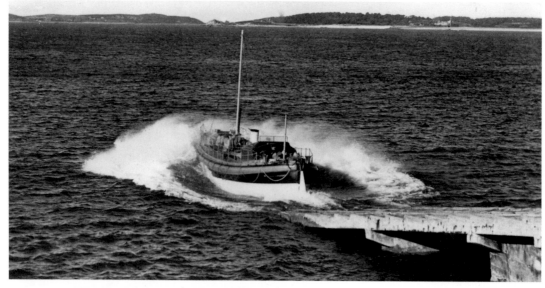

above St Mary's lifeboat *Cunard* (ON.728) launching down the slipway. Built in 1930, she served in the Scillies throughout the war, until 1955. (From an old postcard supplied by John Harrop)

Medal winners

FALMOUTH • 19 January 1940 • Silver medal awarded to Coxswain John Snell and bronze medal to Motor Mechanic C.H. Williams for the rescue of the crew of thirty-five from the steamer Kirkpool in gale-force winds and heavy seas. Two tugs were unable to get near and were riding heavily with seas breaking over them, while Kirkpool was dragging rapidly towards the shore. She lay broadside on with seas breaking over her and the engine room filled with steam. The lifeboat was handled by the coxswain with great skill to effect a rescue, with seas repeatedly breaking right over his boat.

APPLEDORE • 18 October 1944 • Bronze medal awarded to Coxswain Sidney Cann for the rescue of seven from a concrete harbour unit, one of those used for constructing the Mulberry Harbour for the invasion of Normandy, which had broken from her tow ten miles off Morte Point. In spite of the conditions over Appledore Bar, the Watson motor lifeboat Violet Armstrong got out to sea and travelled over eighteen miles in a gale and very rough seas to reach the casualty. The coxswain and crew received great praise for the way they navigated, having been given three different positions. In a series of difficult operations, the seven crew were taken off the casualty and landed at Ilfracombe at 11 p.m.

disaster. She was launched in the early hours of 23 January 1939 to the aid of a vessel in difficulty two miles off Cape Cornwall. Encountering very heavy seas once out of the shelter of St Ives Head, she was capsized and four of the eight men on board were lost, including the Coxswain, Thomas Cocking.

Although the boat righted herself, the engine could not be restarted and so she drifted helplessly, and when another big sea hit her she capsized again. This time, the mechanic was lost leaving only three survivors on board the disabled lifeboat. As she approached the rocks at Godrevy, another sea hit her and for a third time she was capsized. After righting again, only one man, William Freeman, remained on board, who survived by forcing himself under the canopy above the engine controls. When the lifeboat was thrown ashore by the sea at Godrevy, Freeman crawled out and reached a local farm, from where news of the disaster was sent to St Ives.

This second disaster was worse than the first – seven of the eight lifeboatmen on board were drowned. It hit the small community of St Ives hard, and the station was temporarily closed.

During the Second World War, lifeboat stations in the West Country were relatively quiet, with only a handful of wartime casualties being assisted, including services to aircraft by both the Lizard and St Ives lifeboats, as the latter station reopened in 1940.

The most notable rescue came on 19 January 1940, when, in a south-easterly gale and very heavy seas, Falmouth lifeboat *Crawford and Constance Conybeare* (ON.829) went to help the steamship *Kirkpool*, of West Hartlepool, which was dragging her anchors in Falmouth Bay. The steamer struck the beach and lay broadside on with seas breaking against her, so the lifeboat went in to effect a rescue.

In heavy seas, Coxswain John Snell drove the lifeboat through the surf, round the bows of the steamer to get between casualty and shore, and placed the lifeboat alongside. Fourteen men were saved the first time, and after they had been landed at Falmouth, the lifeboat went back to the steamer and rescued the other twenty-one on board.

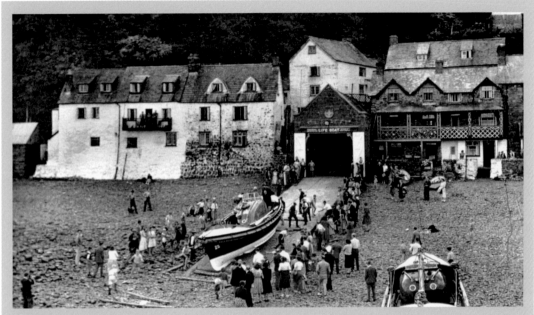

above The scene at Clovelly in September 1949 when the 35ft 6in Liverpool motor William Cantrell Ashley (ON.871) took over from the 35ft 6in motor self-righter City of Nottingham (ON.726). The old boat can be seen to the right, half out of shot, while the new boat is being hauled into the boathouse over skids up the slipway. The first lifeboat house was built on this site in 1870, and rebuilt in 1892 and 1906 for new lifeboats. William Cantrell Ashley was the last offshore lifeboat to be housed there.

below The scene from May 2014 shows the Atlantic 75 Spirit of Clovelly (B-759) being launched for the last time to greet her replacement, the Atlantic 85 Toby Rundle (B-872). The buildings pictured at the foot of the steep hill to the sea at the picturesque Devon village are unchanged from 1949 as almost all have listed status and cannot be altered. However, the lifeboat house has been completely rebuilt and enlarged, although its external appearance remains broadly similar to the original building.

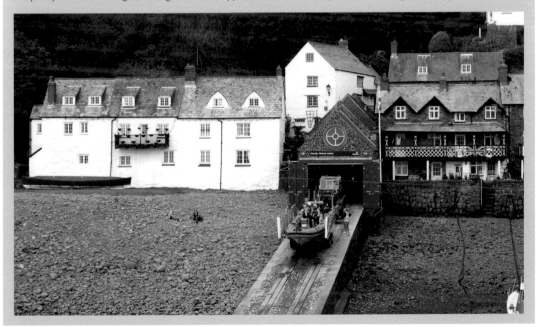

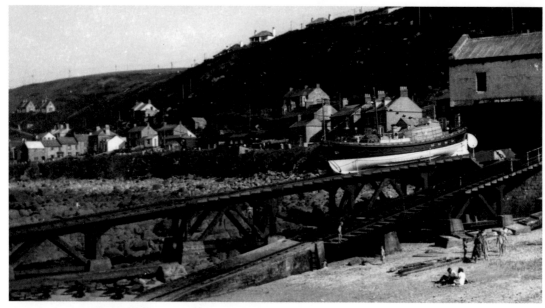

above The first new motor lifeboat in Cornwall after the Second World War was the 41ft Watson *Susan Ashley* (ON.856), which served at Sennen Cove from July 1948 to May 1973, and is pictured on the longer of the station's two slipways.

below St Ives lifeboat crew in oilskins, sou'westers and kapok lifejackets. Coxswain William Peters, back row second left, was awarded the silver medal for gallantry in 1945 for service to the ketch *Minnie Flossie*. (Courtesy of the RNLI)

During the Second World War, lifeboat construction and development more or less stopped. So after 1945 the RNLI embarked upon a building programme of new boats, all of which had twin engines and twin propellers, as the charity looked to share the optimism for a better and brighter future of the immediate post-war years. With many new motor boats being built, the pulling and sailing lifeboat was phased out as a new chapter in the RNLI's history began.

Among the handful of new lifeboats that were completed during the war, the stations at Falmouth, Cadgwith and St Ives were fortunate recipients. Falmouth's new lifeboat, *Crawford and Constance Conybeare* (ON.829), arrived in January 1940, having been completed by the Cowes shipyard of J.S. White, who built many of the RNLI's motor lifeboats. She went on to operate into the 1960s, saving well over 100 lives, with her first service being the dramatic rescue of thirty-five men from the steamship *Kirkpool*, as described above.

Several other fine services were undertaken in the West Country just as the war was coming to an end. On 23 November 1944, Padstow lifeboat *Princess Mary* (ON.715) went to the aid of the steamship *Sjofna*, of Oslo, a mile south of Knap Head, near Bude. After travelling for twenty-eight miles, the lifeboat and her crew arrived to find the smaller Clovelly lifeboat on scene, but unable to reach the casualty. Using a breeches buoy, Padstow lifeboat

left 46ft Watson motor Crawford and Constance Conybeare (ON.829) arrived at Falmouth in January 1940, and was one of only a handful of lifeboats to be completed during the Second World War.

crew, under the command of Second Mechanic William Orchard, took off seven men, before the line was swept away. A further twelve were rescued by a life-saving apparatus set up at the top of the cliff, and *Princess Mary* returned to Padstow after more than twelve hours on service. For this rescue, Acting Coxswain Orchard was awarded the silver medal in recognition of the 'great courage and skill in taking this large lifeboat right into the heavy surf'.

The 35ft 6in Liverpool *Caroline Oates Aver and William Maine* (ON.831) arrived at her Cornish station of St Ives just a week after Falmouth's new boat, and less than a year after the second of the two tragedies that had overtaken that station. She was kept busy during the war, and in the early months of the peace, on 24 October 1945, undertook a particularly fine service. She launched to the ketch *Minnie Flossie*, which was sinking in a westerly gale. By the time the lifeboat arrived the situation had become critical, and so Coxswain William Peters drove the lifeboat straight in to the casualty, despite heavy

below 35ft 6in Liverpool William Cantrell Ashley (ON.871) being recovered across the stones at Clovelly. She was the last offshore lifeboat at the station to be launched across the beach, serving from September 1949 to 1968, saving twenty-four lives during that time.

The war and its aftermath

Post-war medal winners

PADSTOW • 12 August 1946 • Silver medal to Coxswain John Tallack for saving ten men from the steamer Kedah, which was dragging towards the shore in a westerly gale and very heavy seas off St Ives Head.

FOWEY • 23 March 1947 • Bronze medal to Coxswain John Watters for saving seven men from the motor vessel Empire Contamar, which was aground on rocks in Par Bay.

PENLEE • 23 April 1947 • Silver medal to Coxswain Edwin Madron and bronze medal to Mechanic John Drew for saving eight men from the former warship HMS Warspite, which had gone aground off Marazion, near St Michael's Mount.

CLOVELLY • 31 August 1948 • Bronze medals to Bowman Percy Shackson and Mechanic William Braund for manning a small dinghy, taken out by the lifeboat City of Nottingham, to save two young Americans who were swimming and wading around Baggy Point, when they were caught by a rising tide. The sea was breaking around the rocks, and it was dark when the rescue was effected.

below Recovery of the 35ft 6in Liverpool motor Edgar, George, Orlando and Eva Child (ON.861) at St Ives, watched by a crowd of holiday-makers in June 1958. The boat served at St Ives from 1948 until 1968. (Grahame Farr, courtesy of the RNLI)

seas, to snatch the owner and his wife to safety just as the ketch was sinking. For this outstanding rescue, the silver medal was awarded to Coxswain Peters.

On 12 August 1946, less than two years after the *Sjofna* rescue, the Padstow lifeboat men were again involved in a medal-winning service. This time *Princess Mary* went to the aid of the Singapore steamer *Kedah,* which was dragging her anchors close under St Agnes Head, in a gale and huge confused seas. At the third attempt, after being twice damaged, the lifeboat got alongside and rescued the crew of ten. For this rescue, the silver medal was awarded to Coxswain John Murt.

In 1947 two more Cornish stations undertook medal-winning services just a month apart. On 23 March 1947 the reserve lifeboat *The Brothers* (ON.671), on duty at Fowey, saved seven from the motor vessel *Empire Contamar* in gale force winds and heavy seas, a service for which Coxswain John Watters received the bronze medal.

A month later, on 23 April 1947,

Penlee lifeboat *W. and S.* was involved in an even more dramatic service. She launched to the battleship HMS *Warspite*, which was being towed to the breakers when she was wrecked in Mount's Bay. The lifeboat crew, under Coxswain Edwin Madron, managed to save eight from the warship, with the lifeboat being taken into a narrow channel between rocks and casualty to effect the rescue. Coxswain and mechanic were awarded silver and bronze medals respectively.

The first new lifeboats in the West Country in the post-war era were *Susan Ashley* (ON.856), a 41ft Watson for Sennen Cove, and *Edgar, George, Orlando and Eva Child* (ON.861) at St Ives, both in 1948, with Clovelly getting a new lifeboat in 1949. In 1945 the second-hand *Richard Silver Oliver* (ON.794) had gone to Ilfracombe to replace the 32ft Surf lifeboat *Rosabella* (ON.779), which was loaned to the KNZHRM, the Netherlands lifeboat service, to help rebuild their fleet which had been decimated during the war.

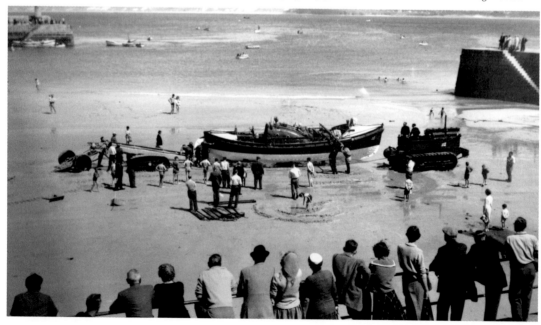

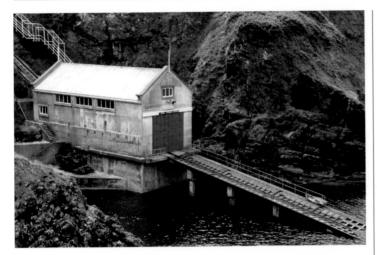

left The lifeboat house and slipway built at Kilcobben Cove for the Lizard lifeboat. The new station, which was originally known as Lizard-Cadgwith, cost £100,000 and consisted of a boathouse and slipway near the foot of the cliffs, approached down the cliffs by about 200 steps.

below left The lifeboat house and slipway built at Trevose Head for the Padstow lifeboat in 1965–67.

below The lifeboat house and slipway at Trevose Head under construction in 1965. It was completed within two years at a cost of £114,600 and became operational on 23 October 1967.

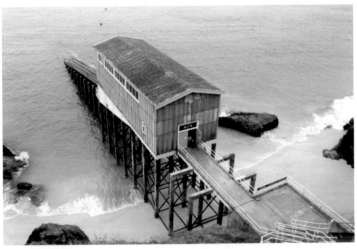

Other changes to already established stations came at Padstow and the Lizard, where new lifeboat houses and roller slipways were built at specially selected sites. In the late 1950s, it was decided to amalgamate the Lizard and Cadgwith stations with a new station at Kilcobben Cove, a mile and a quarter to the east of Lizard lighthouse, where a new lifeboat house and slipway was built. Observations were carried out which showed that it would be possible to launch a lifeboat at the Cove in any weather and at any state of the tide, and that conditions for rehousing would usually be favourable. The foundation stone was laid on 23 November 1959, and the new house was opened on 13 July 1961 by the Duke of Edinburgh.

A similar investment was made by the RNLI at Padstow during the 1960s following the silting up of the Doom Bar, which made launching difficult from the boathouse at Hawker's Cove and the nearby moorings. Wave recordings taken at Trevose Head showed that a slipway station at this location would enable a launch in any weather conditions, so in 1965 work on a new station began. It was similar to that at the Lizard, and consisted of a boathouse and slipway on the

The war and its aftermath

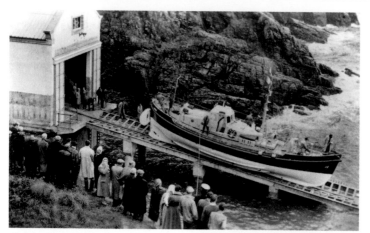

above 52ft Barnett The Duke of Cornwall (Civil Service No.33) (ON.952) on the slipway of the new Lizard-Cadgwith station in the early 1960s. (From an old postcard supplied by John Harrop)

below Naming ceremony of the 71ft Clyde class City of Bristol (ON.1030) on 1 September 1974 at Narrow Quay, Bristol. She was christened by the Lady Mayoress of Bristol, Mrs A.G. Peglar, and served at Clovelly for thirteen years. (Jeff Morris)

foreshore, at the foot of the cliffs, with a slipway 240ft in length.

A somewhat unusual development came in the 1960s when the RNLI built the Clyde class, designated as rescue cruisers rather than lifeboats and, at 70ft in length, the largest rescue vessels ever built by the RNLI. The idea was borrowed from the DGZRS, the German lifeboat society, which used cruising

lifeboats extensively. The class was not only the RNLI's largest lifeboat, but was also the first to be constructed of steel. The Clyde boats had accommodation for the crew to sleep on board, with a messroom and galley, and carried an inflatable inshore rescue boat.

The first of the class, *Charles H. Barrett (Civil Service No.35)* (ON.987), was based at Clovelly, from where she covered St George's Channel, the southern end of the Irish Sea and the mouth of the Bristol Channel. A third boat, with a superstructure larger than on the first two boats, was built in 1974 in North Devon. Named *City of Bristol* (ON.1030), this was sent to Clovelly, where she served from 1975 to 1988. By then she was not being operated as a cruising lifeboat, a concept which proved to be ill suited to UK waters, and when she and her two sisters were withdrawn they were replaced by conventional lifeboats.

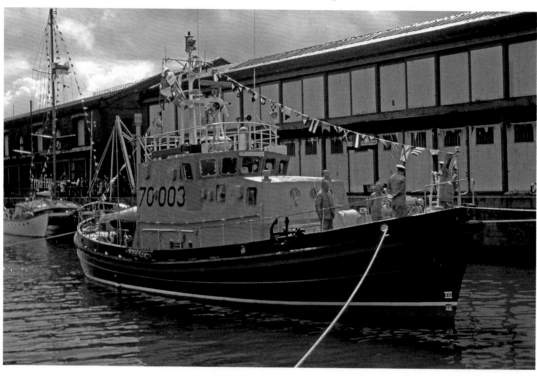

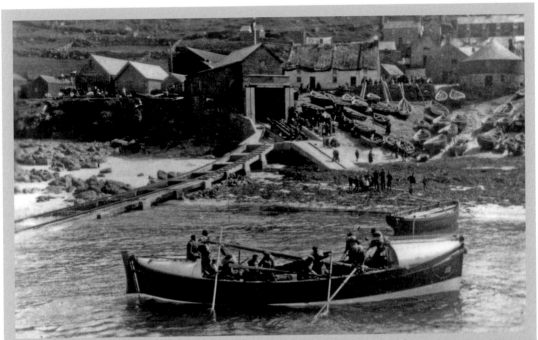

above The first motor lifeboat at Sennen Cove, The Newbons (ON.674), arriving in May 1922. The bow of her predecessor, Ann Newbon, can just be seen beside the boathouse. The launching trolley has been placed at the head of the short slipway ready for the new boat to be recovered. The boathouse was rebuilt in 1927–29 and a second slipway was added, one to be used for launching and the other for recovery, a unique set-up which was the best solution for getting the boat across the rocky foreshore at Sennen.

below The lifeboat house was altered considerably several times since the 1920s, and was almost completely rebuilt for the 16m Tamar lifeboat City of London III (ON.1294), which is pictured launching at the end of her naming ceremony on 24 April 2010. One of the original slipways, on the right hand corner of the boathouse, is visible in this photo and parts of the original walls remain, but the building is essentially a new one compared to the photo above, having been doubled in size to accommodate a turntable.

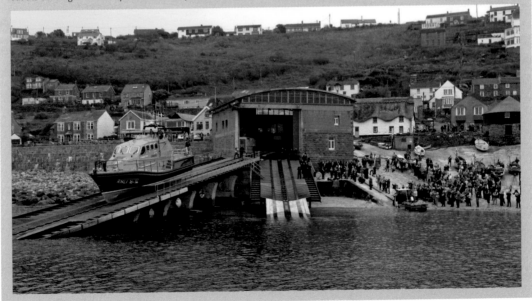

Inshore lifeboats

ILB stations in the SW

1964	St Ives	1990	Marazion
1965	Newquay	1991	Ilfracombe
1966	Bude	1992	Looe
1966	Weston-s-Mare	1994	Sennen Cove
1967	Port Isaac	1994	Rock
1968	St Agnes	1995	Fowey
1970	Minehead	1998	Clovelly*
1971	Pill	2001	Penlee
1972	Coverack	2003	Burnham-o-Sea
1973	Appledore	2015	Portishead*
1980	Falmouth	* Date taken over by RNLI	

above The first ILB house at Bude was typical of the buildings in which the early inshore lifeboats were kept. This house, built in 1966 on the South Pier of the Locks at the harbour end of the canalside road, was used until 2004. (Grahame Farr)

below Inshore rescue boat No.96 outside the boathouse at Bude; she was the station's first inshore lifeboat, and was on station from 1966 to 1975. (Grahame Farr)

A significant development in lifeboat provision came during the 1960s with the introduction of the inshore rescue boat (IRB), or, as it later became known, the inshore lifeboat (ILB). In the 1950s and 1960s more people began using the sea for leisure, taking to yachts, dinghies and surfboards, and as a result the number of inshore incidents to which lifeboats were called increased. Conventional lifeboats were not well suited to dealing with such incidents, being slow and usually requiring at least seven crew. What was needed was a fast rescue craft which could respond speedily to incidents when a few minutes could make a crucial difference.

In response to these changing demands, the RNLI bought an inflatable boat in 1962 for extensive trials, and a delegation visited France where similar boats were in operation, to see the boats in service. Following these initial steps, the first IRBs were introduced during the summer of 1963, when ten were sent to stations around England and Wales. Such was their success that more stations were supplied with the craft in subsequent years, and by 1966 the number of ILBs on station had risen to seventy-two. By the 1970s the inflatable ILB was an established part of the RNLI fleet, and the small craft perform hundreds of rescues annually.

The early ILBs were rudimentary inflatable boats with outboard engines. They were crewed by two or three, powered by a 40hp outboard engine, and could be quickly launched, making them ideally suited for dealing with incidents such as people cut off by the tide, swimmers drifting out to sea and surfers in difficulty. The ILB's advantage over conventional lifeboats was its speed, twenty knots, much faster than any lifeboat in service in the 1960s. The boats were gradually improved, and more equipment, including VHF radio, flexible fuel tanks, flares, an anchor, a spare propeller and first aid kit, was added.

The first IRB to go on station in the West Country was sent to St Ives, on the north coast of Cornwall, in 1964, and worked alongside the offshore lifeboat, a slow 35ft 6in Liverpool type

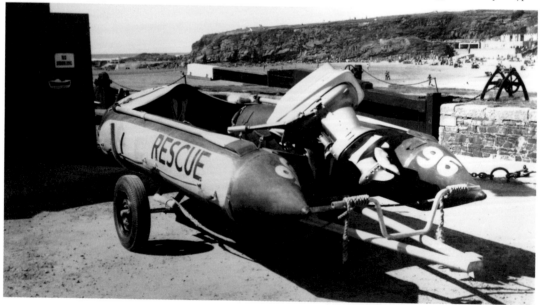

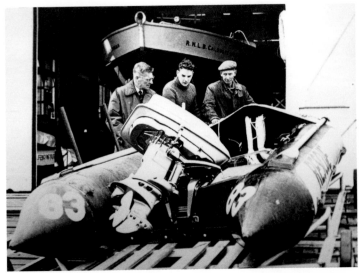

left Inshore lifeboat No.83 at Weston-super-Mare in May 1966 shortly after she arrived at the station. Examining the craft, on the left, is station Honorary Secretary Clifford Smith. A special launching trolley was designed locally to fit the slipway down which the ILB was launched. (Grahame Farr, courtesy of the RNLI)

capable of little more than eight knots. It was joined in the next couple of years by inflatables at Newquay, Bude and Port Isaac. The inflatable craft was found to be ideally suited to working in the heavy surf encountered off the beaches of North Cornwall, and the new ILBs sent to the stations of Bude (opened 1966) and Port Isaac (1967) restarted a life-saving service that had once been fulfilled by pulling lifeboats.

The first new station to be opened where no lifeboat had previously been based was St Agnes, also on Cornwall's north coast. The new station became operational in April 1968 with its ILB being one of those paid for by appeals made through the *Blue Peter* TV programme. This not only provided funds but also greatly raised the profile of the new type of lifeboat, which, when the first of these appeals was launched on 5 December 1966, was regarded as something of a novelty.

The first *Blue Peter* appeal was so successful that not one but four ILBs were able to be purchased. The ILBs were named *Blue Peter I* to *Blue Peter IV*, with the fourth boat going to St Agnes. Further Blue Peter appeals

in subsequent decades provided replacements for the original boats, with the 'Pieces of Eight' appeal of 1993–4 proving such a success that it also funded an all-weather lifeboat (which went to Fishguard). The last *Blue Peter*-funded lifeboat at St Agnes was sent to the station in March 2005.

As these first ILBs were outstanding rescue tools, the RNLI realised that a larger inshore lifeboat, capable of night operation, with a greater range and twin engines, could be added to the fleet. Development of various different types

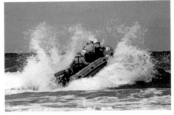

above St Agnes D class inflatable Blue Peter IV (D-453) breaks through surf off the beach. The ILBs were at first in service during the summer months only, usually from April to October, but this was gradually extended with all ILB stations becoming operational year-round.

below Blue Peter IV (D-453) being beached prior to recovery at St Agnes.

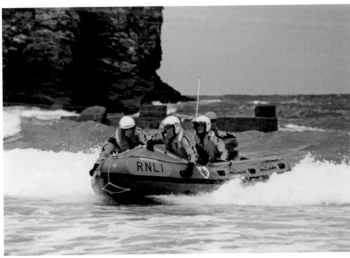

Inshore lifeboats

above Two photos of Minehead's first inshore lifeboat, the standard D class inflatable D-177, being launched and recovered across the rocky beach. Tractor T75 was sent to the station in 1968 to launch the offshore lifeboat, but was needed to launch the ILB across the town's very steep beach. (Jeff Morris)

right D-177 setting off from Minehead. She arrived on 30 March 1970 and served until October 1983. (Jeff Morris)

below Minehead was also served by an experimental inshore lifeboat, number D-500, one of only three 19ft twin-engined inflatables used by the RNLI. The boat, funded by Minehead Rotary Club, was on station for five years to 1979. (Graham Farr, courtesy of the RNLI)

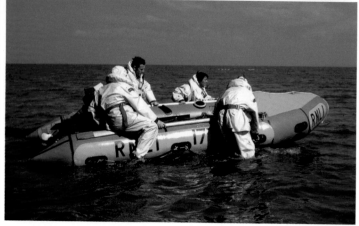

of rigid-hulled boats got under way, and a number of prototypes were built, designated the Hatch and McLachlan types after their respective designers.

The latter was deemed the most suitable, and ten McLachlans, twin-engined craft measuring 18ft 6in by 8ft, were built between 1967 and 1974. McLachlan A-508 served at Falmouth from 1980 to 1987, where she was also used as a boarding boat by the crew to reach the lifeboat moored in the harbour, while two others served in the Bristol Channel. The short-lived station at Pill, near Portishead, used two McLachlans during its four-year existence, while at Weston-super-Mare A-504 was very successful, being operated from 1970 to 1983 and proving very popular with her crew.

Other inshore types were also developed, as designers tried to enlarge and improve the standard inflatable. At Atlantic College in South Wales, a rigid wooden hull was added to the inflatable sponson by students working under the leadership of the college's headmaster, Rear Admiral Douglas Hoare. Twin outboard engines gave the boat a speed of over thirty knots, while the sponsons gave the boat great stability.

This new design was refined, with much input from RNLI Inspector David Stogden, to become the Atlantic 21, the first rigid-inflatable lifeboat, and went on to become very successful. During the early 1970s trials of the design took place, and in 1972 the first boats of the class went to Appledore, Hartlepool, Littlehampton and Queensferry. Appledore, with its treacherous bar, has operated Atlantic rigid-inflatables ever since, and the Atlantic has proved to be one of the most versatile, adaptable

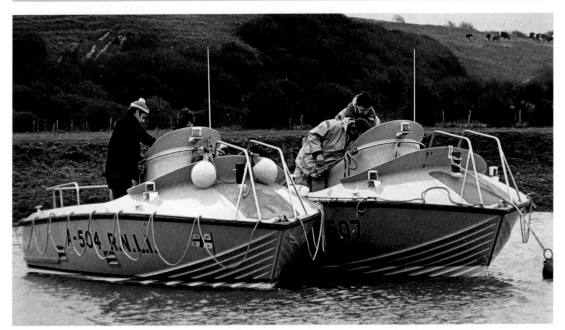

and effective rescue craft ever built. Their use has become ever more widespread, and many stations in the Bristol Channel now operate Atlantics. In Somerset, ILBs effectively took over operations at both Weston-super-Mare and Minehead, stations which had hitherto been served by motor lifeboats.

While Weston had the McLachlan, at Minehead the offshore lifeboat *B.H.M.H.* (ON.882), a 35ft 6in Liverpool type, was replaced by a twin-engined Zodiac MkV craft, number D-500 (later C-500), which served from 1974 to 1979. Both Weston and Minehead now operate Atlantics alongside D class inflatables, a combination of boats widely used.

As well as new designs, the use of ILBs was continually expanded with the number of ILB stations continually increasing. A station at Marazion, located at St Michael's Mount, was opened in 1990. In 1992 a D class inflatable was sent to Looe, on Cornwall's south coast, and two years later a new station was opened at Rock, to cover the waters of the dangerous

Camel estuary. ILBs were added to all-weather lifeboats at Sennen Cove (in 1994) and Fowey (in 1995). In 1998 the RNLI took over the independent service that had operated at Clovelly since 1990, and in 2003 did the same at Burnham-on-Sea, where sea rescue had previously been provided by a local independent organisation. The situation at Portishead was the same; the RNLI formally adopted the station in 2015 after an independent Lifeboat Trust

above Return of McLachlan A-504 to Weston-super-Mare from refit in February 1974, with relief McLachlan A-507 ready to depart. (Grahame Farr files, courtesy of the RNLI)

below McLachlan lifeboat A-504 served at Weston-super-Mare from 1970 to 1983, and is now on display at the RNLI Historic Lifeboat Collection at the Historic Dockyard in Chatham, Kent.

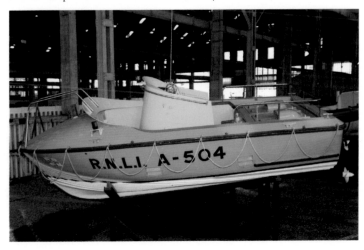

Inshore lifeboats

had set up a rescue service for the area in 1996 and operated a number of ILBs funded entirely by local donations.

Every year ILBs help or save many people in difficulty, and a number of outstanding medal-winning services have been performed by ILB crews, showing how the relatively small boats have been used by their volunteer crews in situations far more challenging than any for which they were originally intended.

The McLachlan lifeboat at Weston-super-Mare, with Julian Morris at the helm, was used to save five men from a motor boat which had been wrecked in an easterly gale and rough seas. The boat was at the base of a sheer cliff in a small cove, midway along the north side of the Brean Down peninsula. In effecting a rescue, the lifeboat was frequently grounding as Helmsman Morris attempted to get close to the rocky ledge on which the five men were standing. A line was thrown to the men, by which the lifeboat crew pulled them to safety and onto the lifeboat.

At St Ives in 1982, services performed by the ILB within little more than a month of each other resulted in Eric Ward being awarded two bronze medals. The first was to a capsized

above The first Atlantic 21 inshore lifeboat in the West Country served at Appledore. After the prototype Atlantics had been tried and trialled at Appledore, Wildenrath Wizzer (B-520) was built for the station and served there from 1974 to 1986. (Courtesy of the RNLI)

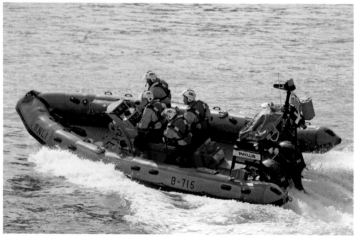

right Atlantic 75 Phyllis (B-715) served at Newquay from 1995 to 2007. The Atlantic 75 was the second incarnation of the RNLI's rigid-hulled inshore lifeboat, taking over from the Atlantic 21.

dinghy, during which the lifeboat's propeller became fouled. The second involved a search close inshore, with the ILB being taken through broken waters and among dangerous rocks.

At Port Isaac, the ILB may not be the busiest, but on several occasions it has been used for some very challenging rescues. On 6 September 1998 the station made headline news when two of the volunteer crew became trapped in a cave and the boat itself became a total loss. The ILB had launched to rescue a father and son trapped in a cave. The ILB was anchored and veered down into the cave, but was caught by two waves in quick succession. The crew were swept out of the boat and the boat itself was thrown into the cave. Conditions in the cave were very difficult, but the two lifeboat crew, together with the two casualties, were able to wait for the tide, and once this had dropped they made their escape. Miraculously all four reached safety and, with Padstow lifeboat on scene, were airlifted to hospital.

In 2012 three Port Isaac crew members received gallantry medals for an outstanding service, and this was only the second time that all the crew of a D class inflatable lifeboat have received gallantry medals. On 8 April

2012 the ILB was launched, crewed by Helmsman Damien Bolton, Nicola-Jane Bradbury and Matthew Main, in force four to five winds to rescue two people who had been swept into rough water close to the cliffs between Port Isaac and Tintagel. The two casualties were near semi-submerged rocks and were being tumbled in the confused and breaking three-metre waves, making any rescue extremely challenging.

Operating at the extreme limits of the ILB's capabilities, Damien used great seamanship skills to manoeuvre the ILB towards the two men, who were struggling to stay above the crashing surf, and the lifeboat crew managed to pull one of the men to safety. The other was then recovered to the lifeboat, but, tragically, did not survive.

above The twin-engined C class inflatable was a development of the D class ILB, but only a few were built; C-512 served at Newquay, where she is pictured leaving the harbour on service in 1989.

ILB medal services

WESTON-SUPER-MARE • 13 September 1975 • Bronze medal awarded to Helmsman Julian Morris in recognition of the courage, seamanship and determination he displayed when the McLachlan lifeboat A-504 rescued five men from the motor boat 4D, which was stranded on rocks at Brean Down in a strong north-easterly gale and a very rough sea.

ST IVES • 8 April 1982 • Bronze medal awarded to Helmsman Eric Ward in recognition of his courage and skill when the D class ILB rescued four from a sailing dinghy which had capsized on Hayle Bar. Crew William Thomas and Philip Allen were accorded the Thanks of the Institution on Vellum.

ST IVES • 15 July 1982 • Bronze Second-Service Clasp awarded to Helmsman Eric Ward in recognition of his courage, tenacity and seamanship when the D class ILB carried out a search close inshore amongst rocks for the sole occupant of the yacht Ladybird. The Thanks of the Institution on Vellum was also accorded to crew members Thomas Cocking Jnr and John Stevens.

APPLEDORE • 1 December 1985 • Bronze medal awarded to Helmsman John Pavitt in recognition of his courage, determination and seamanship to save a board sailor and his board in a strong southerly gale and very rough seas using the Atlantic 21 ILB.

left The lifeboat crew and station personnel at Portishead on the occasion of the formal opening of the station in June 2015 following its adoption by the RNLI and building of a new lifeboat house.

Inshore lifeboats

right D class inflatable Spirit of the PCS RE (D-517) at Port Isaac, where she was placed on service in May 1997. Just sixteen months later, on 6 September 1998, she was wrecked on service in severe conditions going to the aid of two people stranded in a cave. Fortunately nobody was lost, but the boat was completely wrecked. The ILB had been funded by Officers and Soldiers of the Royal Logistics Corp, and the replacement, Spirit of the PCS RE II (D-546), was funded by a local appeal to replace the wrecked craft.

below D class inflatable Copeland Bell (D-707) is put through in Port Isaac's small harbour, with medal-winning crew Damien Bolton, Nicola-Jane Bradbury and Matthew Main on board. D-707 is the latest in a long line of ILBs to serve at Port Isaac, a station where the inflatable lifeboat has been used to perform many extraordinary rescues. (Courtesy of Nathan Williams/RNLI)

For outstanding courage and bravery in the face of great danger, Damien was awarded the silver medal and Nicola-Jane and Matthew were each been awarded the bronze medal. Michael Vlasto, RNLI Operations Director, said afterwards: 'This was a service carried out in very difficult conditions with confused and breaking seas very close to a dangerous lee shore, semi-submerged rocks and floating rope. Helmsman Damien Bolton and his two crew Nicola-Jane Bradbury and Matthew Main were aware of the risk they were exposing themselves to, but felt that the potential of saving a life outweighed that risk. Although this rescue was also marked by tragedy, it is a testament to their bravery, skill and tenacity that one of the men survived.'

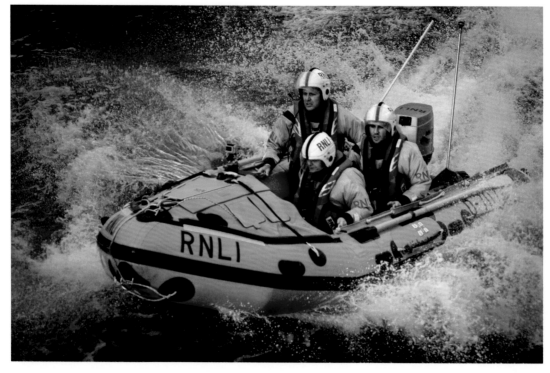

The new lifeboat stations built at Lizard and Padstow, together with the introduction of the inshore lifeboat, were part of a continued modernisation of the RNLI's lifeboat fleet which has taken place since 1945. While the immediate post-war era saw the building of large numbers of traditional wooden-hulled displacement lifeboats, since the 1960s there have been considerable advances in all-weather lifeboat design. Probably the most significant of these has been the introduction of the 'fast' lifeboats capable of speeds greater than the eight or nine knots managed by the first generation of motor lifeboats.

The first design of 'fast' lifeboat was the 44ft Waveney, which was based on a United States Coast Guard (USCG) design. In 1963 the RNLI purchased a 44ft steel-hulled lifeboat from the USCG and following successful trials of the boat, which included it visiting Cornwall, undertook a building programme. This boat, self-righting by virtue of its watertight wheelhouse, was faster than the conventional lifeboats then in service and completely different from the traditional lifeboat designs. The type was given the class name Waveney, and a total of twenty-two saw service around the UK and Ireland, with one of the boats serving at Fowey from 1988 to 1996.

Good as the Waveney proved, a slightly larger and faster lifeboat was required, so new 50ft and 52ft types were developed by the RNLI. The 52ft design became the Arun class, and the

above The 47ft Watson motor Louisa Ann Hawker (ON.965) at moorings off Appledore, the station she served from 1962 to 1987. The 47ft Watson was the last of the traditional double-ended wooden-hulled displacement types to be built by the RNLI. (Author's collection)

below The 37ft 6in Rother class lifeboat Diana White (ON.999), an eight-knot design, under construction during 1973 at the Littlehampton boatyard of William Osborne; she was sent to Sennen Cove in November 1973. (Jeff Morris)

The modern era

right The prototype 44ft Waveney 44-001 at Padstow on 29 May 1964 during her demonstration and evaluation tour of the United Kingdom and Ireland. Staff Coxswain Widney Hills was in charge of the boat during the tour, which enabled serving lifeboat crews to assess the revolutionary new design first hand. (Courtesy of the RNLI)

Solomon Browne's crew

PENLEE • 19 December 1981 • Penlee lifeboat Solomon Browne went to the aid of the coaster Union Star after its engines failed in heavy seas. After the lifeboat had rescued four people, both vessels were lost with all hands; in all, sixteen people died including eight volunteer lifeboatmen. Coxswain William Trevelyan Richards was awarded the gold medal for the manner in which four people were taken off the coaster; the remainder of the crew, Second Coxswain/Mechanic James Madron, Assistant Mechanic Nigel Brockman, Emergency Mechanic John Robert Blewett, crew members Charles Greenhaugh, Kevin Smith, Barrie Robertson Torrie and Gary Lee Wallis were awarded bronze medals. The Medals were presented to the widows and parents by HRH Princess Alice, Duchess of Gloucester in London on 11 May 1982.

below The ill-fated Penlee lifeboat Solomon Browne (ON.954) launching down the slipway at Penlee Point. In December 1981 she went to the coaster Union Star, but was tragically wrecked while attempting to save the coaster's crew. (Author's collection)

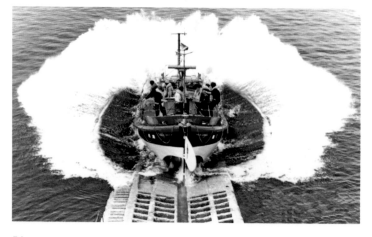

50ft design was named the Thames class. The first 'fast' lifeboat to go on station in Cornwall was the prototype 50ft Thames class boat Rotary Service, which was stationed at Falmouth in 1974. However, the Arun proved to be a better boat and, since its inception has become one of the finest lifeboat types ever developed for use by the RNLI.

Capable of a speed between eighteen and twenty knots, the Arun represented a radical departure for lifeboat design and was completely different from anything that had gone before. In 1978 a new 52ft Arun, Elizabeth Ann (ON.1058), was sent to Falmouth, where she served with distinction. Another Arun, Robert Edgar (ON.1073), was stationed at St Mary's in 1981 where the slipway launch was abandoned in favour of a mooring in the harbour. A further Arun, Mabel Alice (ON.1085), was stationed at Penlee in 1983, operating from Newlyn.

The Arun was sent to Penlee to replace a 47ft Watson motor, a type in widespread use, which was tragically lost in December 1981. Named Solomon Browne, she was wrecked on service to the coaster Union Star, having gone out in hurricane force winds and mountainous seas. Her brave crew of eight succeeded in approaching the vessel to take off four of the eight people on board. However, in going back to the vessel, the lifeboat was overwhelmed and all on board were lost. Nobody saw exactly what happened, and despite an extensive search throughout the following days nobody was found alive.

The RNLI awarded the gold medal posthumously to Coxswain William Trevelyan Richards, and bronze medals to each of the seven crew lost. Like the tragedies at St Ives in 1938 and 1939, events at Penlee greatly affected the local community, particularly the small village of Mousehole from where all eight members of the crew came.

The modern era

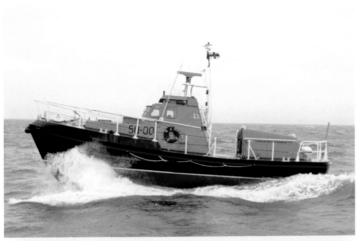

left The first 50ft Thames class lifeboat 50-001 (ON.1031) taking part in the RNLI's 150th anniversary celebrations and International Lifeboat Conference at Plymouth in 1974. The boat served at Falmouth from 1974 to 1978, and was later transferred to Dover. (Courtesy of the RNLI)

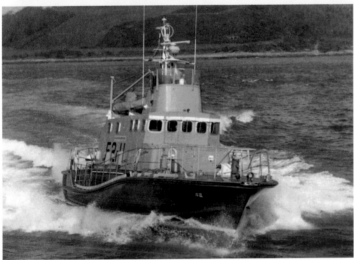

left 52ft Arun Elizabeth Ann (ON.1059) was stationed at Falmouth from 1979 to 1997. She was the first Arun to operate in the West Country, and is pictured during the early years of her career, with the davit for launching the small inflatable she carried in place; this piece of equipment was later replaced. (Author's collection)

below The naming ceremony of Penlee's 52ft Arun Mabel Alice (ON.1085) at Newlyn Harbour on 18 July 1983. The boat was christened by HRH The Duke of Kent, President of the RNLI. (Author's collection)

Yet in spite of the great loss suffered by this small community, men immediately volunteered to form a new crew and operate another lifeboat. At first a relief lifeboat was supplied, and in 1982 a new 52ft Arun was allocated to the station. The new boat *Mabel Alice* (ON.1085) was placed on station on 8 May 1983 and on 18 July 1983 was named by HRH The Duke of Kent and dedicated at a moving ceremony at Newlyn Harbour.

The introduction of the Waveney and Arun designs in the 1960s and 1970s marked the beginning of the

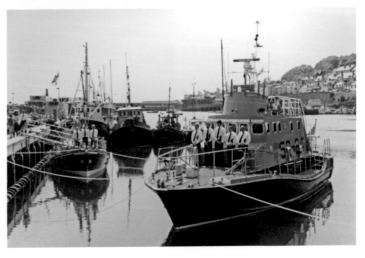

The modern era

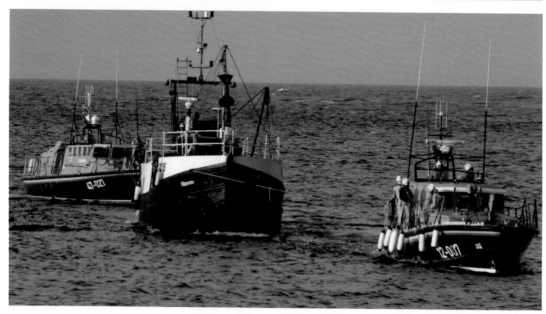

above Appledore's 47ft Tyne George Gibson (ON.1140) steadies the 60ft trawler Pacemaker after it has fouled its propeller, as it is towed in by Ilfracombe's 12m Mersey Spirit of Derbyshire (ON.1165). (Courtesy of the RNLI) .

Medal winners

PENLEE/SENNEN COVE • 6/7 December 1994 • Bronze medal awarded to Coxswain/ Mechanic Neil Brockman in recognition of his fine seamanship and leadership when, jointly with the Sennen Cove lifeboat, the Penlee lifeboat Mabel Alice assisted in the rescue of five people from the fishing vessel Julian Paul, which had fouled her propeller to the west of Longships. The casualty was taken in tow in very rough seas and storm force winds and brought into Newlyn. Coxswain/Mechanic Terence George of the Sennen Cove lifeboat was also awarded the bronze medal.

FALMOUTH • 2 November 2005 • Bronze medal to Coxswain Mark Pollard in recognition of his leadership and outstanding seamanship when the Falmouth lifeboat assisted to save the motor vessel Galina and her crew of eight. The service was carried out at night in extreme weather with force ten winds gusting to force eleven. Despite the severe conditions, a tow was established and Galina was slowly towed to meet a coastguard vessel.

right 17m Severn The Whiteheads (ON.1229) off the Isles of Scilly. She is one of three Severn class lifeboats in Cornwall.

modernisation undertaken by the RNLI. However, at stations where boats could not be moored afloat, other designs of 'fast' lifeboat were needed. So, in the 1980s, two new classes were developed: the 47ft Tyne and 12m Mersey, intended for slipway and carriage launching. One of the first of the Tynes, James Burrough (ON.1094), went to Padstow in 1984, and in 1988 further Tynes were stationed at The Lizard and Appledore. The Lizard boat, David Robinson (ON.1145), was

funded from the legacy of the late Sir David Robinson, who had also funded the Arun lifeboat at Penlee.

The 12m Mersey class was introduced in the late 1980s, and of the first ten to be built, two came to the south-west in 1990. The seventh of the class, Spirit of Derbyshire (ON.1165), went to Ilfracombe, and the ninth was stationed at St Ives, where an impressive new lifeboat house was built to accommodate the new boat and its launch rig as well

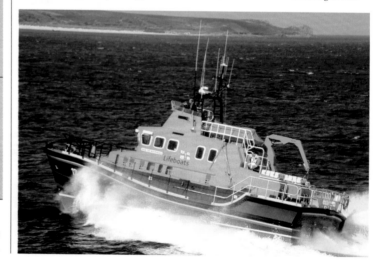

as the inshore lifeboat, and provide modern crew facilities. Named *Princess Royal (Civil Service No.41)* (ON.1167), the new boat went on station in October 1990 and formally named by HRH The Princess Royal in July 1991.

During the early 1990s even faster lifeboats, intended to be kept afloat and replace the Aruns and Waveneys, were introduced. Two new designs, the 14m Trent and 17m Severn, were developed, each capable of speeds up to twenty-five knots which reduced the time taken to reach a casualty. These new types began entering service in the mid-1990s. A Trent, named *Maurice and Joyce Hardy* (ON.1222), went on station at Fowey in October 1996; 17m Severns were placed at Falmouth in January 1997, St Mary's in December 1997 and Penlee in 2003.

In 2005 another twenty-five-knot design was introduce, the 16m Tamar class, which was intended to operate from stations where slipway launching is employed. One of the first of the new Tamars, *Spirit of Padstow* (ON.1283), was allocated to Padstow where a new lifeboat house was constructed during 2005–06 big enough to take the new design. The old boathouses that had been suitable for the Tyne were too small for the Tamar, and so there followed a major shoreworks programme that also saw the rebuilding of the lifeboat station and slipways at Sennen Cove and The Lizard. The 16m Tamar *City of London III* (ON.1294) was placed on station at Sennen in January 2010, and in 2010–11 the Lizard station was completely rebuilt with a new lifeboat house at the Kilcobben Cove site used since the 1960s so that a 16m Tamar could be stationed there. The boat, *Rose* (ON.1300), duly arrived on station in July 2011. She was initially operated from moorings while work on the new lifeboat house was completed.

above Falmouth's 17m Severn Richard Cox Scott (ON.1256) with HM The Queen on board on 1 May 2002 at the start of her Golden Jubilee tour of Great Britain. One of her first engagements was the naming of the new Severn class lifeboat, which then took her on a tour of the harbour.

left With St Michael's Mount in the background, relief 52ft Arun A.J.R. and L.G. Uridge (ON.1086) leads the new 17m Severn Ivan Ellen (ON.1265) into Newlyn harbour on 11 March 2003 as the new boat arrives at her Penlee station.

below 14m Trent Maurice and Joyce Hardy (ON.1222) leaving Fowey. She is the only Trent class lifeboat in the south-west.

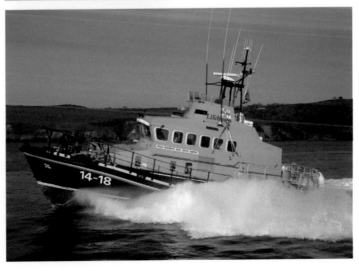

The modern era

above Crew training at Sennon Cove involving the station's own lifeboat City of London III (ON.1294) with the then new Tamar for Appledore (on right), Mollie Hunt (ON.1296), which was on passage to her station, 21 March 2010. (Tim Stevens)

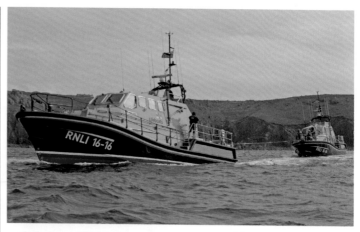

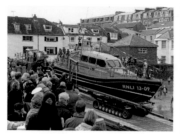

above Watched by hundreds of well-wishers and supporters, the new 13m Shannon The Barry and Peggy High Foundation (ON.1316) is launched at the end of her naming ceremony at Ilfracombe on 26 June 2015.

below The first 13m Shannon class lifeboat ON.1308 (later named Jock and Annie Slater) at Hayle in April 2013 during launch and recovery trials for the new design. (Jack Lancaster)

The latest development has seen the introduction of the 13m Shannon class lifeboat, designed primarily for launching across a beach, to replace the 12m Merseys. The Shannon is transported by a specially-designed Supacat launch and recovery (L&R) rig, a complicated piece of equipment which speeds up launching and simplifies the recovery procedures.

The Shannon was also notable as the first RNLI all-weather lifeboat to be powered by water jets instead of propellers, making it very manoeuvrable and able to work in shallower waters. Launching trials with the first Shannon were held at Hayle, on Cornwall's north coast, in April 2013 with the Atlantic surf providing a stern test for boat and launch rig.

The first two Shannons in service went to Dungeness and Exmouth in 2014, and the next in the south-west, after Exmouth, was at Ilfracombe. Named *The Barry and Peggy High Foundation* (ON.1316), she arrived in June 2015 and was named at a ceremony three weeks later.

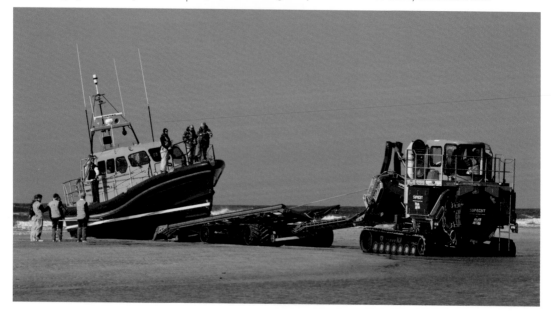

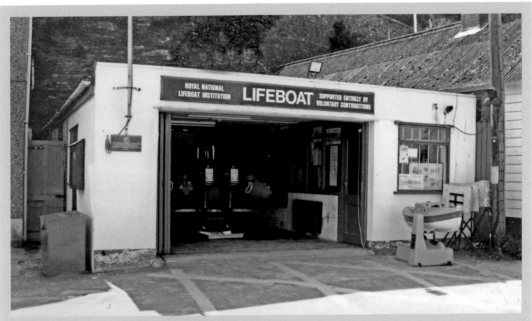

above An inshore lifeboat station was established at Newquay in 1965, with operations centred on the town's small harbour. This ILB house was built in 1974, funded by the Newquay Round Table, for a D class inflatable. It housed a twin-engined C class inflatable from 1983 to 1994, with this picture taken in August 1992. The somewhat rudimentary building offered little in the way of crew facilities and was typical of the boathouses used in the 1960s and 1970s for the RNLI's inshore lifeboats.

below When the station was upgraded in 1994–95 to operate an Atlantic 75, a new lifeboat house was built on the same site in the harbour. The new building was considerably larger, housing Atlantic and a D class ILB, and providing modern crew facilities.

RNLI Lifeguards and Beach Rescue

above The Arancia IRB A-28 on patrol at Harlyn Bay in North Cornwall. The Arancia was developed in New Zealand in the 1970s as an inflatable surf rescue craft for rough inshore conditions and measures 3.88m by 1.73m. Power comes from a single 30hp outboard engine. The design is used worldwide but the IRBs used in the UK are built at the RNLI's Inshore Lifeboat Centre in Cowes.

below The Arancia IRB at Harlyn Bay is transported across the beach using a Honda Quadbike and launched from a simple trailer for a quick get-away.

The introduction of lifeguards and beach life-saving services by the RNLI in the twenty-first century was a significant development, with the RNLI adding a new element to its operations. There have been strong links between the RNLI and beach lifeguarding and, in fact, the first gold medal for gallantry was awarded to Charles Freemantle in 1824 for swimming with a line from a beach to rescue the crew from the *Carl Jean*, a vessel stricken on rocks near Christchurch, Dorset.

Much later, in the 1960s, Warren Mitchell, a lifeguard from Australia, was working in Newquay when he saw an RNLI inflatable inshore lifeboat on service. He was inspired by this, took the idea back to Australia and developed the modern lifeguard inshore rescue boat, the Arancia.

But it was not until September 2000 that the RNLI became involved in lifeguarding with the introduction of a pilot scheme to evaluate expansion into beach lifeguarding around the UK. A pilot Beach Rescue service, later rebranded as Beach Lifeguards, was launched in 2001 to cover twenty-six beaches in the central south and south-west of England with the aim of providing a 'joined-up service' to save more lives. Cornwall was at the forefront of this new development, with the county's beaches among the first to be served by RNLI lifeguards.

Since 2001 the service has been greatly expanded, and by 2004 it covered eight local authorities on fifty-seven beaches in Hampshire, Devon and Cornwall. In Cornwall, lifeguards on beaches in the Caradon, Carrick, Restormel and North Cornwall

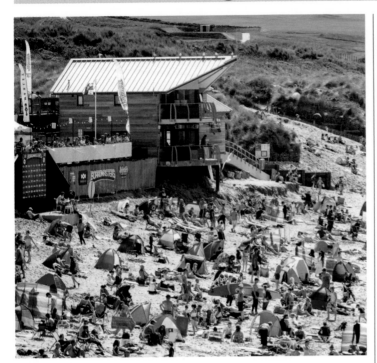

above/left The RNLI's impressive lifeguard facility on Fistral beach at Newquay was completed in 2010 and officially opened on 1 August 2011 by the RNLI's Operations Director, Michael Vlasto. It overlooks one of the county's busiest beaches, which is also one of the main centres for surfing in Cornwall and the UK. The building, which cost £500,000, was designed by St Ives-based architects Poynton Bradbury Wynter Cole and project managed on site by Royal Haskoning. In the first year that the building was open, RNLI lifeguards dealt with over 520 incidents and assisted nearly 630 people. (Courtesy of the RNLI)

districts came under the RNLI Beach Lifeguards service umbrella as part of the initial roll-out of the service. Further expansion has seen RNLI lifeguards introduced at beaches on the east coast, in Wales, Scotland and the north-west.

The service is provided under a contractual or service level agreement with the local authority for which the RNLI receives payment. This is normally sufficient to pay for the seasonal salary costs and is not less than the local authority used to pay for their lifeguard service.

Due to the success of the service, the provision of a Beach Lifeguards service became part of the RNLI's 'concept of operations'. The service aims to reach any beach casualty up to 300m from shore within the flags on RNLI lifeguard-patrolled beaches within three and a half minutes.

The number of lifeguards at any one beach, as well as the type and amount of equipment, varies depending on

local need, and is determined by a risk assessment of the beach and the predicted visitor numbers. Lifeguard Units are usually equipped with radios, rescue boards, rescue tubes, oxygen, spinal boards and collars, a defibrillator and various other items of essential lifesaving equipment. Depending on the need, many beaches are served by a four-wheel drive vehicle, an all-terrain vehicle, an Arancia inshore rescue boat, and a rescue water craft (RWC).

The lifeguards themselves undertake training on courses run by Surf Life Saving GB, Surf Life Saving Association Wales and Royal Life Saving Society UK. Lifeguards are measured against strict criteria, and their fitness is tested to ensure they can meet the physical demands of the work, such as moving equipment, handling casualties and running and swimming to a casualty.

While 95 per cent of a lifeguard's work is preventative, trying to stop accidents before they happen by

below Lifeguard on a rescue watercraft (RWC) in the surf at Perranporth beach, Cornwall. The RWC is used by lifeguards to rescue people in the water speedily. (Courtesy of the RNLI)

RNLI Lifeguards and Beach Rescue

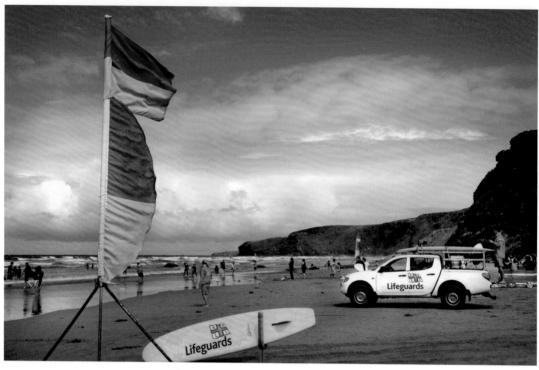

above RNLI lifeguards on patrol in Cornwall using beach boards and a 4x4 vehicle. (RNLI/Nigel Millard)

Lifeguard awards

PERRANPORTH BEACH, CORNWALL • 22 September 2006 • Four RNLI lifeguards responded to a thirty-six-year-old surfer who got into difficulties in notoriously dangerous seas around the rocks at Droskyn Head. He was left clinging to a rock ledge at one of the natural arches. Kris O'Neil and Sophie Grant-Crookston went to his aid using an RWC from which Sophie swam to the man and secured him in a rescue tube. Kris requested further from the IRB which, crewed by Robin Howell and David Green, was driven into the cave to find Sophie. Waves were breaking into the boat as it was manoeuvred through the rocks. Sophie helped the exhausted man into the IRB before she climbed in. For this rescue, Sophie was awarded the bronze medal.

TREBARWITH STRAND, CORNWALL • 28 June 2008 • Silver medals to two senior lifeguards, Chris Boundy and John Dugard, after they saved the life of a sea angler who fell from rocks into dangerous water at Trebarwith Strand in Cornwall. They became the first RNLI lifeguards to receive the silver medal, the RNLI's second-highest award.

offering advice, watching from rescue boards, scanning the beach and spotting any hazardous areas on beaches, in 2014 19,353 people were aided by lifeguards around the UK. By 2015 the RNLI was providing lifeguard patrols on over 200 beaches, and had recruited more than 1,300 lifeguards. To cover beaches in Cornwall and Devon in 2015, 473 lifeguards were employed at peak season.

Typical of the work of the lifeguards is an incident on 13 July 2015, when RNLI lifeguards at Tolcarne beach in Newquay rescued a family of four after they had drifted half a mile from the nearby harbour due to the strong cross shore winds. The conditions were challenging, with strong cross-shore winds and a choppy swell. The family had hired some water sports equipment, kayaks and paddle boards, but once in the water, strong offshore winds led to the family drifting across the bay, half a mile from

the harbour. RNLI lifeguards Anthony Middleton, George Tickner and William Jarvis launched the RWC within five minutes, quickly picked up the family and returned them to the shore safely.

William Jarvis, RNLI senior lifeguard at Tolcarne beach, said: 'We managed to launch extremely quickly and we were able to tackle the challenging conditions of the day, allowing us to rescue the family safely and professionally. The family did the right thing by signalling for help as soon as they were in difficulty, as it allowed us to reach them as fast as possible.'

The beaches covered by RNLI lifeguards in 2014 were as follows: in Carrick and Kerrier district, seven on the south coast and seven on the north coast; fifteen in Penwith district, which includes Land's End and the beaches around; fifteen in Newquay and Padstow district; and sixteen in North Cornwall and North Devon district.

Lifeboats of the South West Coast of England, station by station

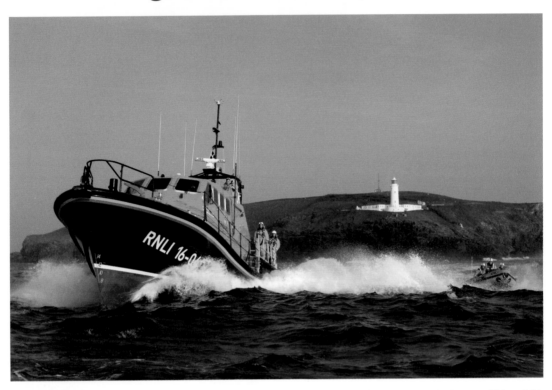

Introduction to Part Two

In 2015 the RNLI were operating twenty-one lifeboat stations on the south-west coast of England and the Bristol Channel. Many of the stations also have long and proud histories, and their volunteer lifeboat crews have performed numerous outstanding, courageous and famous rescues.

Details of all the stations, past and present, operational and closed, are included in this section, which is arranged geographically from east to west, starting at Looe in Cornwall and heading west, to the Isles of Scilly, along the north coast of Cornwall,

to Devon and Somerset, ending at Portishead and Pill. Where there was once a lifeboat station which is now closed, of which there are sixteen in the region, information is provided about what can be seen today.

The information in each entry includes key data and current lifeboats for each station, location information covering lifeboat houses, launch methods and operational changes, and major events in each station's history. The operational information in the data boxes at the start of each entry is up to date as of 1 July 2015.

above Padstow's 16m Tamar lifeboat Spirit of Padstow (ON.1283) and Rock's D class inflatable Guardian Angel (D-655, Relief) together off Trevose Head.

Looe

Current lifeboats

ILB Atlantic 75
B-793 Alan and Margaret
Donor Gift of Miss Elizabeth Beaton
On station 2.10.2003
Launch Tractor and do-do carriage

ILB D class inflatable
D-741 Ollie Naismith
Donor Appeal in memory of Ollie Naismith
On station 15.11.2010
Launch Tractor and trolley

right The lifeboat house built in 1866 was used until 1930, when the station was closed. It has been used as a shop for many years, and is situated just behind the 2002–3 ILB house.

below The lifeboat house built in 2002–3 for Atlantic and D class inflatable inshore lifeboats, with a slipway into the river.

1866 The station was established after several lives were lost when boatmen went to the assistance of a fishing craft but their boat capsized returning to shore. This, together with the large number of vessels using the harbour, prompted local inhabitants to ask the RNLI to establish a lifeboat station. Fishermen were available to form a crew, and a 32ft self-righter was supplied, being formally named *Oxfordshire* on 28 December 1866. A lifeboat house was built on the beach at East Looe, near the harbour entrance,

with a reading and assembly room for the use of the pilots and fishermen on the first floor, at a cost of £200.

1930 The station was closed, and the last pulling lifeboat, the 35ft self-righter *Ryder* (ON.489), was withdrawn in July.

1991 The committee of management decided on 27 November to establish a summer-only D class ILB station for one season's operational evaluation.

1992 D class inflatable D-355 was placed on service on 15 June; the ILB was kept in a boathouse provided by East Looe Town Trust, situated on the seafront

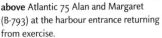

adjacent to the 1866 boathouse.

1997 A new ILB house was opened at Middleton's Corner, East Looe Quay, with a davit launch for the ILB; the boathouse was converted from a stone building, one of the oldest in Looe.

2002–3 The station was upgraded and a second ILB was provided. A new ILB house built for Atlantic 75 and D

class inflatable inshore lifeboats on East Looe Quay on the site of the old crazy golf course; in conjunction with Looe Harbour Commissioners, the boat slipway into the river Looe was rebuilt. The new house incorporates crew room, shower and toilet facilities and was finished in local stone, granite and slate at a cost of £763,297.

above Atlantic 75 Alan and Margaret (B-793) at the harbour entrance returning from exercise.

below The two ILB houses used between 1991 and 2003; the house on the seafront was used from 1991 to 1997, and that at Middleton's Corner (lower) was operational from 1997 to 2003.

left D class inflatable Ollie Naismith (D-741) in the harbour on exercise.

Fowey

Key dates

Opened	1922
RNLI	1922
Motor lifeboat	1928
Fast lifeboat	1982
Inshore lifeboat	1995

Current lifeboats

ALB 14m Trent
ON.1222 (14-18) Maurice and Joyce Hardy
Built 1997
Donor Gift and bequest from Maurice G.
Hardy CBE Ceng, Twyford, Hants, and USA.
On station 10.10.1996
Launch Afloat

ILB D class inflatable
D-681 Olive Two
Donor The Olive Herbert Charitable Trust
On station 28.9.2007
Launch Davit

Station honours

Framed letter of Thanks	2
Thanks Inscribed on Vellum	1
Bronze medal	1

right The inshore lifeboat house and crew facility built in 1997–8 at Berrill's Yard, opposite the lifeboat moorings, on the landward side of the road through the town; the ILB is wheeled out on her trolley and through the barrier to be launched.

opposite 14m Trent Maurice and Joyce Hardy (ON.1222) leaving the river Fowey for an evening exercise.

right 14m Trent Maurice and Joyce Hardy (ON.1222) at her moorings, with the crew facility behind her to the right.

below Looking towards the town quay with, centre right, the building used as a crew facility when the lifeboats were moored off the quay from 1922 until 1995.

1922 The lifeboat station to cover the area was transferred to Fowey from Polkerris, where the station was closed; the first lifeboat, the 40ft self-righter *James, William and Caroline Courtney* (ON.394) was kept afloat in the estuary.
1928 A motor lifeboat, *H.C.J.* (ON.708), intended for Holyhead, was sent to the station in August for a short period; the station's own motor lifeboat, *C.D.E.C.* (ON.712), arrived in December and served Fowey for twenty-six years. The motor lifeboats were kept moored afloat just off the town quay until the 1990s, and no boathouse was built; a building was found for the crew's gear close to the town quay; the service boards were displayed on the outside walls of the Royal British Legion Club.
1954 The station's second motor lifeboat, the 46ft 9in Watson motor *Deneys Reitz* (ON.919), arrived in November having been funded by the South African Branch of RNLI.
1959 A Centenary Vellum was presented to the station.
1982 The station's first fast lifeboat, the 33ft Brede *Leonore Chilcott* (ON.1083) became operational in October.
1995 New moorings were found for the lifeboat upstream from the Quay, opposite Berrill's Yard.

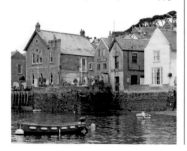

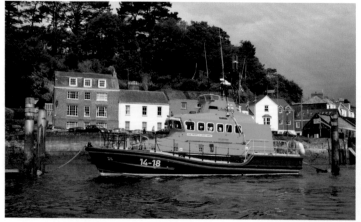

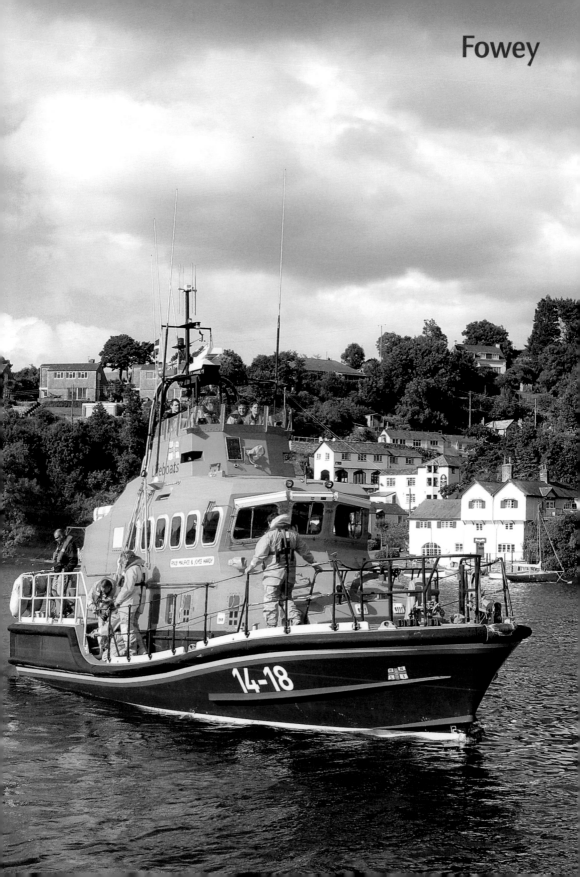

Fowey

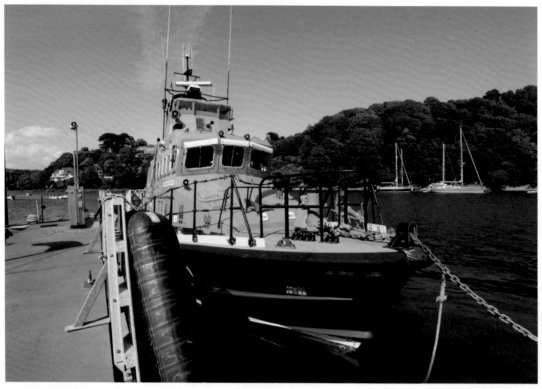

above 14m Trent Maurice and Joyce Hardy (ON.1222) at moorings at Berrill's yard.

below D class inflatable Olive Two (D-681) on her trolley outside the ILB house.

below right Olive Two (D-681) beneath the launch davit on the quayside.

1996 An inshore lifeboat station was established in August, initially on a summer only basis; the D class inflatable ILB was initially kept in a temporary wooden container on the quayside beneath the launch davit, close to the lifeboat moorings.

1997–8 A new purpose-built shore facility and ILB house were completed in Berrill's Yard, opposite the lifeboat moorings, on the landward side of the road through the town. Funded from the bequest of Marie and George Higginson, the new building was formally opened on 4 October 1997 with the 14m Trent Maurice and Joyce Hardy being named at the same time.

2000–1 A new and larger pontoon was installed at Berrill's Yard to improve boarding arrangements.

2004 A new pontoon berth was completed at a cost of £63,247.

Key dates

Opened	1859
RNLI	1859
Closed	1922

Station honours

Silver medals	10
Gold medals	1

left The lifeboat house built in built on the beach at Polkerris in 1903 which was used until the station closed in 1922, and is easily identifiable as an old lifeboat house. closely linked to Fowey, the station was known as Fowey (1859–93) and Polkerris & Fowey (1896–1905) as well as Polkerris.

1856 After the wreck of the schooner *Endeavour*, of Ipswich, at Gribben Head on 6 May, local landowner William Rashleigh asked that a lifeboat station be estbalished in the area.

1859 A station was opened at Polkerris, and a lifeboat house was built on the beach at a cost of £138 4s 0d. The first lifeboat, the 30ft self-righter *Catherine Rashleigh*, was named after Rashleigh's wife and was the first of four lifeboats to serve the station.

1903 A new lifeboat house was built at a cost of £1,880 5s 0d; it was used until the station closed in 1922.

1918 Pushing poles were supplied to make it easier to get the lifeboat afloat as obtaining horses for launching had become increasingly difficult.

1922 Operations were transferred to Fowey, where the lifeboat could be kept afloat, and Polkerris was closed. The last lifeboat, 35ft Watson James, William and Caroline Courtney (ON.515), left on 22 August having saved two lives in her eighteen years on station, and was sold.

below One of the old service boards that can be seen inside the lifeboat house.

below left The lifeboat house of 1903, used until 1922, was later converted into the Lifeboat Café and shop.

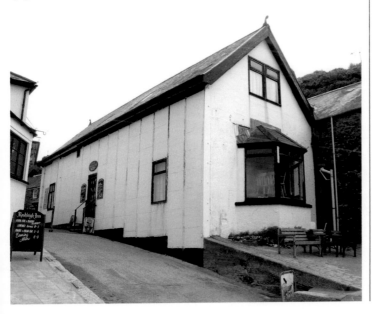

LIST OF SERVICES RENDERED BY THE
FOWEY LIFEBOAT
OF THE
ROYAL NATIONAL LIFEBOAT INSTITUTION

THE ROCHDALE & CATHERINE RASHLEIGH
LIFEBOAT

LIVES SAVED

1867 MAR 17ᵗʰ Schooner "DEVONIA" of PADSTOW 5
1872 MAR 27ᵗʰ DUTCH Schooner "DOURO" 4
1873 FEB 2ⁿᵈ Schooner "HAWK" of CHEPSTOW & 4
1876 DEC 30ᵗʰ Brigantine "CELINE" 13

THE "ARTHUR HILL" LIFEBOAT

1883 SEPT 1ˢᵗ Ketch BACCHUS of NANTES 3
1885 NOV 18ᵗʰ Schooner TAM O'SHANTER of GOOLE

1885 DEC 19ᵗʰ Trawler DEWDROP of BRIXHAM
1894 AUG 24ᵗʰ Schooner MARY-ANN of FOWEY
1895 DEC 22ⁿᵈ Schooner "EMILY" of PADSTOW 4
7

THE
"JAMES WILLIAM & CAROLINE COURTNEY"
LIFEBOAT

1907 FEB 12ᵗʰ Brigantine "ADELAIDE" of FOWEY
STOOD BY—ADVISED TO SAVE VESSEL
1913 MAY 30ᵗʰ FRENCH Schooner VOLONTAIRE 2
1914 MAY 24ᵗʰ A Small BOAT Landed 1
1914 NOV 4ᵗʰ Schooner "ABEJA" of EXETER
Stood By VESSEL

Mevagissey

right The lifeboat house built at Port Mellon in 1868–9 was used until the mid-1890s, and has since been converted into a private residence.

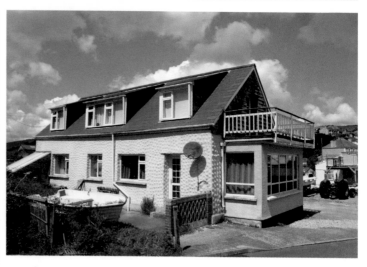

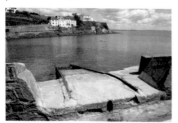

above The launchway onto the beach at Port Mellon, in front of the lifeboat house, was used by the lifeboat during the first quarter century of the station's existence. Port Mellon was just south of Mevagissey harbour, and the building was part of a boatbuilding yard in the 1960s.

below The lifeboat house and slipway built in 1895–6 enabled the boat to be launched quickly, but the site was very exposed and the building often sustained storm damage. It was used until 1930, when the station closed, and later became an acquarium but has largely retained its original outward appearance.

1869 The RNLI agreed to establish a lifeboat station at Mevagissey as there was no lifeboat between Polkerris and Falmouth. A lifeboat house was built at Port Mellon, a small fishing cove to the south of Mevagissey harbour, on ground leased free of charge by the Earl of Mount Edgcumbe. A small slipway made up of rails was built onto the beach so that the lifeboat could be launched. The first lifeboat, a standard 33ft ten-oared self-righter named *South Warwickshire* (ON.181), arrived in October and served until 1888.

1888 The lifeboat was moved to Mevagissey, where it was kept afloat in after the outer harbour had been built, and a new 37ft self-righter, named *John Arthur* (ON.224), was placed on station.

1895-6 A new purpose-built concrete lifeboat house and slipway were built at the harbour at a cost of £1,974 12s 9d.

1897 A new 37ft twelve-oared self-righter, named *James Chisholm*, was placed on station in June.

1930 The station was closed following the stationing of a motor lifeboat at Fowey, and the lifeboat was withdrawn.

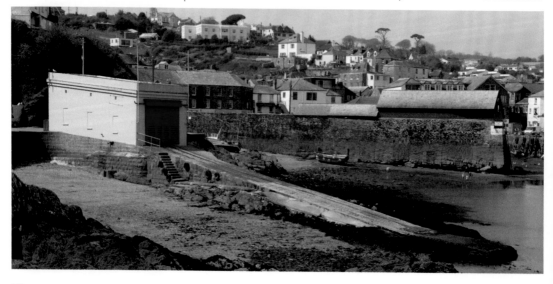

Key dates

Opened	1870
RNLI	1870
Closed	1887

left The first boathouse, built in 1870, was later used as an Anglican church and is hardly recognisable as a lifeboat house.

1869 The RNLI's committee of management decided at a meeting on 4 November that £500 received from the legacy of the late Jacob Gorfenkle, of Liverpool, to provide a lifeboat in Cornwall, would be used to open a new station at Portloe.

1870 A site for a boathouse was found and two cottages were purchased for £30 and then demolished, with the stone being used in the new boathouse built by local builder W.W. Dunstone at a cost of £169, on a site near the top of a long steep incline, the upper part of which was extremely narrow and only just wide enough for the lifeboat carriage to pass. A 33ft ten-oared self-righter named *Gorfenkle* arrived in September and the station was formally inaugurated on 4 October 1870.

1875 In April a better site for the boathouse became available.

1877 A new boathouse was built on the site in the cove just above the high-water line by W.W. Dunstone for £216.

1887 The lifeboat had not been launched once on service and so, on 5 May the RNLI's Committee of Management decided to close the station and *Gorfenkle* was withdrawn.

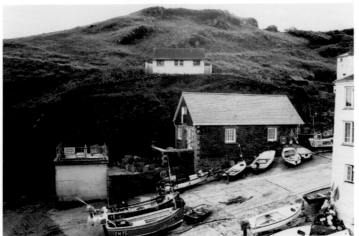

left/below The lifeboat house built in 1877 in the cove just above the high water line was used for only ten years. It subsequently became the village school, and later a private residence.

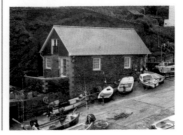

Falmouth

Current lifeboats

ALB 17m Severn
ON.1256 (17-29) Richard Cox Scott
Built 2001
Donor Bequest of the late Mrs Ruth Marygold
Dix Scott, of Cornwall, named in memory of
her late husband Richard; Mrs Scott had a
love of the sea since childhood and had lived
in Cornwall for many years
On station 18.12.2001
Launch Afloat

ILB Atlantic 75
B-756 Eve Pank
Donor Legacy of Lieut Colonel Pank
On station 28.7.2007
Launch Trolley

Station honours

Framed Letter of Thanks	9
Thanks of the Institution on Vellum	2
Bronze medals	4
Silver medals	5
Gold medals	2

above right The original lifeboat house,
built in 1867, can be seen at the far end of
the quay, to the left; it no longer exists.

below The lifeboat station and moorings.

1867 The RNLI established a lifeboat
station after several wrecks in the
area during 1865 and 1866 prompted
local residents to press for a lifeboat.
A wooden lifeboat house was built by
J. Roberts near the dry docks at a cost
of £158 and the first lifeboat, a 33ft
ten-oared self-righter named *Gloucester*,
was sent to the station.

1885 The boathouse was moved to a
new site and a sea wall was built, at a
cost of £160; the house was used until
1918, when the lease on the building
was terminated following a major
redevelopment of the docks, and the
house was eventually demolished.
1918 The lifeboat was placed on
moorings in the middle of the large

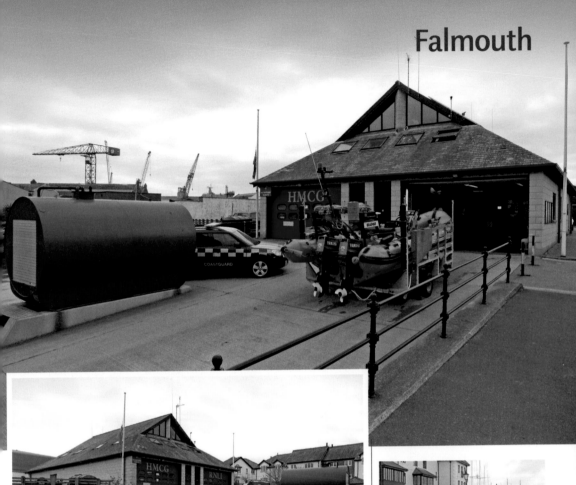

harbour, with the crew reaching it via a special boarding boat.

1931 The first motor lifeboat, the 45ft Watson motor *The Brothers* (ON.671), was placed on station in April.

1956 A new store and workshop were constructed at the edge of the harbour.

1967 Centenary Vellum awarded.

1979 A special framed certificate awarded to the coxswain and crew for display at the station in recognition of their services in connection with numerous yachts in difficulties during the Fastnet Race in August.

1980 A rigid-hulled McLachlan ILB A-508, which was being used as a boarding boat, was redesignated as an inshore lifeboat on 27 March; it was kept moored afloat in the harbour.

1981–2 A new crew room and store house were constructed at Customs House Quay.

1988 The McLachlan ILB was replaced by an Atlantic 21 ILB.

top The lifeboat station building and ILB house were erected in 1993 and the facility is shared with HM Coast Guard.

above left The building erected in 1993 jointly occupied by the RNLI and HM Coastguard, with the two halves being independent of each other.

above The relief Atlantic 75 Braemar (B-774) on the launching trolley, which is lowered into the water by winch.

Falmouth

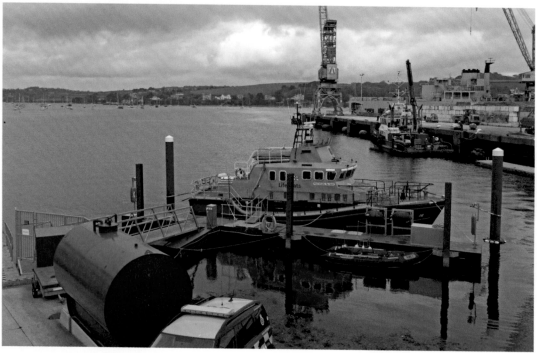

above 17m Severn Richard Cox Scott (ON.1256) berthed at Port Pendennis.

opposite 17m Severn Richard Cox Scott (ON.1256) passing St Anthony Head lighthouse at the entrance to the harbour.

opposite inset 17m Severn Richard Cox Scott (ON.1256) returning to station, with the A&P shipyard in the background.

1993 A new crew facility and ILB house were built in Falmouth Docks at Tinners Walk, Port Pendennis, to accommodate the Atlantic 21, which was launched down a ramp from a trolley attached to a winch; the building included a workshop, drying and changing room, toilet and shower, fuel store, and souvenir sales outlet.

1995 A new pontoon berth was installed and a refuelling facility was constructed for the all-weather lifeboat adjacent to the lifeboat slipway at Tinners Walk, Port Pendennis, to improve boarding arrangements and speed up response times.

right 17m Severn Richard Cox Scott (ON.1256) alongside the pontoon.

below Falmouth lifeboat crew on board 17m Severn Richard Cox Scott.

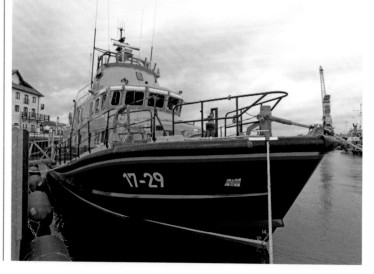

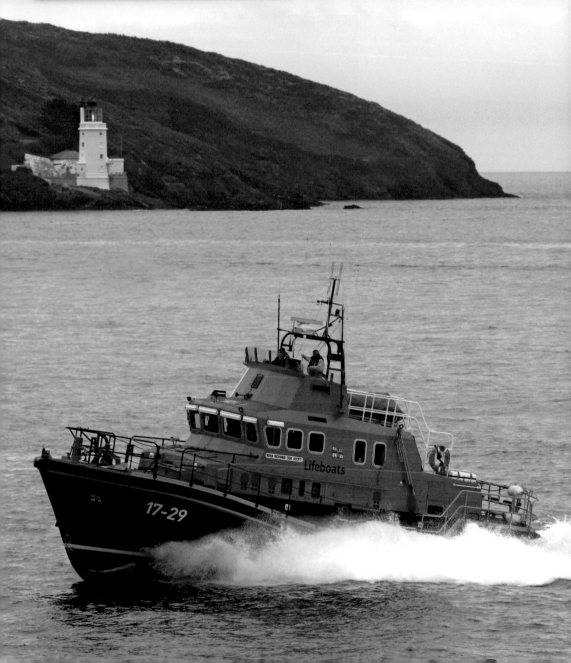

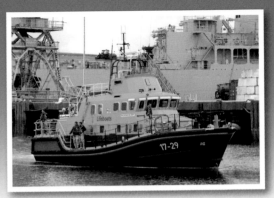

Falmouth

Porthoustock

right The lifeboat house built in 1869 and used until 1942 has been renovated and refurbished for use as the village hall.

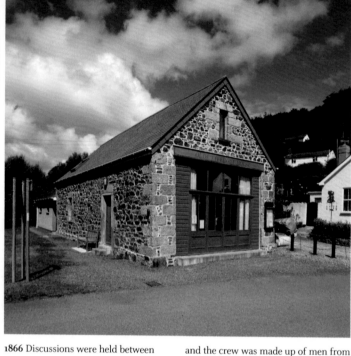

below The lifeboat house built in 1869 stands on the seaward side of the main road that runs through the village, and is now some way from the sea. Originally there was a short run over the beach to the water, but as the sea receded and the bay silted up, wooden rollers had to be used to get the boat out.

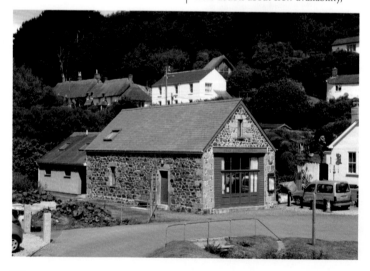

1866 Discussions were held between the RNLI and locals about forming a lifeboat station at Porthoustock.

1869 A lifeboat station was founded to give life-saving cover to the notorious Manacles rocks, just to the south of the village. Although Porthoustock is the nearest cove to the Manacles, there were doubts about crew availability, and the crew was made up of men from Porthoustock, Porthallow and several nearby villages. A lifeboat house was built at a cost of £168 10s 0d and was used throughout the life of the station. The first lifeboat, the 33ft ten-oared self-righter *Mary Ann Story*, was placed on station on 28 September.

1919 A launching track of rollers was laid over the beach to improve launching arrangements.

1938 A 35ft 6in Liverpool motor lifeboat was stemmed for Porthoustock, to be named *W. & B.*, but the boat was sent to the Aldeburgh No.2 station.

1942 The station was closed and the last lifeboat, *Kate Walker* (ON.627), a 35ft self-righter transferred from Lytham in 1931, was withdrawn having undertaken just one service launch during her eleven years at Porthoustock. The lifeboat house has subsequently been sold and become the village hall, with the station's service boards displayed inside.

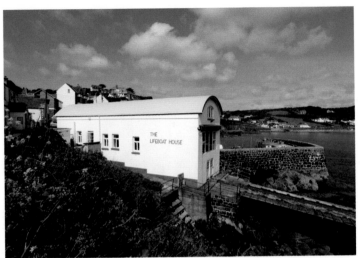

Key dates

Opened	1901
RNLI	1901
Motor lifeboat	1934–72
Inshore lifeboat	1972–80
Closed	1980

Station honours

Bronze medals	1
Silver medals	1

left The lifeboat house, built in 1900–01 and used throughout the life of the station, was later converted into a restaurant.

below The service boards, listing the rescues performed by the station's lifeboats and inshore lifeboats, displayed on a building adjacent to the 1901 boathouse. Three different offshore and three different inshore lifeboats served the station and between them saved a total of 195 lives, of which the ILBs rescued eight.

1899 The RNLI decided to form a new station to improve coverage of the dangerous Manacles rocks, to the north of Coverack, following the wrecks of the steamer *Mohegan* (October 1898) and the liner *Paris* (May 1899).

1901 A lifeboat house and roller slipway, designed by W.T. Douglass, were built just outside the breakwater, near Dolor Point, at a cost of £1,793 6s 8d. The station's first lifeboat, the 35ft Liverpool sailing type *Constance Melanie* (ON.458), arrived in January.

1934 A motor lifeboat, the 35ft 6in Liverpool *The Three Sisters* (ON.771), was placed on station in August.

1954 Alterations to the boathouse and slipway were made for the new 42ft Watson *William Taylor of Oldham*

(ON.907), which arrived in July.

1972 The all-weather lifeboat was withdrawn following a Coastal Review by the RNLI, and a D class inflatable ILB was placed on station; *William Taylor of Oldham* was launched for the last time on 15 May having saved thirty-two lives in eighteen years on station. The ILB became operational on 1 May on a summer-only basis, and was launched from a trolley, which was lowered down the slipway by winch and floated off.

1979 The ILB was withdrawn at the end of the season in October, but following a review of inshore coverage, with a new fast lifeboat at Falmouth an ILB was not deemed necessary at Coverack.

1980 The station was formally closed on 27 March and the boathouse was sold.

below left The lifeboat house and slipway built in 1900, seen from the west.

below The iron launching slipway built in 1900–01 was fixed to the projecting rocks.

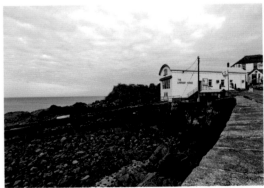

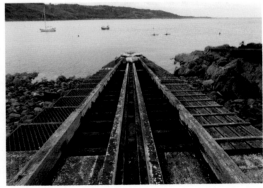

Cadgwith

right The lifeboat house built in 1867 an dused throughout the life of the station, housing a series of self-righting lifeboats which were launched across the beach of the small cove over skids.

below The 35ft 6in motor self-righter Guide of Dunkirk (ON.826), the station's last lifeboat, was funded by the Girl Guides of the Empire and named to commemorate the evacuation in May 1940 of the British Expeditionary Force from Dunkirk. During the twenty-two years she was on station, Guide of Dunkirk launched fifteen times on service and saved seventeen lives.

1867 The station was established to cover the east side of the Lizard Peninsula and a lifeboat house was built by Nicholls & Carter at a cost of £185 2s 0d. The first lifeboat, the 33ft self-righter *Western Commercial Traveller*, arrived on station in September. Most of the Lizard lifeboat crew lived at Cadgwith and were able to man either boat. Launching from Cadgwith was sometimes easier than from Polpeor.

1879 The brick lintel of the boathouse was rotten so was replaced by wood.

1887–8 The boathouse was enlarged at a cost of £134 15s 0d to accommodate a new 37ft self-righter, named *Joseph Armstrong* (ON.105).

1941 The motor lifeboat *Guide of Dunkirk* (ON.826), a 35ft 6in motor self-righter, was placed on station in May.

1963 The lifeboat was withdrawn on 31 May and the station was closed on 1 June following the establishement of the new Lizard-Cadgwith station.

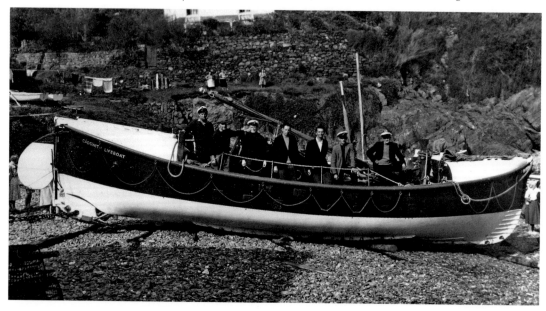

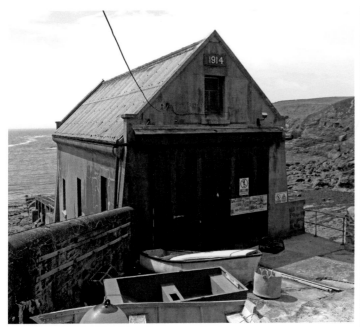

Key dates

Opened	1859
RNLI	1859
No.2 lifeboat (Church Cove)	1885–99
Motor lifeboat	1961
Fast lifeboat	1988

Current lifeboats

ALB 16m Tamar
ON.1300 (16-20) Rose
Built 2011
Donor Anonymous donation from a charitable trust and the Lizard Lifeboat Appeal
On station 16.7.2011
Launch Slipway

Station honours

Framed Letter of Thanks	1
Thanks Inscribed on Vellum	1
Bronze medals	1
Silver medals	5

1859 A station at the Lizard was established after the steamship *Czar* was wrecked on 22 January 1859; some of her crew were rescued by local boatmen, with the incident drawing attention to the need for rescue cover in the area. So the RNLI decided to establish a station, and a lifeboat house was built near the top of the roadway leading down into Polpeor Cove at a cost of £119 13s 7d and the first lifeboat, the 30ft self-righter *Anna Maria*, arrived

left The lifeboat house built in 1892 at the foot of the roadway to Polpeor Cove.

below The lifeboat house and slipway built in 1914–17 for a motor lifeboat at Polpeor Cove; the former house then became a winch house and, when being recovered, the lifeboat was hauled up the beach and through the back of the house.

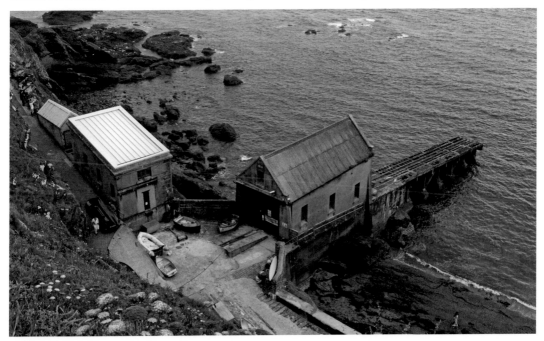

Lizard

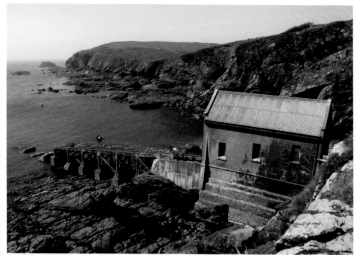

top left Service board on display at Polpeor Cove, close to the small cafés which occupy the site of the first boathouse.

above The service boards, information plaque and RNLI donations box on the cliffs at the top of Polpeor Cove.

above right The lifeboat house and deepwater slipway built at Polpeor Cove, the southernmost tip of the Lizard headland and the most southerly point on the UK mainland, were built in 1914–17.

opposite 16m Tamar Rose (ON.1300) was funded by an anonymous donation from a charitable trust and the Lizard Lifeboat Appeal, and was named on 5 May 2012.

right The lifeboat house built in 1914–17 remains largely unaltered, although its condition has deteriorated. The station operated from this location until 1961, when operations were transferred to Kilcobben Cove. The beach to the left of the boathouse was where the lifeboat was recovered and then, having been hauled to the turntable behind the boathouse, was taken through the rear of the house.

in November, funded by T.J. Agar Robartes and his mother; a carriage was supplied for launching.

1885 A No. 2 station was established at Church Cove, on the east side of Lizard Point, where a lifeboat house was built and a 30ft self-righter, also named *Anna Maria*, arrived in July.

1899 The No. 2 station was closed having been served by two lifeboats; the boathouse still exists, and has been little altered externally; the two enamel roundels either side of the main door remain in place, as does the stone plaque commemorating the donor.

1892 A new lifeboat house was built

at a cost of £895, closer to the beach at Polpeor Cove, thus enabling a faster launch; this was used until 1915, and then housed a winch which was used to recover the lifeboat up the beach.

1914–7 A new lifeboat house, with a deepwater slipway, was built at Polpeor Cove at a cost of £5,000 for the station's first motor lifeboat; to rehouse, the lifeboat was recovered on the beach.

1918 The first motor lifeboat, the 38ft self-righter *Sir Fitzroy Clayton* (ON.628), built in 1911, was placed on station in May. She was replaced by *Frederick H. Pilley* (ON.657), a similar type of lifeboat, in November 1920.

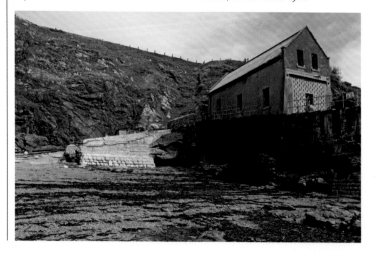

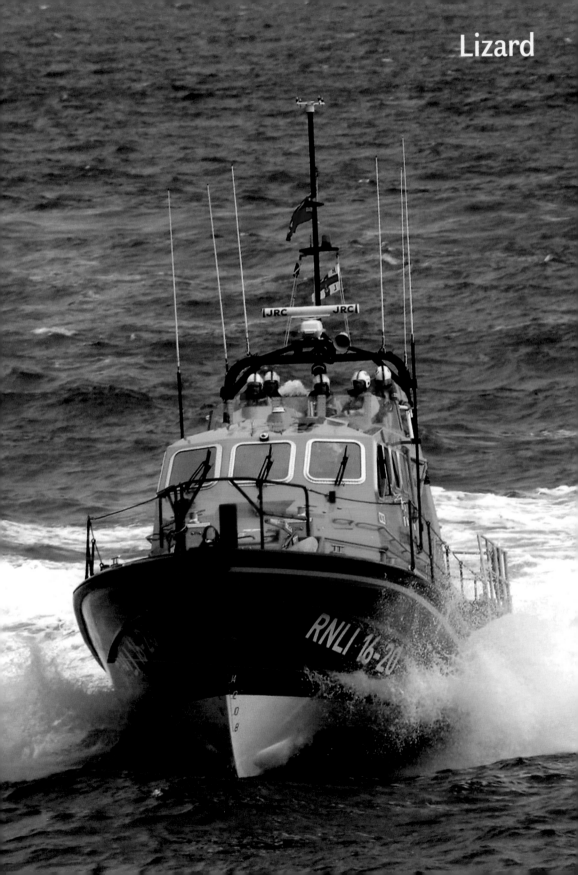

Lizard

Lizard

above The lifeboat house and slipway and roller slipway built at Kilcobben Cove in 1960–61, a mile and a quarter east of Lizard lighthouse; the small building at the top of the cliff houses the machinery which powers the cliff hoist cage to and from the boathouse. This house was used until 2010, and housed three station lifeboats as well as numerous relief lifeboats.

right 16m Tamar Rose (ON.1300), on left, arriving at Lizard for the first time, 10 July 2011 being, and escorted by 47ft Tyne David Robinson (ON.1145) as she makes her first call at Cadgwith Cove.

right 16m Tamar Rose (ON.1300) being launched at the end of her naming ceremony on 5 May 2012.

below The lifeboat house built in 1885 at Church Cove, just to the north of Kilcobben Cove. It was used for what was designated the No.1 lifeboat until November 1899, when the station was closed. The house cost £285, funded from the gift of Thomas Chavasse and his family. It stood at an angle facing away from the sea, making launching a somewhat awkward procedure, with the lifeboat having to be turned through about 120 degrees in order to get to sea.

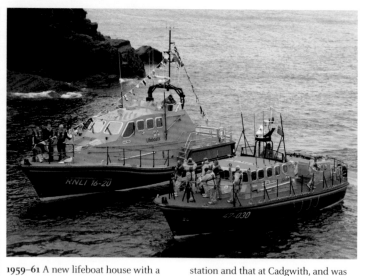

1959–61 A new lifeboat house with a roller slipway was built at Kilcobben Cove, situated on a tongue of rock at the foot of a cliff 140ft high, for 52ft Barnett *The Duke of Cornwall (Civil Service No.33)* (ON.952); the cove is halfway between the villages of Lizard and Cadgwith, and provided a more sheltered area for launching than Polpeor Cove, which was very exposed; an access road nearly a quarter of a mile long was built to the top of the cliff. The new station, which cost about £100,000, replaced both the Polpeor station and that at Cadgwith, and was originally known as Lizard-Cadgwith.

1987 The station's name was formally changed to The Lizard.

1988 The lifeboat house was adapted for the new 47ft Tyne class lifeboat *David Robinson* (ON.1145).

2010–12 A new lifeboat house and slipway were built at Kilcobben Cove on the site of the 1961 boathouse, which was demolished, to house a new 16m Tamar class lifeboat; during construction work, the lifeboat was kept at moorings off Cadgwith or Polpeor.

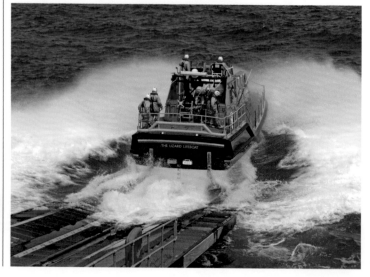

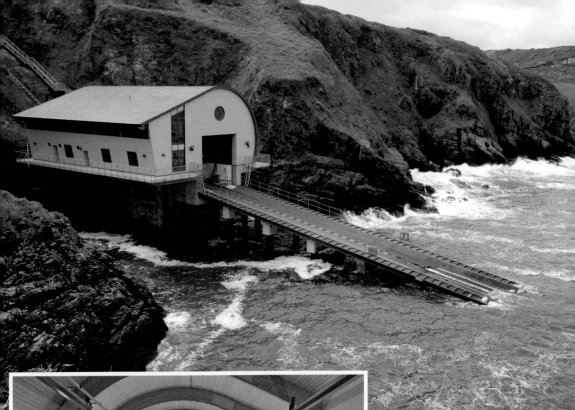

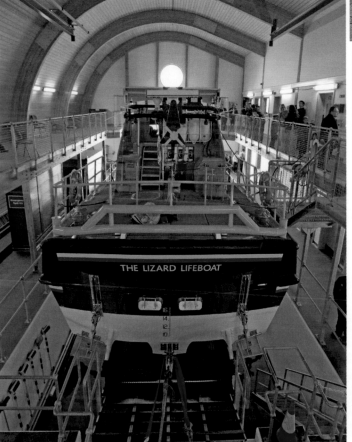

THE LIZARD LIFEBOAT

above The lifeboat house built in 2010–12 on the site of the 1961 boathouse, with some of the original foundation stones being used.

left 16m Tamar Rose (ON.1300) inside the lifeboat house on her tipping cradle.

below Memorial stone on the cliff path adjacent to the winch house, above the lifeboat house at Kilcobben Cove, to the twelve crew of the coaster Ardgarry, which sank in a storm off the Lizard on 29 December 1962. The Duke of Cornwall lifeboat responded to the call for help and spent fourteen hours searching in the storm for survivors, without success.

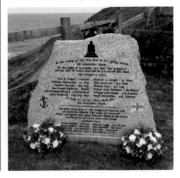

Mullion

right The foundation tablet, which was built at the gable end of the lifeboat house, on display near the harbour at Mullion. The tablet was rediscovered in 1991 and, after being presented to the National Trust, was placed on display.

below The 33ft self-righter D.J. Draper, the station's first lifeboat, outside the lifeboat house built in 1867 at Mullion Cove.

1867 A lifeboat station was established and a boathouse was built at Mullion Cove, to give additional protection for the coast between Porthleven and the Lizard; three wrecks occurred on one night, 6 January 1867, and although both the neighbouring lifeboats were brought to the scene by road, neither was in time to save life. On her first launch, on 21 March 1867, the *D.J. Draper* lifeboat helped to save three lives from the barque *Achilles*, but this was the station's only life-saving launch. **1887** A new 37ft twelve-oared self-righter, named *Edith*, was placed on station in June.

1908 The station was closed, and the lifeboat *Nancy Newbon*, a 38ft self-righter on station since October 1894, was withdrawn. The boathouse was demolished without trace, and the site is now a car park. In forty years the Mullion lifeboats undertook only fourteen service launches, and the lifeboats were often unable to launch from the exposed beach.

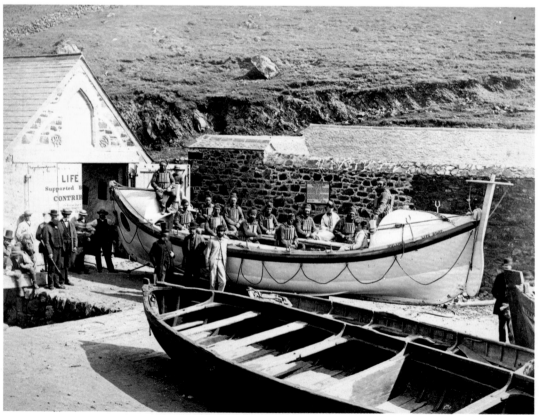

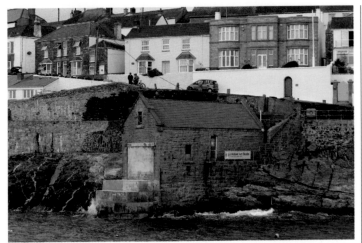

Key dates

Opened	1863
RNLI	1863
Closed	1929

Station honours

Bronze medals	2
Silver medals	2

left The lifeboat house built in 1894, overlooking the harbour entrance, was used until the station closed in 1929. The launching slipway has gone, but the building has had a variety of uses and retains its original external appearance.

1863 A lifeboat station was established after T.J. Agar Robartes offered to provide funds for it; a lifeboat house was built at Breageside at a cost of £145 10s, on land leased from Edward Coode of St Austell for 10s per annum. The lifeboat was launched by carriage, but at low tide and in heavy weather this could be very difficult from the site.

1894 A new lifeboat house and slipway were built on the northern side of the entrance channel, overlooking the harbour, at a cost of £1,485 11s 1d, to improve launching arrangements.

1896 An unusually high tide in October broke through the doors of the boathouse, but the lifeboat was held in place; iron barred gates were subsequently fitted.

1906 The roof was damaged in a gale, and the house was flooded; repairs were put in hand at a cost of £147 10s 10d.

1929 The station was closed and the last lifeboat, the 35ft self-righter Dash (ON.501), was withdrawn in July. By the 1980s the slipway had been washed away by storms, although the house remained and has had various uses.

below The lifeboat house built in 1894 was completed with a slipway to improve launching arrangements. The station was served by four lifeboats, all self-righters. The house was used by a fish-canning firm for keeping shellfish in tanks until required for processing, then became the Shipwreck Centre Museum, and most recently the Lifeboat Art Studio.

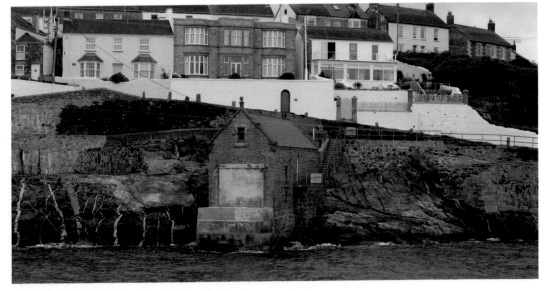

Marazion

right The boathouse used for the D class inflatable and launch vehicle in one of the buildings facing the harbour of St Michael's Mount, from where the station operated throughout the eleven years of its existence. During the station's operational life, its lifeboats and crews launched 112 times on service and saved twenty-one lives.

below Relief D class inflatable Ordnance Survey Bosun (D-432) on station in May 1998. The station boat at this time was D-411, which had been funded by the South West Federation of Sea Anglers.

1990 An inshore lifeboat station was established for a trial period, becoming operational on 28 April; the D class inflatable ILB was kept in one of the quayside buildings on St Michael's Mount, and launched into the small harbour beneath the Mount, which faces the village of Marazion.

1991 The trials were successful, and on 1 October Marazion became an independent station, having initially been a satellite station to Penlee, with the new D class inflatable D-411 placed on station on 23 March.

1999 The new D class inflatable *Global Marine* (D-552) was placed on station in November, but served for just a year.

2001 Station permanently closed on 31 October; inshore cover provided by an Atlantic 75 ILB operating from Penlee.

Penzance

1803 A lifeboat, built by Henry Greathead at South Shields to his North Country design, was obtained for service at Penzance, funded by a number of local donations together with help from Lloyd's; the boat was neglected and sold for debt after nine years of inactivity.

1824 In June the Mayor, Edward C. Giddy, organised a Branch Association

right The lifeboat house at the end of Penzance promenade built in 1856, with the 32ft self-righter Richard Lewis on her carriage outside. She was on station from 1865 to 1884, saving eighty-six lives during that time in eighteen service launches, and even capsized on service in December 1868, without loss of life. This photo dates from the late 1860s.

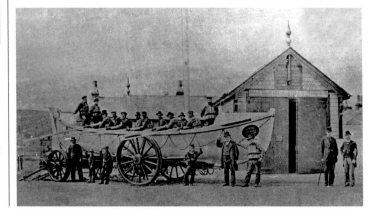

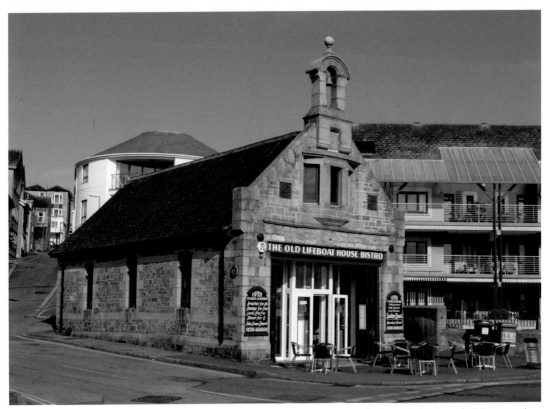

of the newly-formed RNIPLS and began collecting subscriptions for a lifeboat.

1826 The lifeboat, a 24ft type built by William Plenty at Newbury at a cost of £130, arrived in October.

1828 The lifeboat was wrecked in November on her first service, and the station then seems to have lapsed.

1853 A locally-built self-righting type lifeboat, measuring 30ft by 8ft, was built at a cost of £150 as the RNLI re-established the station; the lifeboats were launched by carriage, and often taken many miles to reach a casualty.

1855–6 A new wooded lifeboat house, measuring 38ft by 16ft, was built at a cost of £88 near the railway station.

1862–3 The boathouse was moved to Wherrytown, adjacent to the coastguard station. The formal opening, with the naming of the new lifeboat *Richard Lewis* by the RNLI

Secretary of that name, took place on 10 September 1867.

1884 A new lifeboat house was built at the foot of Jennings Street, facing the tidal harbour, into which the boat could be launched from the Abbey slipway; built by Perkins & Caldwell, it cost £575 6*s* 6*d*, funded from the gift of Henry Martin Harvey, JP, of Launceston.

1885 The building was formally opened on 11 February, and housed a new 34ft self-righter, *Dora* (ON.49).

1899 The 38ft Watson sailing lifeboat *Elizabeth and Blanche* (ON.424), the second boat of that name, was placed on station in July.

1908 *Elizabeth and Blanche* was moved to Newlyn, and Penzance was served by two second-hand lifeboats to 1917.

1917 The station was closed and the last lifeboat, the 34ft self-righter *Janet Hoyle* (ON.386), was withdrawn.

above The boathouse built in 1884 and used until the lifeboat was withdrawn in 1917. It was sold to Penzance Town Council for £200, and towards the end of the twentieth century was in use as an RNLI Display Centre, with some illustrations and paintings inside. It later became the Old Lifeboat House Bistro restaurant.

below The date roundel above the main door of the lifeboat house. The other roundel is inscribed 'RNLBI'.

Penlee

Key dates

Opened 1908–13 (Newlyn), 1913–83 (Penlee
 Point), moved to Newlyn 1983
RNLI 1908
Motor lifeboat 1922
Fast lifeboat 1983
Inshore lifeboat 2001

Current lifeboats

ALB 17m Severn
ON.1265 (17-36) Ivan Ellen
Built 2002
Donor Legacy of Harold *Ivan Leech*
On station 15.3.2003
Launch Afloat

ILB Atlantic 75
B-787 Paul Alexander
Donor Mr and Mrs Richard Archer
On station 16.8.2002
Launch Tractor and do-do carriage

Station honours

Framed Letter of Thanks	2
Thanks of the Institution on Vellum	1
Bronze medals	11
Silver medals	1
Gold medals	1

right The 38ft Watson sailing lifeboat
Elizabeth and Blanche (ON.424) on her
carriage and under a tarpaulin at Newlyn,
from where she was operated between
1908 and 1913 having been built for
Penzance. The harbour at Newlyn was
completed in the late nineteenth century
with its entrance facing north-east across
Mount's Bay, making it very sheltered in
almost all weathers.

opposite 17m Severn Ivan Ellen
(ON.1265) on exercise in Mount's Bay.

1908 The lifeboat *Elizabeth and Blanche*
(ON.424) was moved from Penzance to
Newlyn harbour, where she was kept
on her carriage in the open protected
by a heavy canvas, on the foreshore
beneath the Fisherman's Arms.

1912-3 A new lifeboat house and roller
slipway were built at Penlee Point,
just to the north of the small village
of Mousehole, at a cost of £3,326, and
Elizabeth and Blanche was moved there
from Newlyn in September, at which
point operations transferred to the new
Penlee station.

1922 The first motor lifeboat, the 45ft
Watson *The Brothers* (ON.671), was

placed on station in December.

1931 A Centenary Vellum was presented
by Mrs Molyneux Favell on 15 August
during the inaugural ceremony of the
new 45ft 6in Watson motor lifeboat
W. and S. (ON.736), which arrived in
June, and the vellum was received by
Alderman Charles Tregaga, JP, CC.

1954 An Anniversary Vellum, marking
150 years of service of the station, was
presented on 12 March by Lady Tedder
to Coxswain Edwin Madron.

1960 The lifeboat house was adapted
to house the new 47ft Watson type
lifeboat *Solomon Browne* (ON.954).

1963 A new winch engine was installed

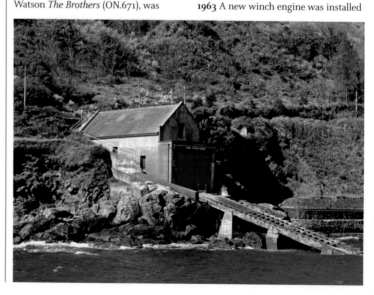

right The lifeboat house and slipway at
Penlee Point, built in 1912–3 and used until
the 1980s, still maintained by the RNLI.

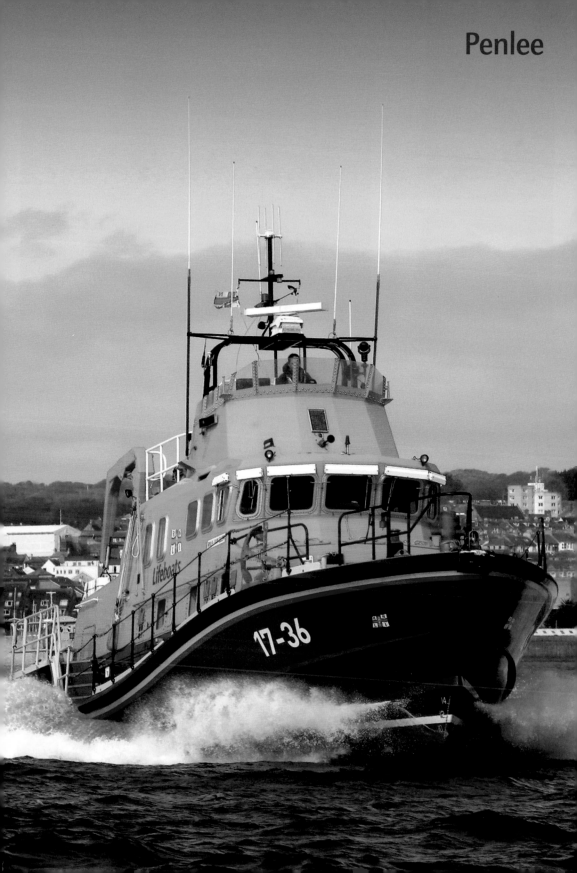

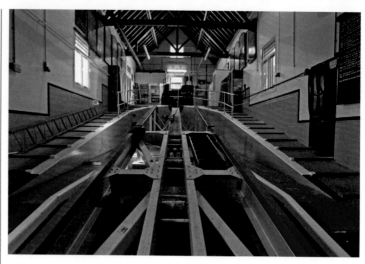

above Inside the now empty lifeboat house at Penlee Point, with the original winch and platform as it was (right), with a reminder of the lifeboat Solomon Browne (top) and the service boards (above).

below The memorials to the eight lifeboat men lost in Solomon Browne in December 1981: a memorial garden was created outside the lifeboat house at Penlee Point (below), with a stone tablet on which the names of those lost are inscribed (bottom); a wooden table made from the lifeboat's remains is in Mousehole Methodist Chapel (right); in Paul church is a stone memorial with a plaque on the front (far right).

in the lifeboat house.

1979 A special framed certificate awarded to the coxswain and crew in recognition of their services in connection with numerous yachts which got in difficulties during the Fastnet Race on 16 August.

1981 The lifeboat *Solomon Browne* was wrecked on service to the coaster *Union Star* on 19 December with the loss of all eight of her crew, as well as the eight crew from the coaster.

1982 A series of temporary Watson lifeboats served from the boathouse in the aftermath of the disaster, including

the former St Mary's lifeboat *Guy and Clare Hunter* (ON.926), while the station's operations were transferred to a new berth in Newlyn harbour.

1983-4 A berth was dredged in Newlyn harbour for the new 52ft Arun lifeboat *Mabel Alice* (ON.1085), and moorings were taken up on 8 May; an assembly room was constructed, providing a crew room, workshop, store and toilet.

1985 Penzance Town Council decided to create a Memorial Garden, which was built on land adjacent to the boathouse at Penlee Point. The garden was designed by S. Lee, Senior Architect of

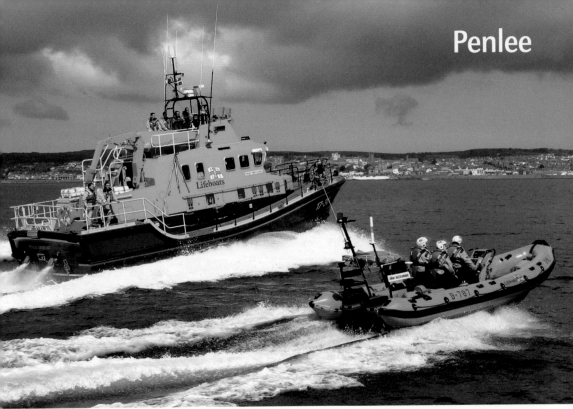

British Airways, and was built by the Springboard Youth Training Scheme. The centrepiece of the garden was a stainless steel memorial plaque given by the Port Talbot Branch of the RNLI, while the boathouse was maintained as it was when operational. Various other memorials were created, with one in Paul church and another in Mousehole Methodist Chapel.

2001 An inshore lifeboat was based at Newlyn, taking over from the Marazion station at St Michael's Mount, which was closed, and a boathouse was built in Newlyn harbour for the Atlantic 75 and its launching rig and tractor.

2003 A new pontoon was installed, funded by the legacy of the late Harold Lane-Fox, to improve boarding arrangements for new 17m Severn

above 17m Severn Ivan Ellen (ON.1265) and Atlantic 75 Paul Alexander (B-787)

below left 17m Severn Ivan Ellen (ON.1265) passing St Michael's Mount.

below/bottom The crew facility built in 1983 when the station's operations were transferred to Newlyn harbour.

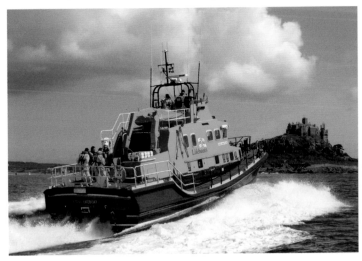

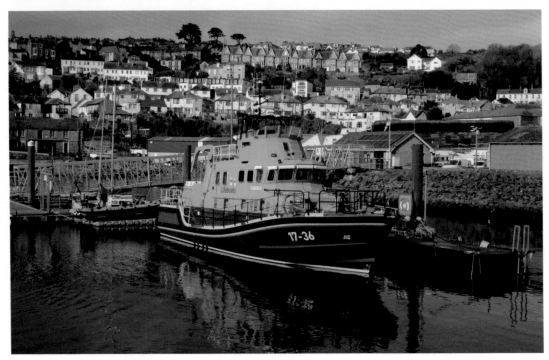

above 17m Severn Ivan Ellen (ON.1265) at moorings in Newlyn harbour.

below right Atlantic 75 Paul Alexander (B-787) on exercise in Mount's Bay.

below Relief Atlantic 75 Duckhams 2001 (B-773) in the Versadock berth.

bottom The ILB house used for the Atlantic when it was launched by tractor and carriage between 2001 and 2013.

lifeboat *Ivan Ellen* (ON.1265), which arrived in March.

2006 The harbour was developed with new pontoons installed, and so a new lifeboat pontoon was provided.

2013 A floating Versadock was provided for the Atlantic 75, enabling the ILB to be launched more easily and be available at all states of the tide; the

launching tractor was withdrawn, and the ILB house was vacated.

2015 An appeal was launched to fund a new and larger crew facility to replace the 1983 facility, which had no training room or proper changing room. The new building has a visitor experience, changing facilities, workshop and first floor crew and training rooms.

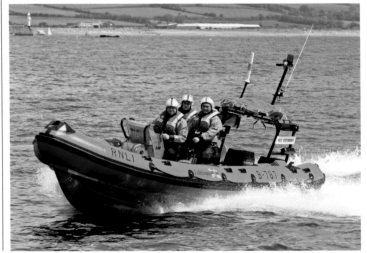

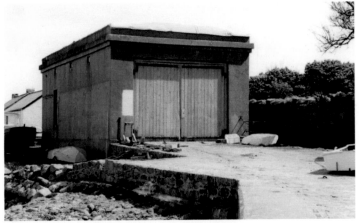

Key dates

Opened	1890
RNLI	1890
Closed	1920

Station honours

Silver medals	1

left The lifeboat house at Perigilis Bay, as rebuilt in 1902–3, was used until 1920. It housed the station's last two lifeboats, both of which were named Charles Deere James and funded from the gift of Mrs S.C. Guthrie, Tunbridge Wells.

below The first Charles Deere James (ON.516), a 38ft Liverpool type lifeboat which served at St Agnes from 1904 to 1909, outside the boathouse on the bogie carriage which was supplied in 1902–3.

1889 The RNLI decided to establish a lifeboat station on St Agnes to improve lifesaving coverage around the Scillies. Up until then, local men had preferred to use their gigs, but in April 1889 an inspector again visited the island and locals said they wanted a lifeboat.

1890 A lifeboat house and launchway were built at Perigilis Bay at a cost of £988 18s 2d on a site granted by Mr Dorrien-Smith; a 34ft self-righter, named *James and Caroline* (ON.275), was placed on station in August.

1902–3 To overcome problems with launching the lifeboat, as horses were not available from 1901, the boathouse was rebuilt and a launchway was constructed, measuring 1,068ft, which made it the longest in use by the RNLI. The lifeboat was mounted on a bogie carriage, which ran on rails down the launchway to the sea. Two launchways were built, one for use at high water and the longer one for low water. The cost of the improvements was £4,945.

1920 The station was closed following the placing of a motor lifeboat at St Mary's; obtaining a crew had become difficult and extensive repairs were required to the slipway. The last lifeboat, *Charles Deere James* (ON.590), a 38ft Watson sailing lifeboat which had been placed on station in July 1909, was withdrawn in the spring.

left The lifeboat station at Perigilis Bay, on the west side of the island, with the historic lighthouse, the island's most notable landmark which dates from the seventeenth century. Three lifeboats were stationed at St Agnes, and during the thirty years of the station's existence the crews launched on service thirty-four times and saved 206 lives.

below The foundations of the two slipways, which were built in 1902–3, remain largely intact, and have been used to launch local boats, while the house has been used as a store.

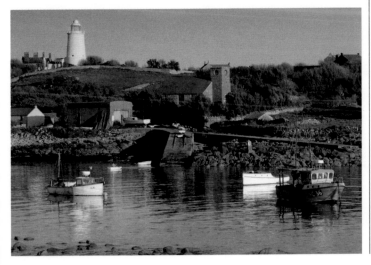

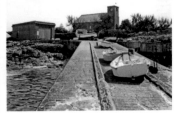

St Mary's (Scilly)

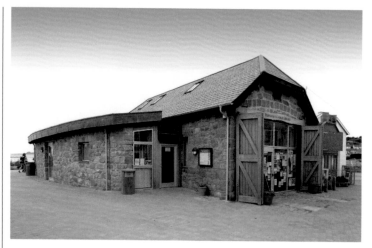

Key dates
Opened 1837–39, 1840–55 and 1874
RNLI 1837
Motor lifeboat 1919

Current lifeboats
ALB 17m Severn
ON.1229 (17-11) The Whiteheads
Built 1997
Donor Bequest of Miss Olive Elsie Whitehead,
Newquay, Cornwall
On station 1.12.1997
Launch Afloat

Station honours
Framed Letter of Thanks	1
Thanks of the Institution on Vellum	29
Bronze medals	16
Silver medals	9
Gold medals	1

right The lifeboat house built at Porthcressa in 1874, with the main doors facing away from the beach. It has been converted into the Porthcressa library.

below The lifeboat house and slipway built in 1899 at Carn Thomas, used for the lifeboat until 1981 and then for the wooden motor boarding boat.

1837 A letter from Captain Steel was sent to the RNIPLS in May requesting a lifeboat be supplied to St Mary's. The former Brighton lifeboat, a 26ft non-self-righter built by William Plenty, was transferred to the islands in September; it was the first of two Plenty-built lifeboats to serve at St Mary's, both provided by the RNIPLS, and both kept in a boathouse which cost £59 to build on the Town Beach at Hugh Town; the first boat was broken up in 1839.

1840 The second boat arrived, and lasted for fifteen years, but like the first boat did not save any lives.

1855 The station was closed in June and the lifeboat was sold locally.

1874 The station was reopened by the RNLI following two significant shipwrecks in the area in 1870.

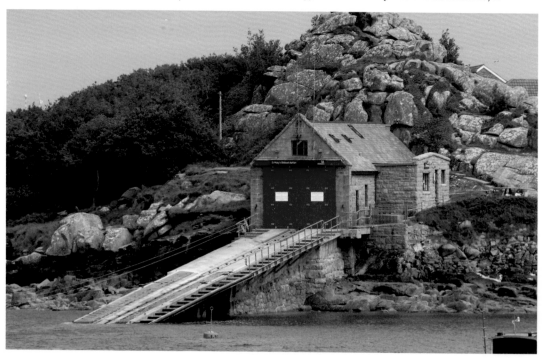

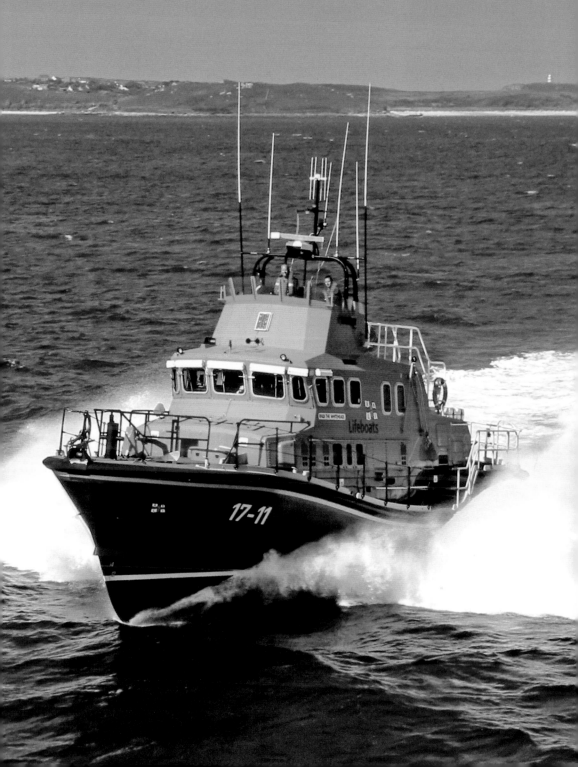

17m Severn The Whiteheads (ON.1229)
heading back to St Mary's.

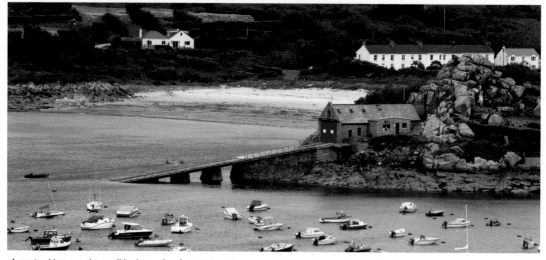

above Looking over the small harbour of Hugh Town towards Carn Thomas and the lifeboat house and slipway built in 1899. Just off the slipway, to the far left, can be seen the inflatable boarding boat used by the full-time mechanic to go to the lifeboat.

below 17m Severn The Whiteheads (ON.1229) at her moorings.

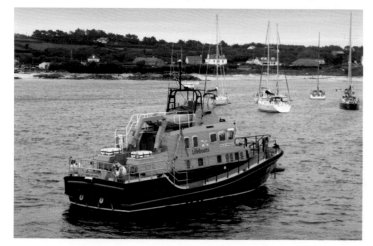

A lifeboat house was built on the beach at Porthcressa at a cost of £316 11s 0d on a site given by local landowner T.A. Dorrien-Smith. The 37ft twelve-oared self-righting lifeboat *Henry Dundas* arrived on station in August.

1890 The 42ft self-righting type lifeboat *Henry Dundas* (ON.271), one of the largest self-righters in the RNLI fleet, was sent to the station; it was kept afloat on moorings in St Mary's harbour as it was too large to be launched from the beach. However, the boat was not liked by the crew and was only used once on service.

1891 A smaller lifeboat, the 38ft self-righter *Henry Dundas* (ON.313), was sent to the station; it was carriage launched, but this was a long and difficult operation requiring many helpers, in addition to the crew.

1892 Moorings were again taken up in the harbour as up to thirty shore helpers had been required to get her afloat from her carriage; the lifeboat went back into the boathouse during the summer months.

1899–1900 A new lifeboat house with a slipway were built at a cost of £1,607 19s 9d at Carn Thomas, on the east side of the harbour to improve the launching arrangements. In December 1899 a new lifeboat, the 38ft Watson sailing lifeboat *Henry Dundas* (ON.434), the fourth to be so named, arrived.

1902 The slipway was lengthened by 40ft at a cost of £165.

1913-15 The lifeboat house was adapted and largely rebuilt for a new motor lifeboat, at a cost of £3,155.

1919 The station's first motor lifeboat, the 45ft Watson *Elsie* (ON.648), arrived at the station in October, and went on to serve for eleven years.

1937 A Centenary Vellum was awarded to the station, presented on 9 August.

1955 The lifeboat house was altered

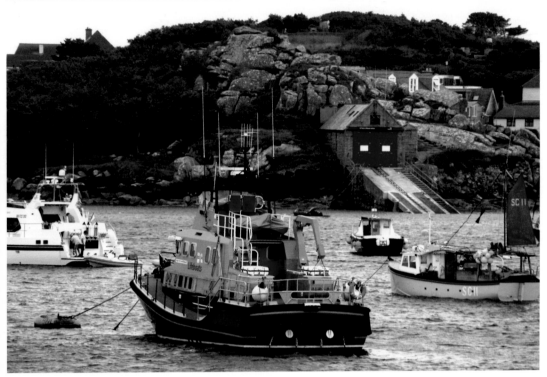

for a new lifeboat, the 46ft 9in Watson motor *Guy and Clare Hunter* (ON.926).

1960 The lifeboat house was adapted to accommodate the lifeboat after it was fitted with a wheelhouse.

1987 A 150th Anniversary Vellum was presented to the station.

1981 Moorings in the harbour were taken up for a fast afloat lifeboat, the

52ft Arun *Robert Edgar* (ON.1073), which arrived on station in June. The boathouse was converted into a crew facility and office, and was also used for housing the boarding boat, with the alterations being funded by a gift from Mrs Marion Acatos.

2010 Repairs were made to the slipway used by the wooden boarding boat.

above 17m Severn The Whiteheads (ON.1229) at moorings in St Mary's harbour, with the lifeboat house at Carn Thomas in the background.

below left The boarding boat BB-243 inside the lifeboat house; the boat is launched down the slipway.

below Looking up the slipway towards the lifeboat house and boarding boat.

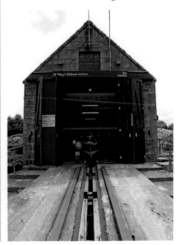

Sennen Cove

Key dates

Opened	1853
RNLI	1853
Motor lifeboat	1922
Fastlifeboat	1991
Inshore lifeboat	1994

Current lifeboats

ALB 16m Tamar
ON.1294 (16-14) City of London III
Built 2009
Donor The City of London Branch
On station 8.1.2010
Launch Slipway

ILB D class inflatable
D-763 Amy Brown
Donor Legacy of Michael Walton Brown
On station 28.11.2013
Launch Trolley and Tooltrak vehicle

Station honours

Thanks of the Institution on Vellum	6
Bronze medals	17
Silver medals	8

above right The lifeboat house of 1875, now heavily altered, in use as a gift shop.

opposite The spectacular sight of 16m Tamar City of London III (ON.1294) being launched down the slipway. (Tim Stevens)

below The lifeboat house and slipway built in 1927–29, considerably modified since, being rebuilt and enlarged in 2000–01 and in 2009 for the 16m Tamar.

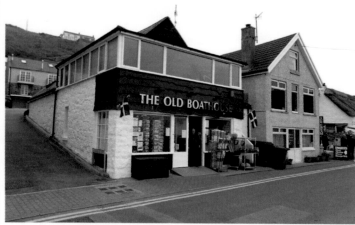

1851 Following the wreck of the snow *New Commercial*, of Whitby, near Cape Cornwall, steps were taken to establish a lifeboat station to cover Land's End.

1852–3 A lifeboat house was built at the head of the beach, and a 25ft 8in self-righting lifeboat arrived in June 1853.

1864 The boathouse was rebuilt at a cost of £80 5s 0d to accommodate a new lifeboat, the 32ft self-righter *Cousins William and Mary Ann of Bideford*.

1875 A new lifeboat house was built at a cost of £275 on the landward side of the cove road; it was used until 1896

during which time the lifeboats were carriage launched.

1896 A new lifeboat house was completed on the site of the original boathouse of 1852, with a slipway and separate carriage house, at a cost of £1,680, with a further £325 for the roadway to Whitsand Bay.

1919–22 A new slipway was constructed in readiness for a new motor lifeboat then under construction.

1922 The stations first motor lifeboat, the 40ft self-righter *The Newbons* (ON674), arrived in May and was

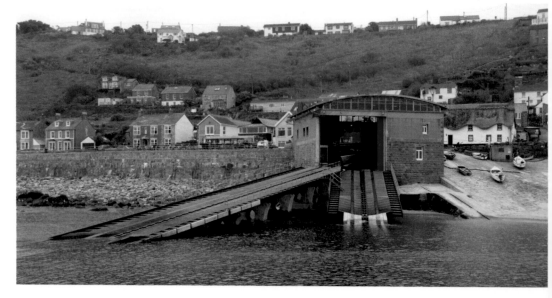

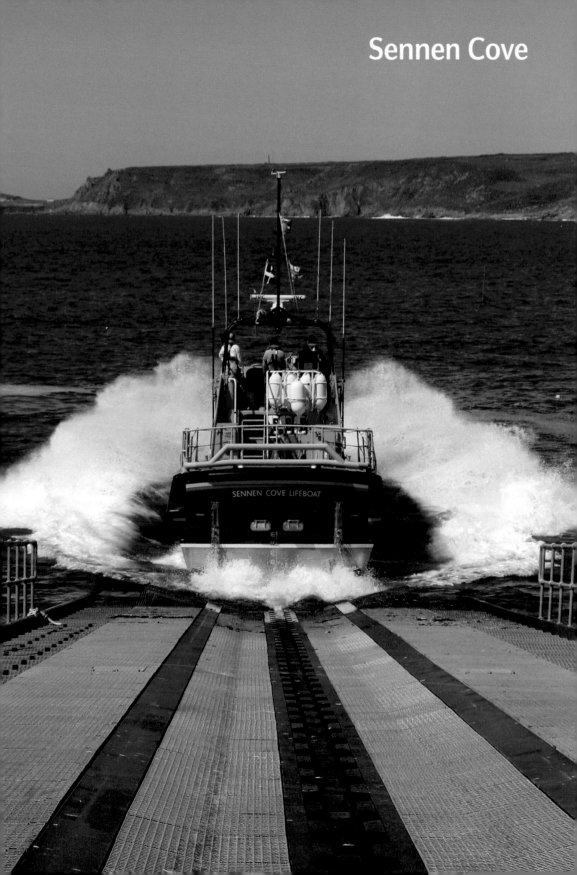

Sennen Cove

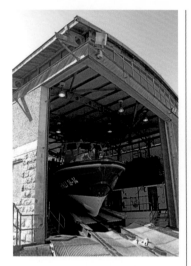

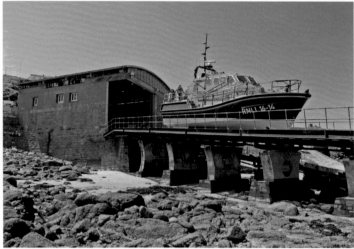

above 16m Tamar City of London III (ON.1294), on the cradle at the head of the long slipway, inside the lifeboat house.

above right Recovery of 16m Tamar City of London III (ON.1294) up the long slipway; the unique set-up at Sennen Cove, with two slipways, is necessary to enable recovery of the lifeboat at all states of the tide and in all sea states.

below 16m Tamar City of London III (ON.1294) at sea following her naming ceremony on 24 April 2010.

launched by trolley down the slipway.

1927–9 The lifeboat house was extensively altered with two slipways being built to provide a unique launch and recovery system; originally the lifeboat was recovered up one slipway bow first, then turned on a turntable inside the boathouse and made ready for a launch down the other slipway.

1972 Major work was carried out to adapt the lifeboat house and slipway

to accommodate the 37ft 6in Rother Diana White (ON.999), which arrived on station in November 1973.

1991 The two slipways were virtually rebuilt in readiness for the new 12m Mersey The Four Boys (ON.1176), which was placed on station on 5 December.

1994 An inshore lifeboat station was established in February on a summer only basis; the ILB was launched by trolley, either over the beach or down

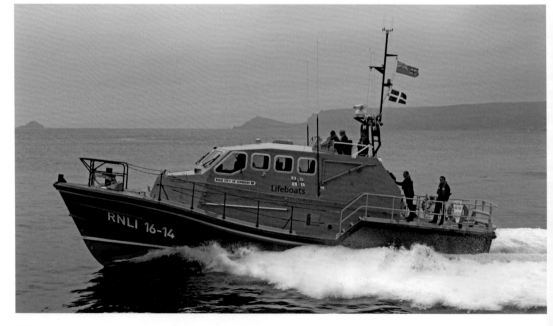

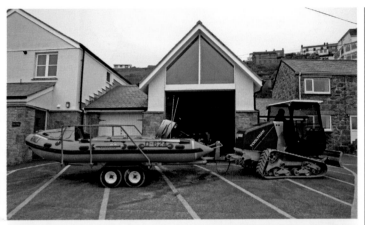

left D class inflatable Spirit of the RLC (D-624) being rehoused in the ILB house completed in 2008 behind the lifeboat house. The small tracked Tooltrak vehicle, sent to the station in 2010 to make launching the ILB easier, was developed by the RNLI in partnership with Loglogic of Collumpton and is used at a number of lifeboat stations in the south-west.

left D class inflatable Amy Brown (D-763) being launched by Tooltrack vehicle TT03 on 17 May 2014 at the end of her naming ceremony. (Paul Richards)

the slipway, and recovered up the beach using a winch and later a Land Rover.

1997 A new launch slipway was created down the longer of the two slipways to improve launching at low water, and the system of recovering the lifeboat bow first was abandoned.

2000–1 The lifeboat house roof was raised and replaced, new doors were fitted, improved crew facilities were provided and the house was adapted in readiness for the next generation of fast slipway lifeboat, a tipping cradle installed at the head of the slipway.

2008 A new inshore lifeboat house, together with a house for the mechanic, was completed in May at a cost of £273,000 behind the lifeboat house.

2009–10 The slipway was rebuilt for 16m Tamar lifeboat, and the lifeboat house was modified with a hydraulic tipping cradle installed, which also included the lowering of the floor and upgrading of winches.

below D class inflatable Amy Brown (D-763) ready for the surf conditions off Sennen Cove. (Tim Stevens)

St Ives

Current lifeboats

ALB 13m Shannon
ON.1318 (13-11) Nora Stachura
Built 2015
Donor Bequest of Nora Stachura, Swindon, who passed away in December 2008
On station 11.2015
Launch Supacat and carriage

ILB D class inflatable
D-668 Colin Bramley Parker
Donor Gift of Miss Diane Saxon in memory of Mr Colin Parker
On station 5.2.2007
Launch Trolley and Tooltrak

Station honours

Framed Letter of Thanks	6
Thanks Inscribed on Vellum	13
Bronze medals	20
Silver medals	18

above right The lifeboat house built in 1860 and used until 1867 as it is today.

below The lifeboat house rebuilt in 1911 in the south-west corner of the harbour.

below right The same lifeboat house was used until 1993 and has since been converted into a restaurant.

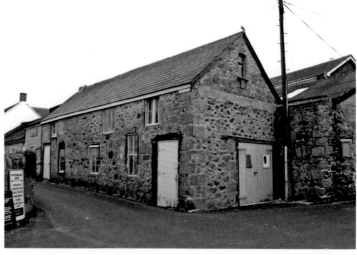

1840 The first St Ives lifeboat, built by Francis Adams of St Ives, was operated under the auspices of a local committee, who raised £50 locally with the remainder coming from the RNIPLS; the 30ft non-self-righting lifeboat, named *Hope*, was kept in a shed 400 yards from high water mark, but by 1860 was no longer serviceable having been neglected for many years.

1860–1 The RNLI took over the station, a lifeboat house was built in Island Road and a new 30ft Peake self-righter was supplied; the house was used until 1867 as it proved difficult to get the lifeboat out of it due to the narrow streets that had to be negotiated to launch. This first boathouse, located near Porthgwidden Beach, was later used as a joinery workshop and store.

1867 A new lifeboat house was built on Market Strand on the site of a vacant cellar, which was demolished; this house, which cost £190 in total, was altered and modified a number of times as the harbour developed. A series of pulling and sailing self-righting lifeboats served the station until 1932, being launched by carriage from several local beaches as well as farther afield.

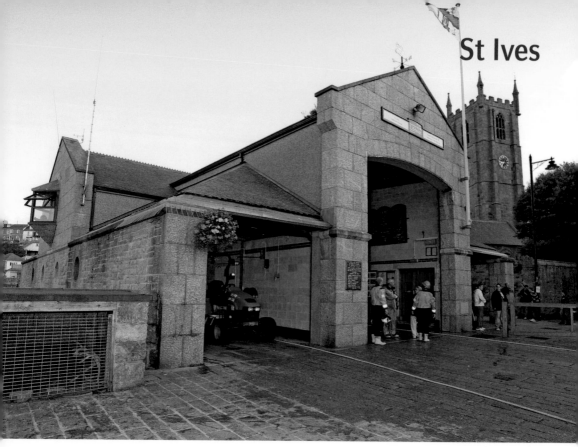

1879 The boathouse, described as 'a larger one than usual', was lined with wood at a cost of £46.

1890 A new slipway was built by Land & Son at a cost of £70, and a hauling-up winch was also installed.

1911 The 1867 boathouse was rebuilt on the quay, in the south-west corner of the harbour, at a cost of £361 6s 5d.

1933 The station's first motor lifeboat, the single-engined 35ft 6in self-righter *Caroline Parsons* (ON.763), was placed on station in March.

1938 On 31 January, after the lifeboat *Caroline Parsons* had rescued the twenty-three crew from the steamer *Alba*, she was capsized by a large sea. Five of *Alba's* crew drowned, but Coxswain Thomas Cocking and his eight crew scrambled ashore, although the lifeboat was wrecked. This was the first time a motor lifeboat had capsized.

1939 On 23 January the lifeboat *John and Sarah Eliza Stych* (ON.743),

Caroline Parsons' replacement the previous year, launched in a violent gale to the aid of an unknown vessel. The lifeboat capsized three times north of Clodgy Point and seven of the eight lifeboat men on board were drowned. Within twelve months two lifeboats and twelve lives had been lost, an event

above The lifeboat house built in 1993–4 for the 12m Mersey class lifeboat and D class inshore lifeboat, pictured before it had been altered for the 13m Shannon.

below 13m Shannon Nora Stachura (ON.1318) on passage to her station, November 2015. She was the first Shannon class lifeboat to serve in Cornwall. (Martin Fish)

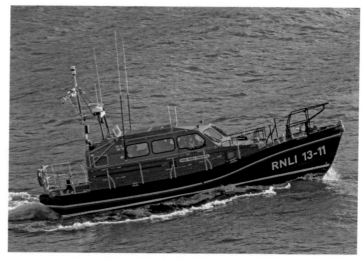

St Ives

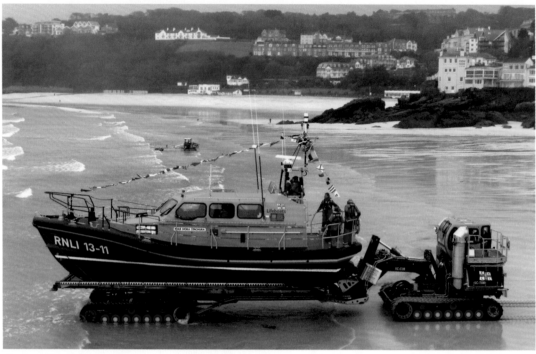

above First launch of 13m Shannon Nora Stachura (ON.1318) after her arrival on station, 14 November 2015.

opposite 13m Shannon Nora Stachura (ON.1318) approaching the beach.

below right Lifeboat crew, volunteers and station officials with the 13m Shannon Nora Stachura (ON.1318) on the day the boat arrived at St Ives, 14 November 2015.

below The plaque on the lifeboat house in memory of the lifeboat men lost in 1939.

unparalleled in the history of the RNLI.

1946 A Centenary Vellum was awarded.

1963 An inshore lifeboat supplied on temporary duty in connection with the St Ives Life Saving Association

1964 The ILB station was permanently established in April; the ILB was kept in a small boathouse at the Sloop car park, off Fish Hill.

1981 A new Marley house was built for the ILB to replace the old timber house.

1987 The ILB house was extended to accommodate twin-engined C class ILB C-516 and launching tractor.

1993 A new 'Penza' lifeboat house was constructed at the landward end of West Pier, adjacent to the 1911 house; this accommodated the 12m Mersey

THIS TABLET WAS ERECTED BY
ALDERMAN W^M CRAZE
TO THE MEMORY OF THE CREW
OF THE ST IVES LIFEBOAT
(JOHN and SARAH ELIZA STYCH)
WHO LOST THEIR LIVES IN ST IVES BAY
WHILE GOING TO THE HELP OF OTHERS
IN DISTRESS.
JANUARY 23^RD 1939.
THOMAS COCKING (COXSWAIN)
MATTHEW S. BARBER
WILLIAM B. BARBER
JOHN THOMAS
RICHARD Q. STEVENS
JOHN B. COCKING
EDGAR BASSETT
GREATER LOVE HATH NO MAN
THAN THIS

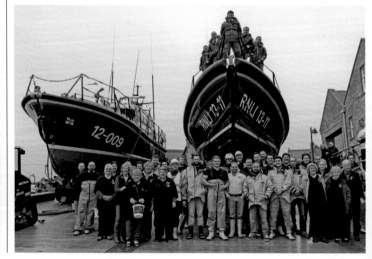

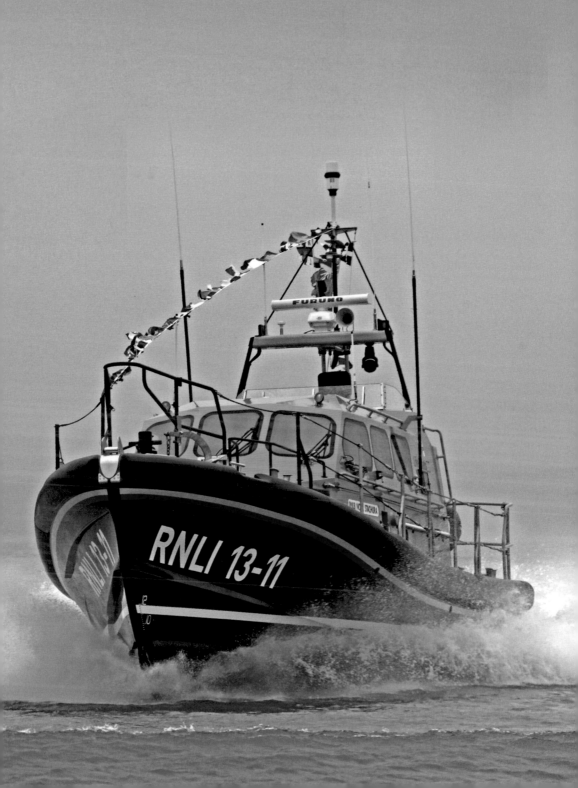

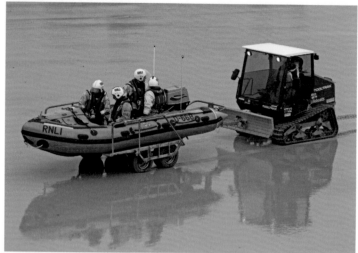

above Two photographs of the ILB house built in 1981, extended in 1987 and used until 1993; pictured when in service (top), and after the ILB had left (lower).

above right D class inflatable Colin Bramley Parker (D-668) being launched by the Tooltrak vehicle TT22.

right The 17ft 6in twin-engined C class inflatable Belsize Charitable Trust No.1 (C-516) served from 1986 to 1995.

below D class inflatable Colin Bramley Parker (D-668) in surf off the harbour.

class lifeboat *Princess Royal (Civil Service No.41)* (ON.1167), Talus MB-H launching tractor and D class inflatable ILB; a new launching slipway was also constructed. The house was formally opened on 16 July 1994.

2015 The lifeboat house was modified to accommodate the new 13m Shannon class lifeboat and its Supacat Launch & Recovery system. The work included widening the main doors, installing a new fuel tank, and updating the crew changing facilities. Repairs were also made to the seaward facing wall of the station. The work lasted twelve weeks, during which time the 12m Mersey lifeboat was kept on the slipway with temporary buildings used as crew facilities and storing equipment.

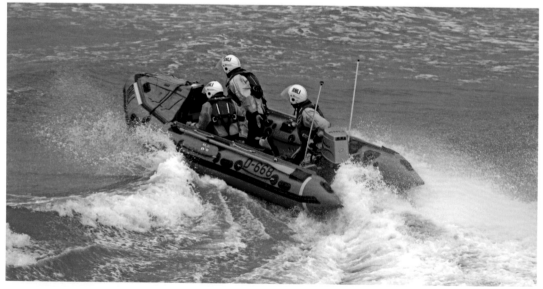

Hayle

Key dates

Opened	1866
RNLI	1866
Closed	1920

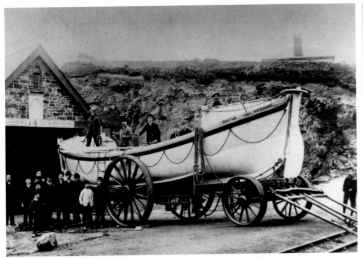

left The second Hayle lifeboat E.F. Harrison, which had been built in 1887 as New Oriental Bank but was renamed in 1892 after being appropriated to the gift of a donor after whom she was named. The 34ft self-righter is pictured on her launching carriage outside the original lifeboat house built in 1866.

1865 Following the loss of several ships on the Hayle bar, including *Providence* on 28 October 1865 and *Bessie* on 11 January 1866, the RNLI agreed to establish a station, with a lifeboat based there able to cover the area between Land's End and St Ives.

1966 The station was established and a lifeboat house was built for £166, in a quarry by the road leading from Copperhouse Creek, for the first lifeboat, the 32ft ten-oared self-righter *Isis*.

1897 A new and larger lifeboat house was built on the same site for £175.

1920 With the coastal trade declining at the port of Hayle, the RNLI decided to close the station and the last lifeboat,

Admiral Rodd (ON.567), built in 1906, was withdrawn. During the station's fifty-four-year existence, its lifeboats launched forty times on service and saved ninety-five lives. The boathouse was relocated onto the quay next to the river and used for many years by the local power station as a store.

1995 In July Justin Lee of BBC Radio Cornwall unveiled a plaque to Hayle's lifeboatmen which had been lost since the beginning of the century; it was restored to its rightful place after turning up in a local field having originally been presented to the RNLI in 1866 by Oxford University, which funded the station's first lifeboat.

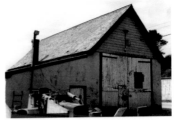

above/below Two photographs showing the lifeboat house built in 1897 as it was just before being demolished. It was located near to the power station, which was also demolished, with no trace left of the building. (Paul Richards)

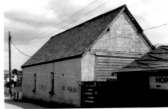

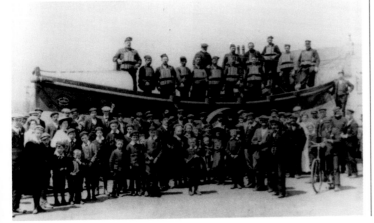

left The last lifeboat was Admiral Rodd (ON.567), a 36ft self-righter which spent fourteen years at Hayle and saved ten lives in thirteen service launches.

Key dates

Opened	1968
RNLI	1968
Inshore lifeboat	1968

Current lifeboats

ILB D class inflatable
D-787 XKalibur
Donor Jaguar Enthusiasts Club and
community fund-raising
On station 23.10.2015
Launch Trolley and Tooltrak vehicle

Station honours

Framed Letter of Thanks	2
Thanks Inscribed on Vellum	6
Silver medals	2

right The small ILB house at Trevaunance Cove, where the inshore lifeboats have been housed since the station was established in 1968, one of four stations supported by the *Blue Peter* TV Appeals. The building accommodates the ILB on her trolley and Tooltrak launch vehicle.

below D class inflatable Blue Peter IV (D-641) patrolling outside the surf line.

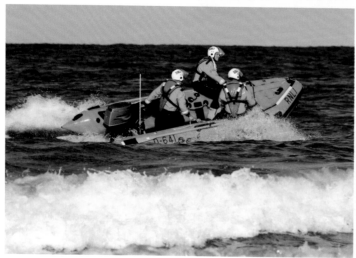

1967 The establishment of an inshore lifeboat station was proposed but was postponed because of difficulties in finding a suitable house.

1968 An inshore lifeboat station was established in April, initially as a summer-only station to deal with the incidents close to rocks or in shallow water between the adjacent St Ives and Newquay stations. The ILBs have all been provided by the BBC children's programme, *Blue Peter*, from money raised through successive appeals, and have been named *Blue Peter IV*. The ILB was kept in a small house on the road leading to the beach at Trevaunance

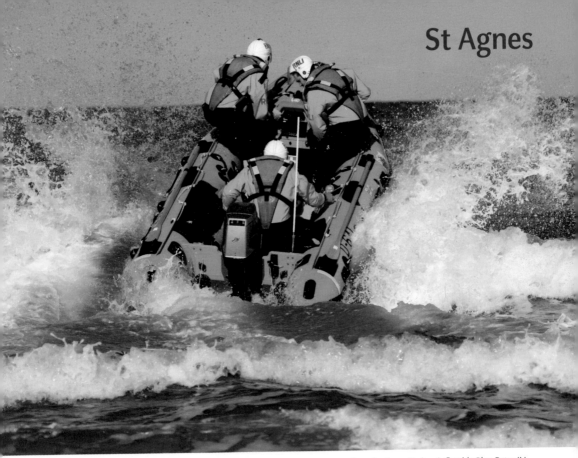

Cove, and is launched across the beach.

1985 A tractor house was built for a new launching vehicle.

1996 Due to increase in incidents, the ILB was placed on year-round service, rather than summer only operation.

2002 The ILB was adapted for night time operations.

2003–4 The ILB house was renovated and a new shore building was provided. A small house at the top of the hill leading down to the small cove was acquired and renovated to provide improved crew facilities as well as a fundraising outlet; the new building was officially opened on 23 May 2004.

above D class inflatable Blue Peter IV (D-641) breaking through waves in surf conditions that are typical of the north Cornish coast.

left The house overlooking Trevaunance Cove which was renovated for use as crew facilities, offices and a shop. The renovation work took three months and, together with the refurbishment of the ILB house completed in August 2004, cost a total of about £450,000.

Newquay

Key dates

Opened	1860–1934, 1940–45 and 1965
RNLI	1860
Motor lifeboat	1940–45
Inshore lifeboat	1965, 2nd ILB 1994

Current lifeboats

ILB Atlantic 85
B-821 Gladys Mildred
Donor Bequest of Gladys Mildred Hay,
Saltash, Plymouth
On station 31.10.2007
Launch Tractor and do-do carriage

ILB D class inflatable
D-773 Enid Mary
Donor Bequest of Mrs Enid Mary May
On station 5.11.2014
Launch Trolley

Station honours

Framed Letter of Thanks	
Thanks Inscribed on Vellum	3
Bronze medals	7
Silver medals	1
	4

above right The lifeboat house in Fore Street built in 1860 and used until the 1890s. It has been used as a shop for many years but still has the shape of a boathouse.

opposite The lifeboat house built in 1899 on Towan Head, used until 1934.

below The slipway built in 1895 at Towan Head, to make launching easier.

below right The lifeboat house adjacent to the steep slipway built on Towan Head, to the east of the harbour.

1860 A lifeboat station was established at the request of the local coastguard commander, after local coastguards had performed a number of life-saving services. A lifeboat house was built on Fore Street, in the middle of the town, at a cost of £133; the first lifeboat was a small 30ft six-oared self-righter named *Joshua* which served until 1865. In order to be launched, she was taken by carriage to the beaches either to the west or east of the harbour entrance; this house was used until 1899.

1868 The lifeboat capsized on exercise in December, without loss of life.

1895 A slipway was built at Towan Head to enable a direct launch into the sea if possible, rather than launching by carriage from the beach. The slipway, with a gradient of one to two and a half, was one of the steepest lifeboat slipways in the country, making a recovery up it impossible. Instead, the lifeboat was recovered on the beach and taken on her carriage by road back up to the boathouse.

1899 A new lifeboat house was built on Towan Head, opposite the slipway, at a cost of £903 14s 7d; a carriage was still used and the lifeboat could thus be

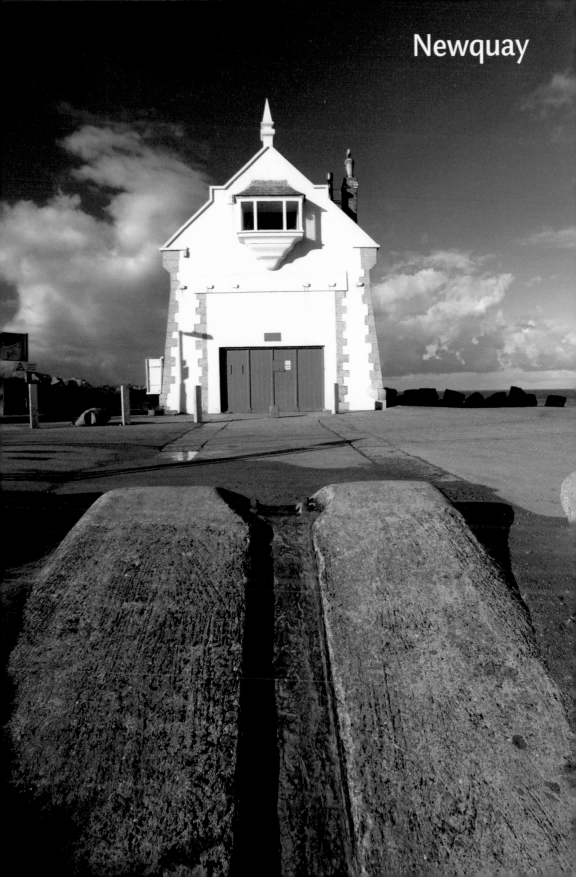

Newquay

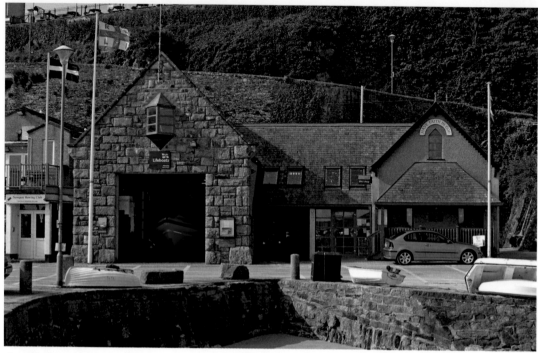

above The lifeboat house built in the harbour in 1994 on the site of the previous ILB house. It houses both inshore lifeboats and crew facilities, which include a drying/changing room and toilet, and there is a souvenir sales outlet.

opposite Atlantic 85 Gladys Mildred (B-821) being put through her paces on 20 April 2008 after her naming and dedication ceremony. (Tim Stevens)

right Atlantic 85 Gladys Mildred (B-821) being launched off Towan Beach by Talus 4WH tractor TW25H.

below Atlantic 85 Gladys Mildred (B-821) returning to station after exercise.

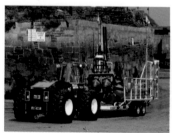

taken further afield if necessary. A new lifeboat, the 35ft ten-oared self-righter *James Stevens No.5* (ON.426), was placed on station in December.

1908 Returning from exercise on 6 March, *James Stevens No.5* capsized twice and all the crew, including the RNLI's district inspector, were thrown into the sea. During the second capsize, all regained the boat except Harry Storey who died from shock; the RNLI's committee of management voted £205 to local funds.

1917 *James Stevens No.5* was wrecked on 17 December on service to steamship *Osten*, of Denmark. The 1900-built self-righter *John William Dudley* (ON.453) was sent to replace the wrecked boat.

1934 The station was closed as horses were no longer available to help recover the lifeboat, *Admiral Sir George Back* (ON.509), which had come to the station in 1920 but performed no service during her fourteen years at

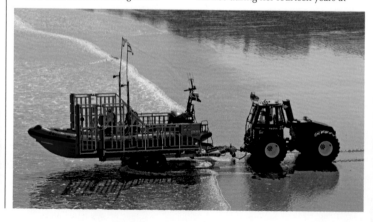

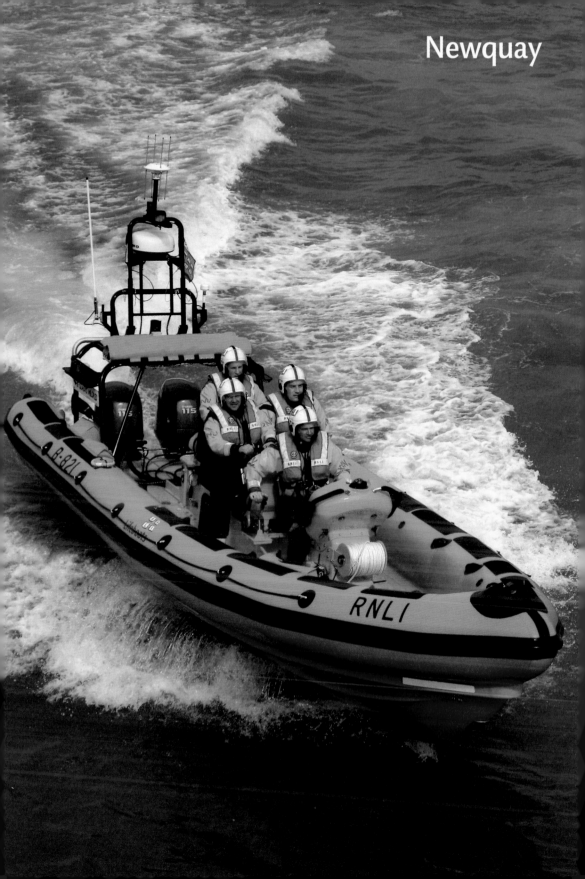

Newquay

above D class inflatable Enid Mary (D-773) being put through her paces in the surf off Towan Beach, adjacent to the harbour.

below D class inflatable Enid Mary (D-773) being recovered up Harbour Beach.

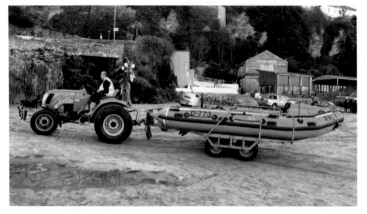

Newquay. The house and slipway at Towan Head have remained virtually unaltered; the house was used by the local council with much of the original items inside, and has a plaque above the main door identifying its origins.

1940 The station was reopened in March as a temporary wartime measure and the 35ft 6in Liverpool motor lifeboat *Richard Silver Oliver* (ON.794) was placed on station in March; she was kept on a carriage within the harbour precincts and was usually launched into the harbour.

1945 When the war ended, the station was closed and *Richard Silver Oliver* was withdrawn in June.

1965 An inshore lifeboat station was established in June; the D class inflatable ILB was kept in a house erected in the harbour.

1974 A new and larger ILB house was built in the harbour, on the same site as previous house.

1983 The station was upgraded when the D class inflatable ILB was withdrawn on 14 December and replaced by twin-engined C class inshore lifeboat C-511.

1994 The 1974 ILB house and old Seaman's Mission buildings were demolished and a new joint ILB house and Seaman's Mission building was constructed in the harbour on ths same site. The station was upgraded to operate two ILBs, with the new boathouse housing Atlantic and D class ILBs and their launching vehicles.

1995 The relief Atlantic 21 *Lions International* (B-539), arrived in February, replaced by the station's one Atlantic 75 *Phyllis* (B-715) in August.

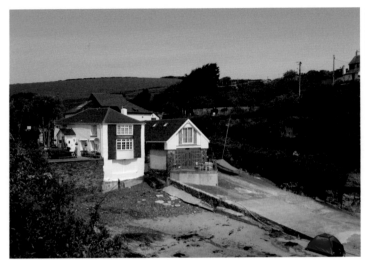

Key dates

Opened	1827
RNLI	1856
Motor lifeboat	1929
Steam	1899–1900
Steam tug and lifeboat	1901–29

Current lifeboats

ALB 16m Tamar
ON.1283 (16-04) Spirit of Padstow
Built 2005
Donor Gift of the late Mis Mickie Allen
On station 17.7.2006
Launch Slipway

Station honours

Framed Letter of Thanks	1
Thanks Inscribed on Vellum	1
Bronze medals	2
Silver medals	28

1827 The first lifeboat, a 23ft non-self-righter built locally and named *Mariner's Friend*, was funded by a local committee and was kept on the quay.

1829 The lifeboat was moved into a boathouse at Hawker's Cove, to the west of Padstow, and a newly founded body, the Padstow Harbour Association, took over the boat's running.

1856 The RNLI took over the station and supplied a new lifeboat, the 30ft self-righter *Albert Edward*,

1863–4 A new lifeboat house was built at Hawker's Cove at a cost of £152 1s 0d alongside the boathouse used by the first lifeboat; this boathouse was for a larger 32ft self-righting lifeboat named *Albert Edward*, which arrived in June 1864. A stone slipway down which the boat was launched was built for £120.

1883 A carriage house was built at Trethillick Lane at a cost of £299 5s 10d, about half a mile out of Padstow towards Hawker's Cove. It housed a launching carriage which was used when the lifeboat had to be taken further afield for launching

1899 The first lifeboat to be kept at moorings in the estuary was the 56ft 6in steam lifeboat *James Stevens No.4* (ON.421), which arrived in February.

1900 On service to the ketch *Peace and*

above left The site at Hawker's Cove from where the nineteenth-century lifeboats were operated. Little now remains of the original boathouse (on left), but the concrete base, keelway and launchway of the 1864 house built by the RNLI remain.

below The lifeboat house and roller slipway, built at Hawker's Cove in 1931, housed the No. 2 motor lifeboat *Bassett-Green* until 1962. It has since been converted into a private house and the slipway has been removed. (RNLI)

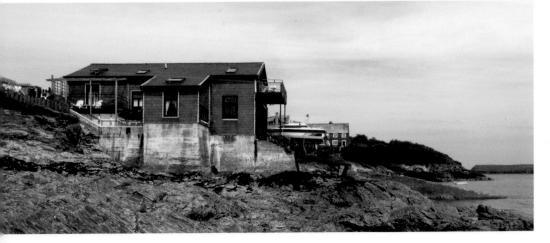

Padstow

above The lifeboat house and slipway at Trevose Head were built in 1965–67 and used until 2007. Major repairs were carried out to the substructures of both the boathouse and slipway in 1991.

opposite 16m Tamar Spirit of Padstow (ON.1283) launching from the lifeboat house at Trevose Head.

below 16m Tamar Spirit of Padstow on exercise off the north Cornish coast.

Plenty on 11 April, both the pulling lifeboat *Arab* (ON.51) and the steam lifeboats were lost, and eight crew from *James Stephens No.4* were drowned. The boat was completely wrecked.

1901 A unique steam tug and lifeboat arrangement was introduced, with the steam tug *Helen Peele* (ON.478) built specially to tow the 42ft self-righter *Edmund Harvey* (ON.475) out on service; the boats were operated from moorings with much success.

1905 The No. 2 lifeboat *Edmund Harvey* broke adrift from her moorings during a north-easterly gale and was stranded on the rocks, but was recovered, and remained in service until July 1929.

1929 A large motor lifeboat, the 61ft Barnett *Princess Mary* (ON.715), was sent to the station in July and was kept at moorings in the estuary, opposite the Hawker's Cove boathouses.

1931 A new lifeboat house and roller slipway were built at Hawker's Cove for a second motor lifeboat, the 35ft 6in self-righter *John and Sarah Eliza Stych* (ON.743); the slipway-launched lifeboats were designated the No. 2 boat in 1938, with the lifeboat at moorings becoming the No. 1 boat.

1955 The 25ft by 8ft wooden boarding boat *William Myatt* (BB.26, built 1931), larger than the standard wooden boarding boats, was supplied to the station, and served until 1965.

1962 By the early 1960s, siltification the estuary was preventing an efficient launch and so the No. 2 lifeboat, the 35ft 6in Liverpool motor *Bassett-Green* (ON.891), on station since 1951, was withdrawn in March. The boathouse was empty for a number of years, with the original blue enamel facia boards left over the doors and the original winch inside, but it has subsequently been converted into a private residence.

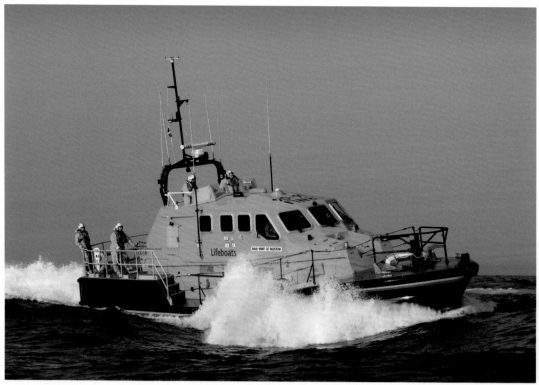

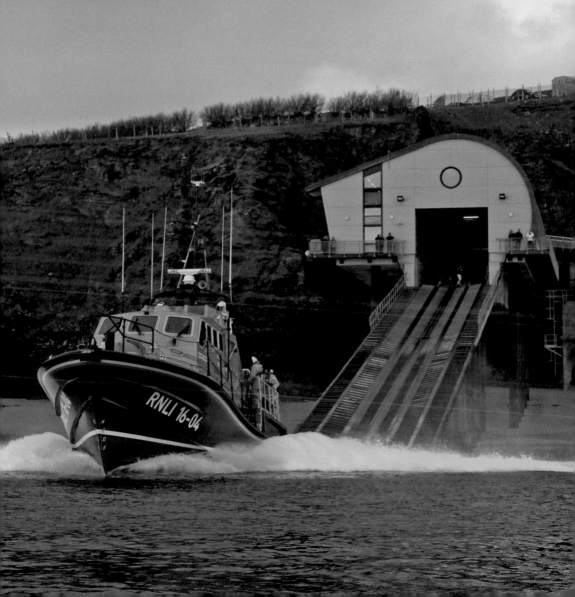

Padstow

above The memorial on the wall of Padstow church to the five lifeboat crew who lost their lives in February 1867, when the lifeboat Albert Edward capsized.

right The impressive memorial in Padstow cemetery erected by public subscription in memory of those who lost their lives in the steam lifeboat.

below When the station moved to Trevose Head in 1967, a shore facility was built in Padstow where the crew would meet and drive to the station. The original facility was rebuilt in about 2008, and the ground floor houses a Land Rover while the upper floor is rented out as a private residence.

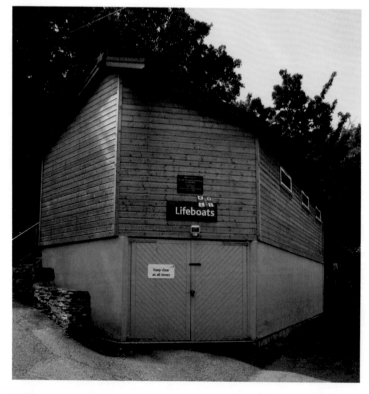

1965–67 A new lifeboat house and 240ft long slipway were built at Trevose Head, to the north of Padstow, at a cost of £114,000; a new road a quarter of a mile long, running from the coastguard station to the top of the cliff, was also constructed. The station was moved from the estuary in October 1967, when the new 48ft 6in Oakley *James and Catherine MacFarlane* (ON.989) was declared operational.

1984 The lifeboat house was adapted to accommodate the 47ft Tyne class *James Burrough* (ON.1094), which was placed on station on 28 December. The work on the boathouse included the installation of a new fuel storage tank and an exhaust ducting system in the boathouse. Improvements to the cliff lift were also carried out to enable it to carry a stretcher with a casualty and two attendants.

1991–92 Following serious deterioration of the substructures of both the boathouse and slipway, major concrete repairs were carried out between April 1991 and January 1992.

2005–06 A new lifeboat house and slipway were built for 16m Tamar class lifeboat *Spirit of Padstow* (ON1283) at Trevose Head, alongside the 1965 boathouse, which was demolished in 2006 after the new house had been completed. The new boathouse was completed on 6 July 2006 at a cost of £6,829,900 and the demolition of the old boathouse was completed on 6 September at a cost of £400,000.

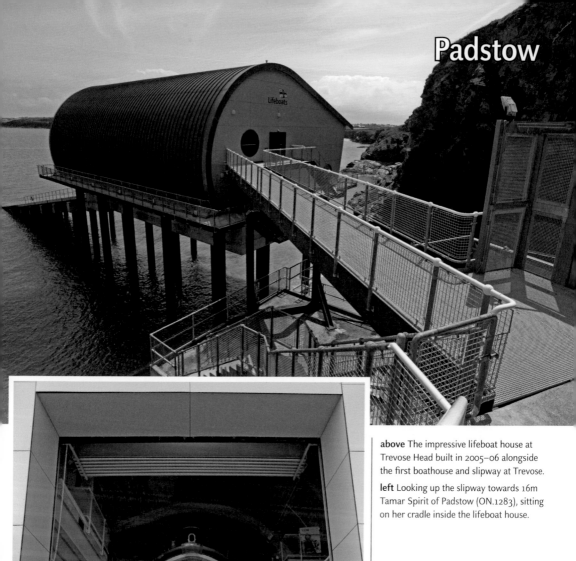

above The impressive lifeboat house at Trevose Head built in 2005–06 alongside the first boathouse and slipway at Trevose.

left Looking up the slipway towards 16m Tamar Spirit of Padstow (ON.1283), sitting on her cradle inside the lifeboat house.

below The 16m Tamar carries an inflatable Y boat, which is launched from the stern of the lifeboat and usually operated by a crew of two.

Rock

Key dates

Opened	1994
RNLI	1994
Inshore lifeboat	1994

Current lifeboats

ILB D class inflatable
D-772 Rusper II
Donor Gift of Pam Waugh aad Anita
Greenwood, named after their home village
On station 6.10.2014
Launch Trolley and tractor

right D class inflatable Rusper II (D-772) is put through her paces at the end of her official naming ceremony on 25 April 2015.

below The Rock lifeboat crew with Rusper II (D-772) on 25 April 2015.

below The ILB house at Rock, on the northern side of the river Camel, was built in 1997. Although Rock is not connected to the Padstow station, despite its close proximity, the Rock crew often work with their Padstow colleagues.

1993 Padstow Harbour Commissioners approached the RNLI about providing an inshore lifeboat to cover the Camel Estuary. Harlyn private rescue service had operated a service but was no longer operating so incidents inside the Doom Bar were being dealt with by other local vessels. In November the RNLI agreed that a D class ILB station be established at Rock.

1994 An ILB station was established on 4 March for one season's evaluation to cover the Camel river, estuary and bar; the ILB and launch vehicle were housed in temporary buildings.

1995 The station was permanently established for all-year-round service from 8 April and the new D class inshore lifeboat *Dolly Holloway* (D-489) was placed on service on 27 September.

1997 A new purpose-built single-storey ILB house was constructed on the beach for the ILB and launching vehicle, completed in June, providing housing for the lifeboat and launching vehicle. It was funded through a local appeal, which raised over £150,000. During the station's first eleven years of operation, the ILB was called out over 220 times with over eighty lives saved.

Key dates

Opened	1869–1933 and 1967
RNLI	1869–1933 and 1967
Inshore lifeboat	1967

Current lifeboats

ILB D class inflatable
D-707 Copeland Bell
Donor Bude Model Boat Appeal, with other donations and gifts from Cornwall
On station 23.11.2009
Launch Trolley

Station honours

Framed Letter of Thanks	2
Thanks Inscribed on Vellum	5
Bronze medals	2
Silver medals	4

1869 The station was established following a petition submitted by concerned inhabitants who wanted a lifeboat available to help small fishing boats operating out of the cove, and adjacent coves, which often got into difficulty when running back in bad weather. A lifeboat house was built at a cost of £230 on the hill leading out of the village to the east, on a site presented by Lord Robartes; this was the only site available at the time. Some street widening was undertaken in the immediate vicinity of the house, but lower down were houses on either side and getting the lifeboat to and from this boathouse was a difficult, time-consuming and energy-sapping

left The lifeboat house built in 1869 was used until 1927, on the east side of the bay, and has been used as a post office and then various different shops, and was owned by the Cleave family, whose ancestor Charles Valentine Mitchell was awarded the station's first silver medal.

below The view from the east looking down to Port Isaac, showing the lifeboat house built in 1927, and used to house the inshore lifeboat since 1994.

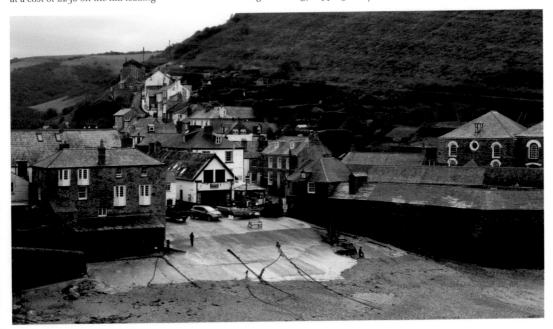

Port Isaac

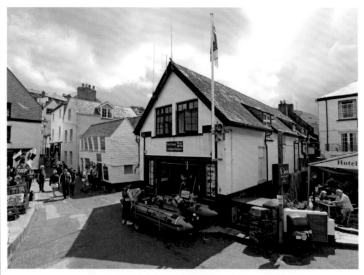

above The building used to house the inshore lifeboat between 1967 and 1994; it was considered very cramped with little space for good crew facilities. It was shared with Port Isaac Fishermen Ltd, and fish landed were also packaged here.

right The lifeboat house built in 1927 was used until the station was closed in 1933. The building, situated on Middle Street, was used as a garage for the Slipway House Hotel, but was reacquired in 1993 and refurbished for the inshore lifeboat; the work was completed in March 1994. The building is in the centre of the picturesque village.

below D class inflatable Copeland Bell (D-707) being recovered up the slipway onto the beach, which was originally used by the station's pulling lifeboats.

business which often involved numerous helpers pulling the lifeboat on her carriage along the street.

1917–18 The station was temporarily closed due to crew shortages as most of the village's male inhabitants were serving in the Royal or Merchant Navies. A subsidised auxiliary motor fishing boat named *Willing Boys* acted as a lifeboat during this time.

1927 A new lifeboat house was built, more conveniently located at the head of the beach, on a site acquired after the demolition of some run-down buildings. The 1917-built 35ft Rubie self-righter *Ernest Dresden* (ON.662) was placed on station in the new boathouse.

1933 The station was closed in May,

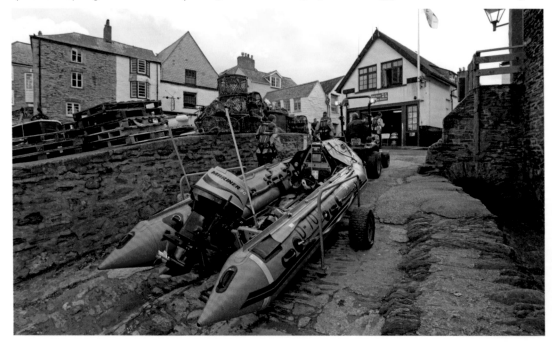

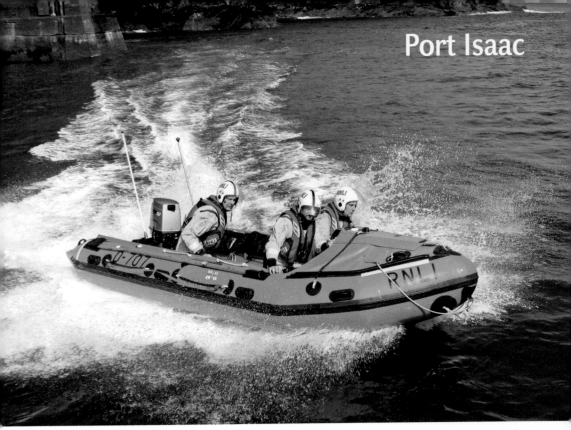

with *Ernest Dresden* never having launched on service during her six years on stations, as the motor lifeboats stationed at neighbouring Padstow provided adequate cover for the area.

1967 An inshore lifeboat station was established in July, with D class inflatable D-139 becoming operational in June; the ILB was kept in a stone building on the beach, which was the property of Port Isaac Fishermen Ltd.

1993–94 The 1927 lifeboat house, then part of the Slipway Hotel, was reacquired in 1993 and the ground floor was refurbished to house the ILB, launch vehicle and crew facilities.

2001 A Centenary Vellum awarded to mark 100 years of service.

above D class inflatable Copeland Bell (D-707) on exercise Port Isaac's small harbour. She is the latest in a long line of ILBs to serve at Port Isaac. On 7 September 1998 the ILB was capsized and wrecked while on service to two people stranded on a beach, and fortunately nobody was lost.

above D class inflatable Copeland Bell (D-707) and her launch vehicle inside the ILB house, with the volunteer crew's drysuits hanging up.

left D class inflatable Copeland Bell (D-707) in front of the boathouse with some of the volunteer crew members and station personnel.

Bude

Key dates

Opened 1837–c.1848, 1853–1922 and 1966
RNLI 1853
Inshore lifeboat 1966

Current lifeboats

ILB D class inflatable
D-756 George Bird
Donor Gift of Mrs Bird in memory of her husband
On station 12.12.2012
Launch Trolley and Tooltrak

Station honours

Framed Letter of Thanks	3
Thanks Inscribed on Vellum	2
Silver medals	12

right/below The lifeboat house built in 1863 with doors at both ends. The building was used until 1923, then became a garage and was later converted into holiday flats. The inscription stone over the doorway commemorating the donors, the Garden family, remains intact.

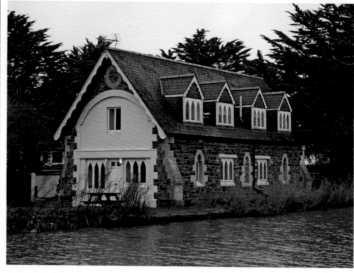

below The building used to house the inshore lifeboat between 1966 and 1994, at the end of canalside road.

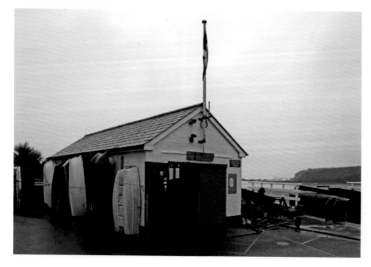

1837 A local committee established a lifeboat station, with a lifeboat funded by King William IV, and had a lifeboat house built, funded by Sir Thomas Dyke Acland; however, the design of the boat, which was a North Country type 24ft 9in in length, was disliked by the local boatmen who were to crew her, and by the early 1850s she was neglected and was in a bad state of repair.

1844 The lifeboat capsized while being exercised in Bude Harbour, two of her crew of ten were drowned, after most of the oars had been broken.

1853 The RNLI took over and revived the station, supplying a new 27ft eight-oared Peake self-righting lifeboat, built in London and which arrived in April.

1863 A new lifeboat house was built on the west side of the canal, above the Falcon Swing Bridge, on land given by Sir Thomas Dyke Acland. At suitable states of tide the boat could be launched from the back of the boathouse directly into the canal, from where it would pass through the locks and then proceed to sea. At low tide, the lifeboat could be drawn through the front doors of the house and via the canal bridge to the beach for launching. A new 33ft self-righter lifeboat, the first of three named *Elizabeth Moore Garden*, was placed on station in June.

1923 The station was closed owing to the almost total disappearance of the local coasting trade, and because the large motor lifeboat due to be placed on service at Padstow was deemed able to cover the area. The last pulling the lifeboat, the 35ft Rubie self-righter *Elizabeth Moore Garden* (ON.616), was withdrawn in September. During their eighty-six years of service, the pulling lifeboats at Bude effected

Bude

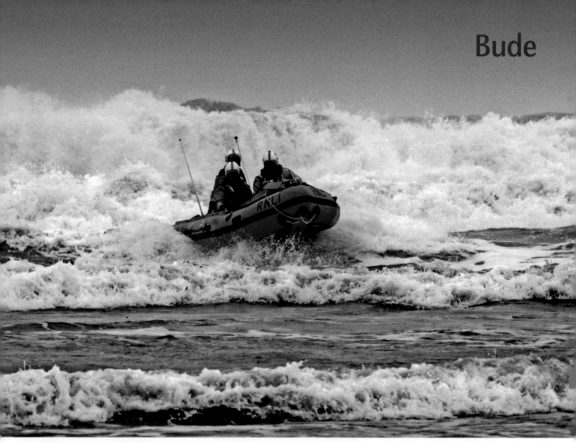

above D class inflatable George Bird (D-756) on exercise in the surf off Summerleaze Beach. The D class ILB is the ideal rescue craft for rescue work in the surf conditions typical of the North Cornish coast and can also be worked close to the rocks if needed without damage.

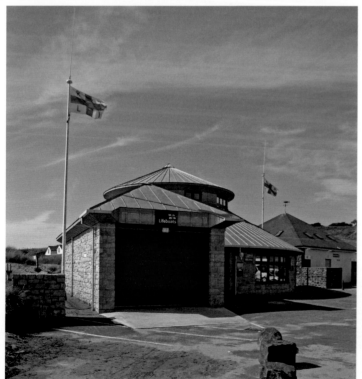

left The lifeboat house built at Summerleaze Beach in 2003–04 for D class inflatable and its launch vehicle, with crew facilities on the first floor in the circular part of the building.

below D class inflatable George Bird (D-756) inside the ILB house.

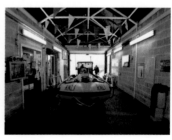

Bude

above The Rescue Water Craft is kept in the building adjacent to the ILB house.

right D class inflatable George Bird being towed across the beach by Tooltrak TT07.

opposite D class inflatable George Bird (D-756) returning to station after exercise.

below Lifeboat Operations Manager Chris Cloke has been involved with Bude RNLI since the station reopened in 1966.

below The lifeboat house built at Summerleaze Beach in 2003–04 with D class inflatable George Bird (D-756) and Tooltrak vehicle TT07 being washed down after a routine training exercise.

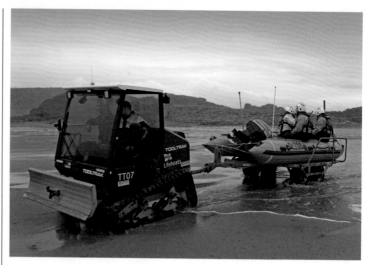

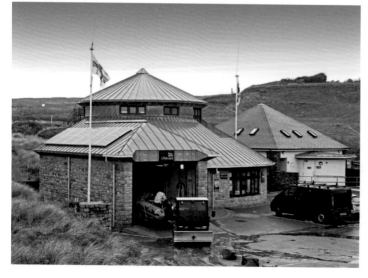

a commendable total of forty-four launches and saved forty-eight lives.

1966 An inshore lifeboat station was established in May, when D class inflatable D-96 was placed on station. An ILB house was built on the South Pier of the Locks, on the west side of the lock and at the harbour end of the canalside road, and the ILB was launched over the beach on a trolley; numerous different launching vehicles and tractors have been used, with the Loglogic Tooltrak vehicle TT07 being sent to the station in 2011.

1984 A Celebration Vellum was awarded to commemorate the station's aggregate service of 105 years covering the periods 1837 to 1923 and 1966 to 1984.

1991 The ILB house was modernised.

2000 Trials for launching the inshore lifeboat over Summerleaze Beach were successfully completed.

2000 Following the trials, D-495 became operational from the Summerleaze site, while a second operational D class lifeboat remained at the original site.

2003–04 A new ILB house was constructed at Summerleaze beach at a cost of £516,000; the new building consisted of a boatroom to house the D class, its carriage and launching vehicle; supporting facilities include workshop and storage for fuel and consumables, with a crew/training room suitable for regular exercise and instruction sessions. The boathouse was funded by Bridget Blundell OBE.

2008 In November the RNLI resolved to redesignate the station for all-year-round, rather than summer-only, operation, and that a Rescue Water Craft (RWC) would also be provided to be used by the volunteer crew and lifeguards. Bude became the first lifeboat station to operate a RWC.

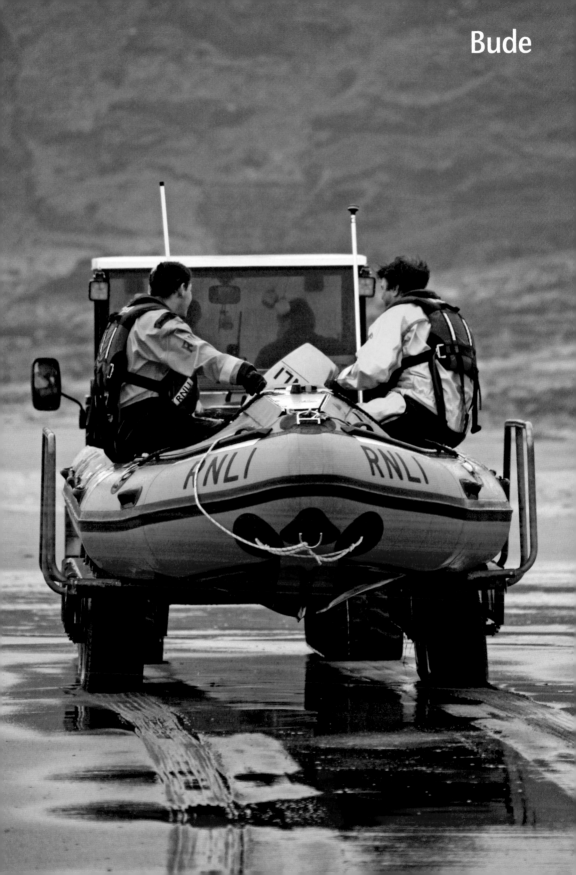

Bude

Clovelly

Current lifeboats

ILB Atlantic 85
B-872 Toby Rundle
Donor The Toby Rundle Lifeboat Appeal
On station 6.5.2014
Launch Tractor and do-do carriage

Station honours

Framed Letter of Thanks	2
Thanks Inscribed on Vellum	1
Bronze medals	4
Silver medals	4

right The lifeboat house of 1870 was extensively altered and rebuilt internally in 1999 to accommodate an Atlantic inshore lifeboat and launching tractor; the pebbles and boulders on the beach can make launching challenging.

below The latest lifeboat to serve at Clovelly is Atlantic 85 Toby Rundle (B-872), seen on a training exercise off the harbour.

1870 The lifeboat station was established following a wreck the previous year; a lifeboat house was built on the harbour shore by R.H. Becley at a cost of £279 19s 0d.

1892 The lifeboat house was rebuilt on the same site, and a stone slipway was constructed on the foreshore to improve launching arrangements at a cost of £1,098 19s 9d.

1906–7 The lifeboat house was altered at a cost of £391 14s 11d for the new 37ft 6in self-righting lifeboat Elinor

Roget (ON.573), which arrived in June.

1936 The first motor lifeboat, the 35ft 6in self-righting City of Nottingham (ON.726), was placed on station in June.

1953 New launching winch installed.

1968 70ft Clyde 'rescue cruiser', Charles H. Barrett (Civil Service No.35) (ON.987), was kept at moorings off the harbour with the intention of cruising in the Bristol Channel.

1971 Centenary Vellum awarded.

1988 The station was closed on 15 August and the 71ft Clyde City of Bristol

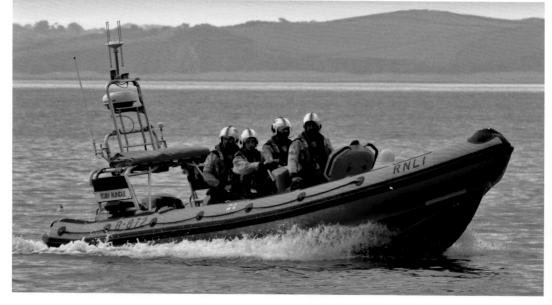

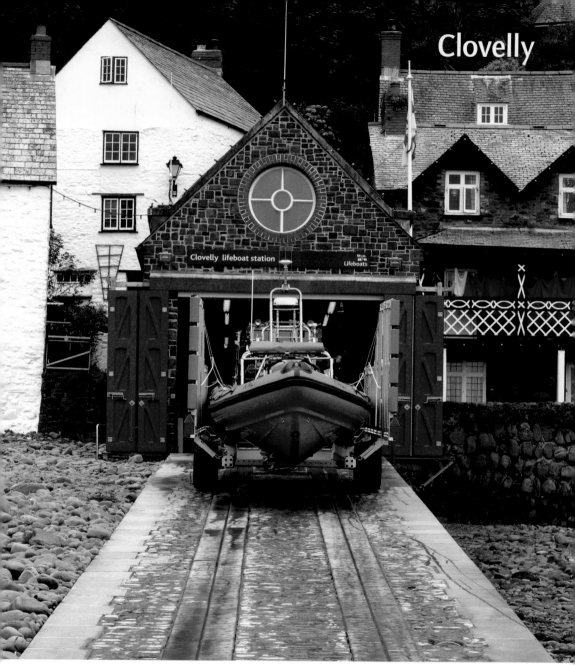

(ON.1030), on station since September 1975, was withdrawn in August.

1990 The lifeboat house was taken over by the independent Clovelly Lifeboat Trust and used for a rigid-inflatable lifeboat, which was operated until 1997.

1998 The station was reopened by the RNLI, with crew training in 1997; an Atlantic 21 was placed on temporary station duty on 14 May operating from the 1870 lifeboat house; in November the station became permanent.

1999 The lifeboat house was completely renovated internally and extended to accommodate the Atlantic 75 *Spirit of Clovelly* (B-759) and launching tractor and provide suitable crew facilities.

2004–5 A bulldozer house was built to the east of the boathouse, funded by the bequest of Miss Kathleen Renee White.

above The lifeboat house dates from 1870 and has been altered at various times; in 1968, when the lifeboat ceased to be shore-based, it was used as a shore facility, but has housed the Atlantic ILBs since 1998 and is a Grade II listed building.

Appledore

Current lifeboats

ALB 16m Tamar
ON.1296 (16-16) Mollie Hunt
Built 2010
Donor Legacy of Miss Evelyn Mary Hunt, Budleigh Salterton, and other gifts and legacies
On station 29.3.2010
Launch Afloat

ILB Atlantic 85
B-861 Glanelly
Donor Gift of Mr Simon Gibson CBE DL, Trustee of the G.C. Gibson Charitable Trust
On station 9.7.2012
Launch Tractor and do-do carriage

Boarding boat Former D class inflatable BB-546 (fromer D-546 Spirit of the PCS RE II, stationed at Port Isaac 1999-2009)
On station 2013
Launch Tractor and trolley

Station honours

Thanks Inscribed on Vellum	3
Bronze medals	7
Silver medals	23

below left The lifeboat house built at Badsteps in 1889, pictured in 1927 having been altered for the first motor lifeboat.

below right The 1889 lifeboat house, pictured in 1992 having been converted for the ILB, was demolished in 2000.

1825 Bideford Bay and Bideford Bar are formidable danger spots where many ships have been wrecked. Lifeboats were located around the treacherous Taw and Torridge bar and estuary, at Appledore, Northam and Braunton, to cover the area, and these stations have a complicated history, particularly during the nineteenth century when lifeboats were stationed at both north and south sides of the river so that a casualty could be reached by the boat most suitably placed, depending upon the wind and tide. The first lifeboat, an 18ft six-oared Plenty non-self-righter, arrived in February 1825 and was kept in a barn near the King's Watch House at Badsteps, in Appledore; it was launched over skids into the river and managed by the Bideford District Association,

above The building known as the King's Watch House, where the first Appledore lifeboats were based; it has since been heavily modified as a private house.

below The building was used by the coastguard for many years, and later by the Lifeboat Committee, the role for which it was being used when pictured in 1927.

one of the many local organisations which were affiliated to the RNIPLS.

1829 The lifeboat was moved into the King's Watch House itself, where it was

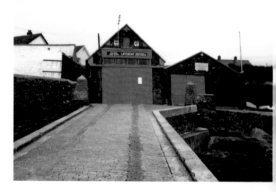

Appledore

left The moorings in the river Torridge were taken up in 1938, and the lifeboat has been kept there ever since. This photo is looking towards the bar with Braunton Burrows visible in the background.

below 16m Tamar Mollie Hunt (ON.1296) at moorings, with the picturesque village of Appledore in the background.

bottom 16m Tamar Mollie Hunt (ON.1296) seen from Badsteps, with Crow Point lighthouse in the background.

Appledore

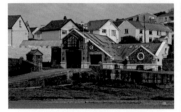

above/right The lifeboat house built at Badsteps in 2000–01 for the Atlantic ILB and her launch rig, the inflatable boarding boat and its tractor, with crew facilities on the first floor and a mechanic's workshop.

below The lifeboat house built at Braunton Burrows, one of several on this site, pictured in about 1903. This station was closed in 1919.

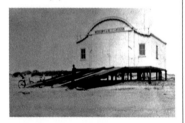

below The site at Badsteps from where the station has operated since 1889, with the lifeboat house of 2000–01 occupying the site of the original boathouse. In what was a somewhat unusual arrangement, the station's first motor lifeboat was launched down the shorter of two slipways from the bogie, but recovered up a longer, curved slipway of lesser gradient. The slipway has been widened, leaving no trace of the rails.

kept until 1831; this building is still in existence, albeit greatly altered, at the top of the slope leading down to the present station at Badsteps.

1831 A new boathouse was erected at a new site at Winterdown, and a second lifeboat, named *Assistance* and built by Harton, at Limehouse, was supplied by the RNIPLS in December; the lifeboats were launched by carriage into the river or over the Burrows. At the same time, operations were taken over by the North Devon Humane Society.

1848 A new lifeboat station was established on the north side of the of the Taw/Torridge estuary at Braunton

Burrows following the wreck of the schooner *Albion* on the North Tail in December 1845, and a boathouse was built to the north of the lighthouse at Airy Point; the crew were usually ferried across the estuary to the boathouse, which was very remote and sited among the sand dunes.

1852 A substantial new stone lifeboat house, measuring 40ft by 17ft, was built at a cost of £120 on Northam Burrows on the south side of the estuary, by the Humane Society, to house a new 30ft self-righter named *Petrol*. Part of the finance for this boat and the move to Northam Burrows came from the RNLI

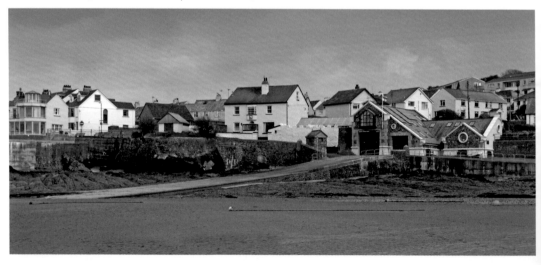

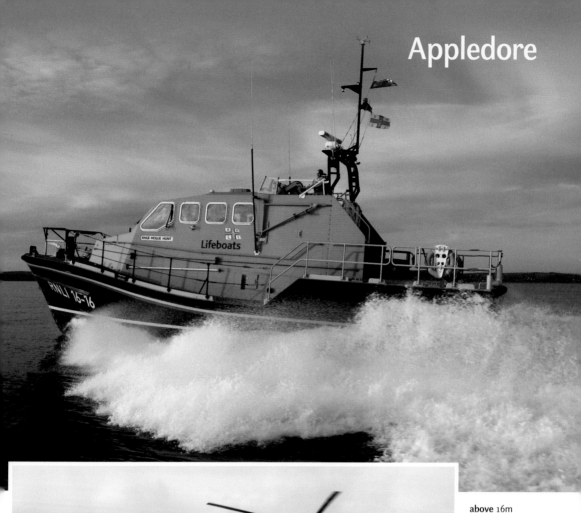

above 16m Tamar Mollie Hunt (ON.1296) heading out of the Torridge on exercise.

left 16m Tamar Mollie Hunt arriving at Appledore for the first time on 22 March 2010, being greeted by the Sea King rescue helicopter from RAF Chivenor.

Appledore

above The former Port Isaac ILB has been converted into boarding boat BB-546, and since 2013 has been used to take the crew out to the lifeboat moored in the estuary.

below Atlantic 85 Glanelly (B-861) launching down the slipway, carrying lifeboat crew out to the 16m Tamar moored in the estuary.

1855 The RNLI took over the North Devon Humane Society, which was in financial difficulty; in the twenty-four years before the RNLI assumed control, the society's lifeboats saved 107 lives.

1856 A new boathouse was built on Northam Burrows, adjoining the 1852 boathouse, for a second lifeboat, the 28ft Peake self-righter *Mermaid*, which the RNLI had built for the station.

1889 The station was moved back to Appledore, where the crew lived, and a lifeboat house was built at Badsteps at a cost of £1,035 17s 3d, with a stone slipway over the river foreshore for a launch into the river; the 34ft tenoared self-righter *Jane Hannah MacDonald* (ON.175), which had been built in 1885 for Northam Burrows, was moved here.

1897 The station at Northam Burrows was closed in January, and the two houses on the Burrows were abandoned; the station had been served by the 34ft self-righter *Bessie Pearce* (ON.323) since 1891, and, on 6 December 1896 she capsized on service to the brig *Carrick*, of St Johns, fortunately without loss of life. The boathouses were pulled down in 1913 after becoming derelict, although a few remains can still be seen close to the seventh green of the Royal North Devon Golf Course.

1918 The station at Braunton Burrows, on the north side of the river, was temporarily closed as many of the launchers had been called up for war service; it was permanently closed when the 36ft self-righter *Robert and*

Appledore

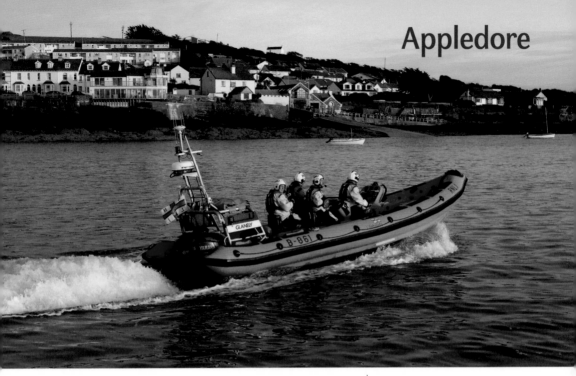

Catherine (ON.632), on station since 1912, was withdrawn in December 1919.

1920–2 The lifeboat house at Badsteps was altered for the station's first motor lifeboat, the 40ft motor self-righter *V.C.S.* (ON.675), at a cost of £7,500; rails were laid and the boat was launched from a specialy trolley; separate slips for launching and recovery were built.

1928 A Centenary Vellum was awarded.

1938 The larger motor lifeboat *Violet Armstrong* (ON.815), a 46ft Watson motor specially adapted to work over the treacherous bar, was sent to the station in August, and was kept afloat at moorings in the river, off Badsteps, as she was too large for the house; the house was then used for the crew's gear and for the boarding boat, which was launched by carriage and tractor.

1972 The prototype Atlantic 21 inshore lifeboat B-500 was sent to the station; it was kept in the 1889 boathouse, launched from a trolley, and initially operated during the summer only.

1974 A new Atlantic 21, *Wildenrath Wizzer* (B-520), was placed on station and operated all year round.

1980 The crew built and funded a first floor crew room within the boathouse to improve facilities.

1989 Improvements were carried out to the boathouse yard, over which a roof was constructed.

2000–01 A new ILB house and slipway were constructed on the site of the 1889 house, which was demolished; the new house provided better housing for the ILB as well as improved crew facilities.

above Atlantic 85 Glanelly (B-861) in the River Torridge, heading back to the lifeboat house at Badsteps, which can be seen in the background.

below Atlantic 85 Glanelly (B-861) on exercise; Appledore was one of the first stations to operate the Atlantic rigid-inflatable design, which was introduced in the early 1970s.

Morte Bay

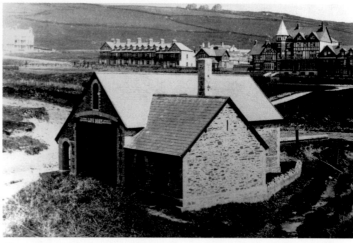

right The lifeboat house which served the station throughout its life, from 1871 to 1900. The low wall was added in 1872 and the side room in 1877 to give rest facilities for the crew and the omnibus drivers who brought them from Ilfracombe.

below The lifeboat house of 1871 was converted for use as a beach shop in the 1980s and 1990s. Despite many alterations, the basic house can easily be made out.

1871 A lifeboat station was opened at Woolacombe to provide an auxiliary station for the Morte Bay area which was difficult to reach from Ilfracombe in westerly winds; the lifeboat was manned by an Ilfracombe crew, who were brought to Woolacombe in a cart. A lifeboat house was built at the south-west corner of the village in the dunes at back of sands at a cost of £185 10s 0d. The first lifeboat, the 33ft self-righter

Jack-a-Jack (ON.225), arrived on station in March and served until 1892.

1877 A 'lean-to' was added to the side of the boathouse at a cost of £105 14s 0d.

1900 On 10 May it was reported to the RNLI that the station had performed only one service since 1871 and so the decision was made to close it; the lifeboat *Theophilus Sidney Echalaz* (ON.339), a 36ft self-righter, on station since 1892, was withdrawn in May.

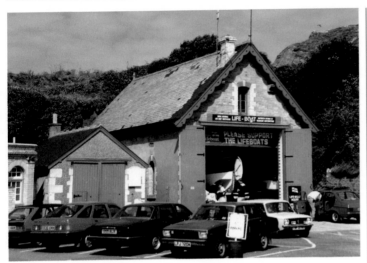

1828 A local pilot boat was fitted out as a lifeboat at a cost of £13 12s 0d at the instigation of local man J.V. Lee, funded with help from the RNIPLS; it is not known whether this boat was ever used, where it was kept, or what became of it.

1850 A lifeboat was built for service at Ilfracombe, measuring 32ft by 8ft, by Thomas and John White, of Cowes, at a cost of £144, organised by the newly-founded Ilfracombe Lifeboat Association; a lifeboat house was built at the corner of Hiern's Lane at the back of the harbour, with a slipway into the harbour. The boat, named Lady Franklyn, was used until about 1866.

1865 Several influential local people wrote to the RNLI asking for the station to be taken over and reformed.

1866 The RNLI took over the station, and a new lifeboat house was built at a cost of £222 15s 0d at the foot of Lantern Hill, in the grounds of the pier, on a site provided by Sir Boucher Wrey; the lifeboat could be launched directly into the sea down a slipway at Warphouse Point by carriage. The first lifeboat, the 32ft self-righter *Broadwater*, arrived in June.

1871 The slipway at Warphouse Point

left The lifeboat house built in 1866 beneath Lantern Hill, later enlarged and modified notably in 1893, pictured in 1989, when housing the 37ft Oakley lifeboat Lloyd's II (ON.986), which was on station from 1966 to 1990.

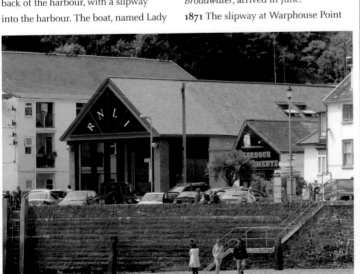

left/below The lifeboat house built in 1996 for the 12m Mersey lifeboat and D class ILB and launching vehciles, providing improved crew facilities and with the slipway providing a launch direct into the harbour; the house was extended in 2015.

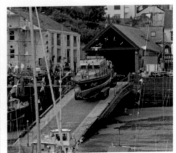

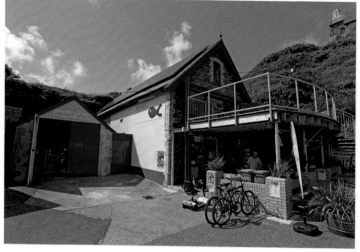

top The tractor house built in 1984 in the harbour has become a small food outlet.

above The station's first service board is on display in St Nicholas Chapel, on Lantern Hill, overlooking the harbour.

top right The lifeboat house built in 1893, used until 1996, became an aquarium.

below The lifeboat house built in 1995–6 was modified in 2015 for the 13m Shannon.

was filled in during the building of new wooden piers; as a result, launching the lifeboat involved taking it through the town and round to the top of the harbour to use the slipway there; this somewhat cumbersome procedure was followed for well over a century.

1893 A new larger lifeboat house was constructed under Lantern Hill, on the site of the previous house, at a cost of £389 2s 11d, to accommodate a larger self-righting lifeboat, the 37ft by 9ft twelve-oared *Co-Operator No. 2* (ON.355).

1930 A Centenary Vellum was awarded.

1936 The first motor lifeboat, the small 32ft Surf type *Rosabella* (ON.779), was placed on station in March.

1945 *Rosabella* was withdrawn in October and presented to the KNZHRM, one of the Netherlands lifeboat societies, to help rebuild their fleet after the war, replaced by the 35ft 6in Liverpool motor *Richard Silver Oliver* (ON.794).

1966 The lifeboat house was adapted and heightened for the 37ft Oakley class lifeboat *Lloyd's II* (ON.986), which arrived on station in July.

1978 150th Anniversary Vellum awarded to the station.

1984 A new tractor house was constructed in the Cove car park, close to the launching slipway, to house the Talus MB-H launching tractor.

1990 The lifeboat house was extended and adapted to accommodate the new 12m Mersey class lifeboat *Spirit of Derbyshire* (ON.1165), which arrived on station in July.

1991 An inshore lifeboat station was established in February, and the D class inflatable D-334 was placed on station in March, initially for one season's operational evaluation; in November it became permanent. The ILB and its launch vehicle were kept in the tractor house built in 1984.

1992 The new D class ILB *Alec Dykes*

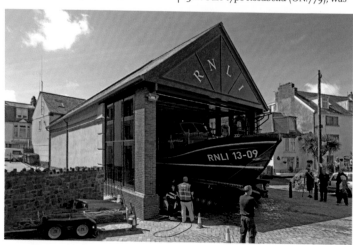

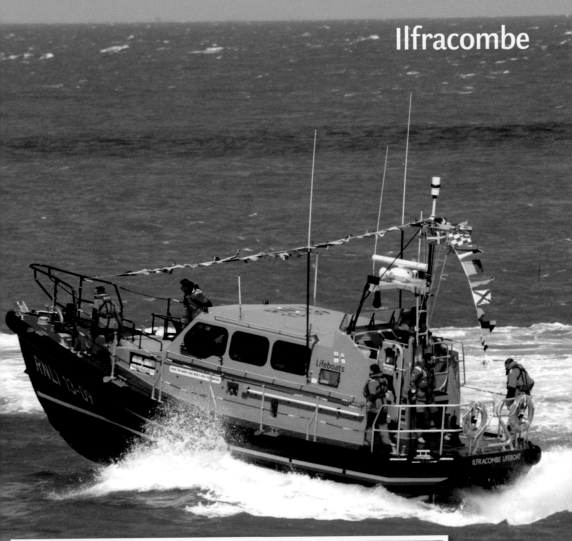

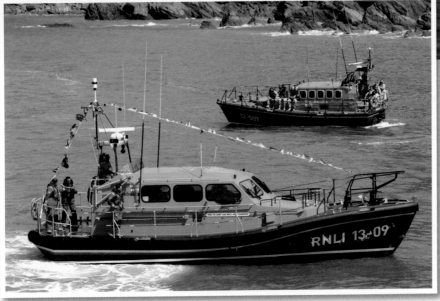

above 13m Shannon The Barry and Peggy High Foundation (ON.1316) arriving at Ilfracombe for the first time, 6 June 2015.

left 13m Shannon The Barry and Peggy High Foundation (ON.1316) with her predecessor, 12m Mersey Spirit of Derbyshire (ON.1165), on 6 June 2015.

Ilfracombe

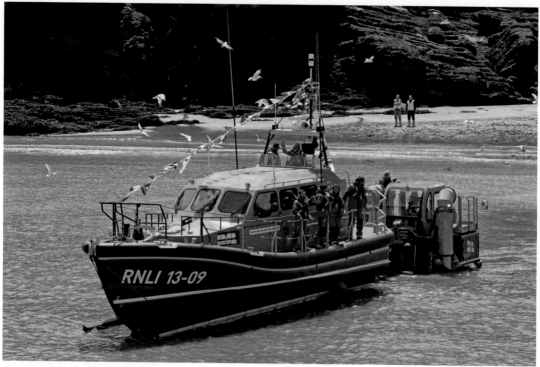

above 13m Shannon The Barry and Peggy High Foundation (ON.1316) being launched for the first time following her arrival on station. The Supacat Launch and Recovery System was specially developed for the Shannon class lifeboat.

(D-422) was placed on station in March. **1995–6** A new lifeboat house was constructed in the harbour, near the launching slipway, to house both the 12m Mersey and D class inflatable lifeboats, as well as their launching vehicles; it included a workshop, souvenir sales outlet, drying cupboard, oil store, crewroom, changing rooms,

shower and toilet.

1998 A new slipway was constructed opposite the lifeboat house, offering a direct launch into the inner harbour to improve launching arrangements. **2015** The lifeboat house was altered internally and extended for the Shannon lifeboat *The Barry and Peggy High Foundation* (ON.1316).

right D class inflatable Deborah Brown II (D-717) has been on station since 2009.

below D class inflatable Deborah Brown II (D-717) being launched at the harbour entrance by Tooltrak vehicle TT11.

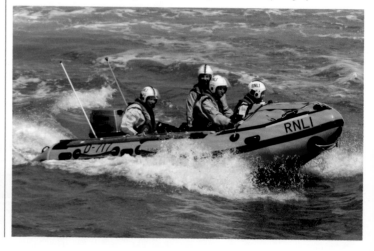

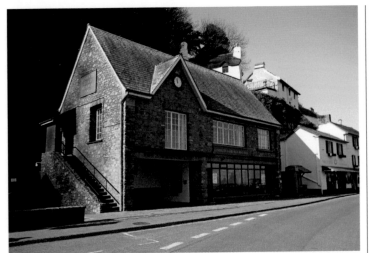

left The North Devon & West Somerset Memorial Hall, which was opened on 12 July 1958, stands on the site of the lifeboat house, which was washed away in 1952.

below The service board and RNLI barometer which can be seen on display in the Memorial Hall.

1869 The lifeboat station was established after the ship *Home*, of St Andrew's, New Brunswick, was wrecked in August 1868 and two of her crew were drowned; the first lifeboat, the 30ft self-righter *Henry*, was temporarily housed in a shelter on the beach until the boathouse was ready. The lifeboat arrived at Barnstaple on 20 January and was brought to Lynmouth on its carriage, being drawn (by eleven) a distance of twenty miles along 'a most hilly road, presenting difficulties of no ordinary character', according to the RNLI's contemporary account.

1870 A new lifeboat house was completed at a cost of £292 9s 6d on the west side of the harbour, on land granted by Lord of the Manor.

1898 The lifeboat house was rebuilt at a cost of £200.

1899 The most famous incident in the history of the station took place on 12 January when the lifeboat was taken overland to go to the aid of the 1,900-ton three-masted ship *Forrest Hall*.

1906-7 The lifeboat house was again rebuilt at a cost of £330 15s 7d, and used until the station closed in 1944.

1944 The station was closed and the last lifeboat, the 35ft self-righter *Prichard*

Frederick Gainer (ON.558), on station since 1906, was withdrawn in June, with motor lifeboats from Minehead and Ilfracombe covering the area.

1952 The boathouse, which had been used as a club, destroyed and washed away by the extensive flooding that affected the whole town on 15 August 1952. Three former crew members lost their lives in the same disaster.

1982 The former Withernsea and Padstow lifeboat *Docea Chapman* (ON.623), built in 1911 and in RNLI service until 1939, was brought to Lynmouth and, renamed *Louisa*, placed in display as part of a display about the famous 'Overland Launch' of 1899.

below Lynmouth lifeboat crew with the lifeboat Louisa (ON.54) on her carriage inside the lifeboat house.

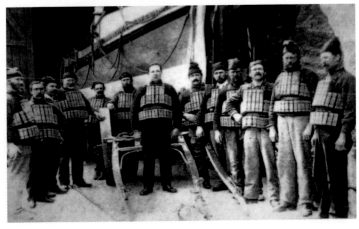

Minehead

Current lifeboats

ILB Atlantic 85
B-824 Richard and Elizabeth Deaves
Donor Legacy of the late Miss Joan Batty,
Minehead, in memory of her late mother
Florence Alice
On station 1.12.2007
Launch Tractor and do-do carriage

ILB D class inflatable
D-712 Christine
Donor Legacy of George Stribling, Essex
On station 9.7.2009
Launch Trolley and Tooltrak

Station honours

Framed Letter of Thanks	1
Thanks Inscribed on Vellum	1

above right The lifeboat house
dating from 1901 was rebuilt in 1993
to accommodate the Atlantic 75 and
launching rig.

opposite Atlantic 85 Richard and Elizabeth
Deaves (B-824) inside the lifeboat house on
the drive-on drive-off trolley.

right Launch of Atlantic 85 Richard
and Elizabeth Deaves (B-824) down the
steep shingle beach at high water using
tractor T990, an adapted all-weather
launch vehicle. This photo gives a good
impression of the steepness of the beach
which probably make launching more
challenging than at any other station in the
United Kingdom and Ireland.

below Launching D class inflatable
Christine (D-712) using the Tooltrak launch
vehicle TT09, on station since 2011.

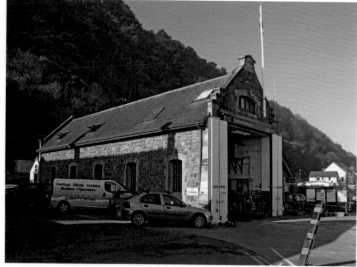

1901 A lifeboat station was established
by the RNLI to 'strengthen the Life-boat
Service on the coast of Somerset'. A
lifeboat house was built to the west
of the harbour, by the entrance to
the Promenade Pier, at a cost of £803
11s 0d, on land given by the lord of the
manor, G.F. Luttrell. The first lifeboat,
the 35ft Liverpool George Leicester
(ON.477) funded from the legacy of
Miss Leicester, Bayswater, was placed
on station in December; the boat was
launched across the beach on skids.
1903 A carriage was supplied to

improve launching arrangements.
1938 The lifeboat house was altered to
accommodate the first motor lifeboat,
the 32ft Surf *Kate Greatorex* (ON.816),
which arrived on station in May.
1950 A tractor garage was constructed
to the rear of the lifeboat house for the
first tractor at the station, number T54.
1970 A D class inflatable inshore
lifeboat, number D-177, was sent to
station in April; the ILB was kept in the
tractor garage at the rear of the lifeboat
house and launched across the beach.
1973 The the offshore lifeboat, the 35ft

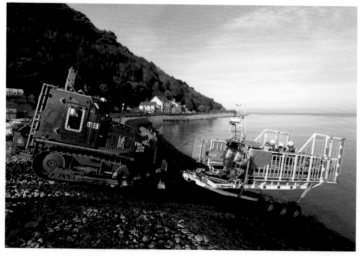

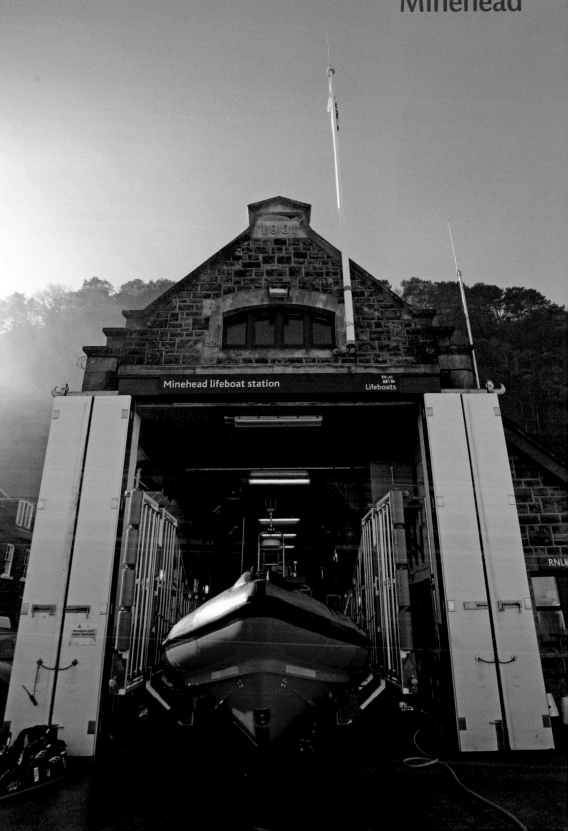

Minehead

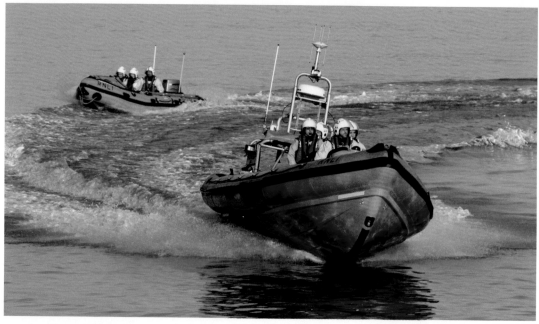

above Atlantic 85 Richard and Elizabeth Deaves (B-824) and D class inflatable Christine (D-712) off the beach.

below Recovery of D class inflatable Christine (D-712) in the harbour.

below right Lifeboat crew from the D class ILB returning up the harbour following a routine exercise; the ILB is usually recovered in the harbour.

bottom The tractor house at the rear of the boathouse built in 1950 and used to house the Tooltrak ILB launch vehicle.

6in Liverpool motor *B.H.M.H.* (ON.882) on station since 1951, was withdrawn on 20 May, and a second ILB, the experimental 19ft Zodiac, number D-500, was supplied.

1979 The station was upgraded with Atlantic 21 *Catherine Plumbley* (B-544), which was placed on station in July.

1993 The lifeboat house was rebuilt to accommodate the Atlantic 75 *Bessie* (B-708) and its launching vehicle; the

front and side of the boathouse was extended to provide improved crew facilities and a souvenir sales outlet. The work was funded by bequests from Freda Helen Luxon and Mrs Aileen Jones, of Minehead, and the crew and lifeboat moved into the rebuilt house on 13 November. The building was officially opened on 10 September 1994.

2001 A Centenary Vellum was awarded to mark 100 years of service.

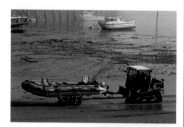

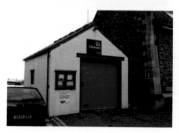

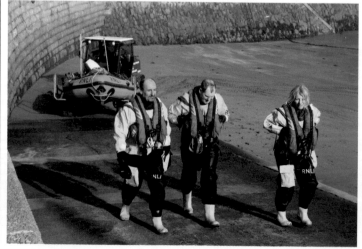

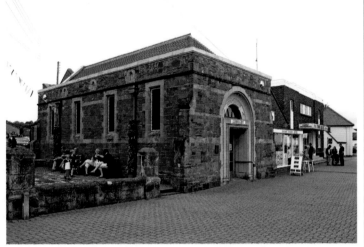

Key dates

Opened	1875
RNLI	1875
Closed	1944

left The lifeboat house built in 1874 as it is today, converted into a public library

below The lifeboat house built in 1874 on the quay, pictured when in use.

1874 The RNLI decided to establish a lifeboat station at a meeting of the committee of management on 2 July.
1875 The station was established and a gift of £1,000 received from Mrs Joseph Somes, of Torrington, was used to fund the first lifeboat and the lifeboat house, which was built on the quay facing the harbour on land given by the Countess of Egremont. The building cost £352 and additional works on the town slipway and its approaches £106. The lifeboat, a standard 33ft self-righter, was named *Joseph Somes* and arrived at the new station on 29 July. She served until 1887, and the station was served by four more lifeboats to 1919.

1944 The station was closed as no services had been carried out since 1937, and the last lifeboat, the 35ft self-righter *Sarah Pilkington* (ON.473) built in 1901, was removed January 1945. She answered only two calls during the twenty-five years she was on station. The lifeboat house was subsequently rebuilt through the generosity of Leonard Laity Stoate and presented to the town as a public library.

above The wooden hauling-off post used in the launch and recovery procedure with a plaque recording its use on the esplanade.

left The 35ft ten-oared self-righter John Lingard Ross (ON.510) was on station from October 1903 to 1919, saving four lives during that time. She is pictured on her wheeled carriage at the town slipway, prior to launching into the harbour. The three lifeboats before this, all self-righters, were all named W.H.G. Kingston having been funded by the Union Jack Magazine Lifeboat Fund. (H.H. Hole)

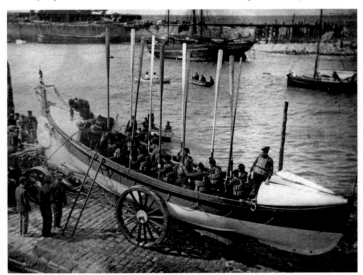

Burnham-on-Sea

Key dates

Opened 1836–1857, 1866–1930 and 2003
RNLI 1866
Inshore lifeboat 2003, 2nd ILB 2003

Current lifeboats

ILB Atlantic 75
B-795 Staines Whitfield
Donor Gift of Mr Jonathon Whitfield
On station 7.1.2004
Launch Tractor and do-do carriage

ILB D class inflatable
D-664 Puffin
Donor Gift of Mrs Oonagh Mitchell,
Oxfordshire
On station 11.12.2006
Launch Trolley and tractor

right The lifeboat house, built in 1874, was used until 1930, when the station was closed. The building has retained its original appearance externally, but all traces of the earlier boathouse beneath the promenade were lost with the building of the new sea wall.

below The lifeboat house and crew facilities built in 2003–4 for Atlantic and D class inflatable inshore lifeboats, situated behind the 1874 boathouse.

1836 A lifeboat station was established by a local committee, which was subsequently taken over by the Bridgwater Corporation, which ran the Bridgwater Harbour Trust. The first lifeboat, which arrived in August, was funded by local landowner Sir Peregrine Acland, who had been impressed by the bravery of three men attempting to save the crew of a ketch.

1847 Bridgwater Corporation supplied a new 26ft ten-oared North Country type lifeboat to replace the first lifeboat. This second lifeboat was kept in half of a double boathouse, which was built at beach level beneath what is now the main promenade. The boat was allowed to decay and became unfit for service. **1857** The lifeboat was broken up having not been maintained.

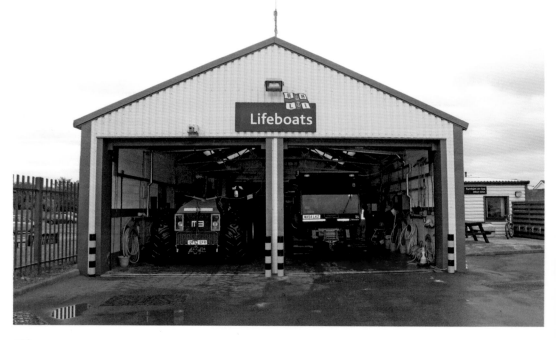

1866 The RNLI reopened the station and a 32ft ten-oared self-righter named *Cheltenham* was supplied in October; a new lifeboat house was built on the sand dunes near the lower lighthouse, on ground owned by the Rev H. Dodd, at a cost of £207 by builder E.J. Tilling.
1874 A new lifeboat house was built in a more convenient position, close to the railway station at the southern end of the promenade, at a cost of £219 5s 1d. Robinson & Napton built a trolley on which the lifeboat sat and which ran on rails, connected by a set of points to the line from the railway station, down to the sea front; the line was extended down the slipway and into the sea so that the lifeboat could be launched and recovered in what was a somewhat unusual arrangement.
1879 In a tragic accident, Edward Press, who had been coxswain since 1866, was drowned.
1896 A small truck was supplied to convey beach roller skids used for launching the lifeboat.

above Atlantic 75 Staines Whitfield (B-795) passing the low lighthouse on exercise off Burnham.

below left Atlantic 75 Staines Whitfield (B-795) launching on exercise at the southern end of the esplanade.

below D class inflatable Puffin (D-664) passing Burnham seafront on exercise.

bottom D class inflatable Puffin (D-664) being recovered on the beach by the Softrak launch vehicle ST04.

Burnham-on-Sea

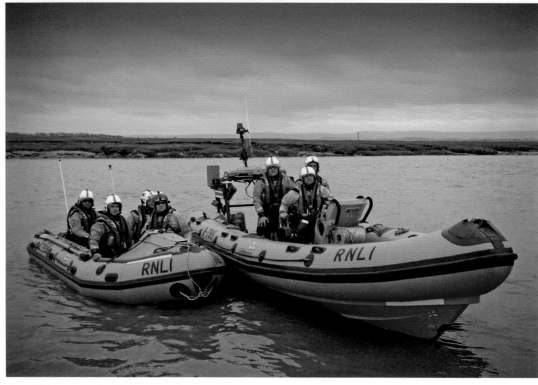

above Lifeboat crew on board Atlantic 75 Staines Whitfield (B-795) and D class inflatable Puffin (D-664) in the River Brue.

below Lifeboat crew and station personnel washing down the two lifeboats outside the boathouse after an exercise.

1903 Water was laid on to boathouse.

1930 The station was closed and the last lifeboat, the 35ft Liverpool sailing type *Philip Beach* (ON.498), was withdrawn in July having saved only five lives in twenty-eight years on station and was sold locally. The motor lifeboats stationed at Minehead and Weston-super-Mare covered Bridgwater Bay. The old boathouse was presented to the Burnham-on-Sea Scout Group in 1937, and was used by them until becoming a cafe.

1994 An independent lifeboat service was started, known as the Burnham Area Rescue Boat, run by a local committee, who operated a small ILB and a rescue hovercraft.

2003 In July the RNLI announced it would take over lifeboat provision and operate two inshore lifeboats, an Atlantic 75 and D class inflatable, launched across the beach. The ILB station operated from a temporary station built on a site behind the 1874 boathouse, on derelict land adjacent to Pier Street, and the ILBs were launched down the original slipway.

2004 The station was officially opened at a ceremony on 15 May during which the new Atlantic 75 was named.

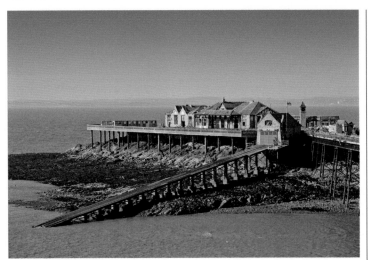

Key dates

Opened	1882
RNLI	1882
Motor lifeboat	1933–1969
Inshore lifeboat	1966, 2nd ILB 1969, 3rd ILB 2013

Current lifeboats

ILB Atlantic 75
B-769 Coventry and Warwickshire
Donor Coventry and Warwickshire
Lifeboat Appeal
On station 13.1.2001
Launch Tractor and do-do carriage

ILB D class inflatable
D-696 Anna Stock
Donor Legacy of Mrs Sophia Anna Stock, of
Weston-super-Mare, which was given to the
RNLI in 1901
On station 7.5.2008
Launch Helgeth-Hagglund BV206 vehicle

Station honours

Framed Letter of Thanks	1
Thanks of the Institution on Vellum	4
Bronze medals	1

1882 The RNLI established a lifeboat station and the first lifeboat, the 25ft self-righter *William James Holt* (ON.259), was kept on davits on Birnbeck Pier, provided at a cost of £60.

1889 A new lifeboat house and 100ft slipway was built on Birnbeck Island, on the north side of the pier at a cost of £718 1s 4d; this house was used until 1902, and was converted into offices and then became derelict when the pier was closed to the public in the 1990s.

1902–3 A new lifeboat house and slipway was built on Birnbeck Island by H.W. Pollard at a cost of £2,575 3s 0d, with the slipway jutting out south-west from the south side of the pier. The slipway has been repaired and strengthened at various times.

1933 The station's first motor lifeboat, the single-engined 35ft 6in Liverpool motor *Fifi and Charles* (ON.765), was placed on station in September.

1961 The boathouse was adapted for the 37ft Oakley class lifeboat *Calouste Gulbenkian* (ON.961), which was placed on station on 17 March.

1962 Improvements were made to the slipway by adding to the roller keelway.

1966 An inshore lifeboat station was established; the ILB D-83 was kept on a trolley at the head of the slipway.

1969 *Calouste Gulbenkian* (ON.961) left the station in February and was temporarily replaced by *Rachel and Mary Evans* (ON.806), which was too large for the boathouse so was placed on moorings; in a westerly gale on 12 April she broke from her moorings and was wrecked on the rocks off Birnbeck Pier, but was partly salvaged. So a second ILB was supplied, and was also kept on a trolley on the slipway.

1970 The second inflatable ILB was replaced by an 18ft 6in McLachlan rigid-hulled ILB, number A-504, which

left The lifeboat house and slipway on Birnbeck Island was built in 1902–03, pictured in 2006, and used until 2007.

below The lifeboat house built on Birnbeck Island in 1902–03, pictured in December 2009 when it was being used only as a crew facility. The old ILB launching trolleys and equipment remain disused at the top of the slipway.

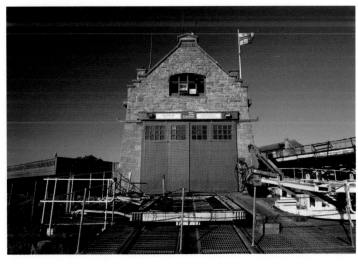

Weston-super-Mare

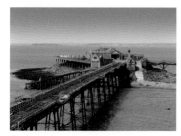

above Looking over the derelict Birnbeck Pier, onto Birnbeck Island and towards the two disused lifeboat houses.

right The original lifeboat house, built on the north side of Birnbeck Pier, was used from 1887 until 1902. The stone roundels above the main door remain intact.

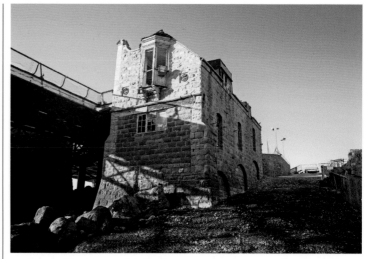

opposite The lifeboat house and slipway built in 1902–3. The house was funded from the legacy of Mrs Sophia Anna Stock, which paid for the lifeboat Colonel Stock.

opposite inset Atlantic 75 Coventry and Warwickshire (B-769) is put through her paces in the Bristol Channel.

below The temporary lifeboat station built in 2013 at Knightstone harbour for the D class inflatable and Tooltrak launch vehicle, with a compound for the Atlantic 75 added.

was launched from a special trolley that ran on rails laid on the slipway.

1974 A new ILB house built on the promenade, and opened for the 1975 season, but did not prove a success and was subsequently converted into publicity and souvenir outlet.

1981 The slipway was damaged and the McLachlan was placed on a mooring.

1982 A Centenary Vellum was awarded.

1983 The McLachlan ILB A-504 was replaced by Atlantic 21 ILB Weston Centenary (B-557) in May and the launching trolley and cradle were adapted for the new rigid-inflatable.

2005 The Atlantic 75 was moved to temporary moorings on the River Axe after the slipway had been condemned.

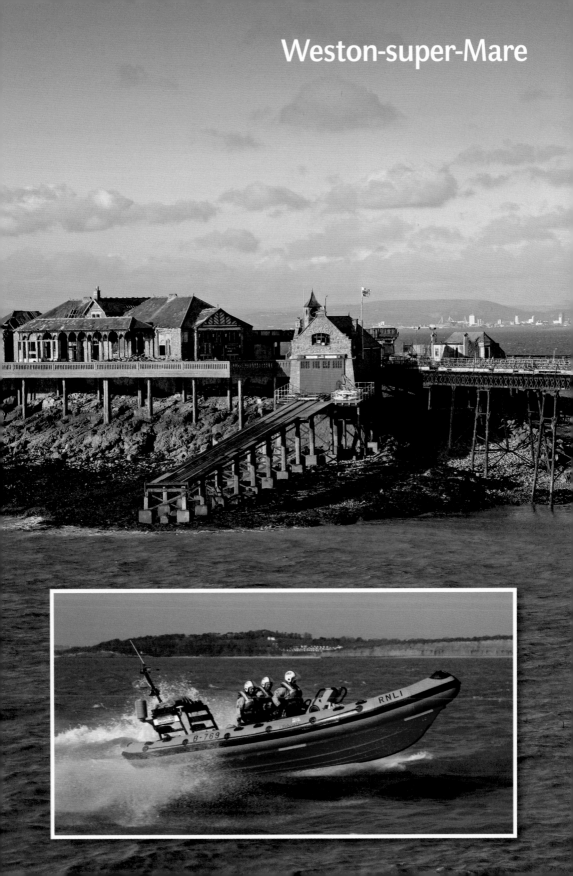

above D class inflatable Anna Stock (D-696) being launched on exercise at Knightstone harbour by the Softrak vehicle.

right Atlantic 75 Coventry and Warwickshire (B-769) being launched on exercise at Knightstone harbour from the temporary facilities near the Marine Lake.

above Atlantic 75 Coventry and Warwickshire and D class inflatable Anna Stock in Knightstone harbour.

below D class inflatable Anna Stock on exercise off Knightstone.

2007 The slipway was not repaired, so trials with carriage launching at Birnbeck Island were carried out; these proved successful, so a carriage launch method was adopted and a compound was constructed for the Atlantic D class inflatable and their launch vehicles on the island, with the boathouse being used as crew facility.

2013 A temporary lifeboat station was set up close to the Marine Lake after safety concerns forced the closure of the lifeboat house at Birnbeck Pier;

the derelict pier became increasingly unsafe for crews getting to the lifeboat house. A 50ft container was provided to house relief D class inflatable D-690. The lifeboats on Birnbeck were to launch only if there was 'a known risk to life' which could not be covered by the temporary facility.

2014 With operations from Birnbeck no longer safe, the station's D class ILB and Atlantic 75 were both moved to the Marine Lake temporary facility for a launch in Knightstone harbour.

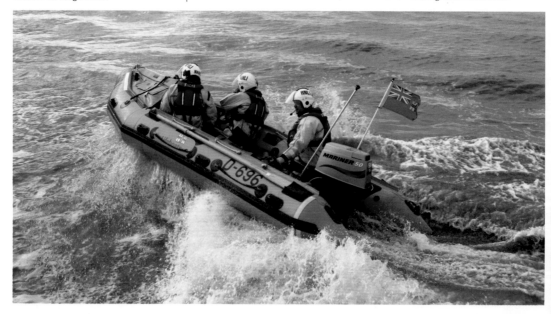

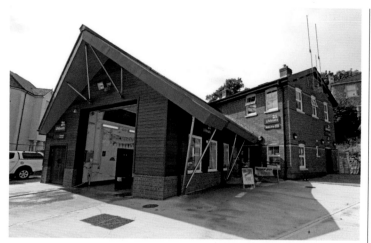

Key dates

Opened	1996
RNLI	2015
Inshore lifeboat	1996

Current lifeboats

ILB Atlantic 85
B-884 My Lady Anne
Donor Gift of Bill Wraith in memory of his late wife.
On station 17.9.2015
Launch Tractor and do-do carriage

left The lifeboat house built by the RNLI in 2014–15 for Atlantic ILB and launch vehicle. The building consists of a boat hall, crew changing facilities and a training room.

above The 6.5m Ribcraft lifeboat Denbar Sage was operated by the Portishead Lifeboat Trust from June 2003 to 2011.

below The lifeboat house built at the entrance to Portishead Marina, with the launching ramp into the Bristol Channel.

1992 When the rescue service provided by the Portishead Yacht and Sailing Club was suspended, feeling in the local community was that the area still needed a sea rescue service, so a petition was raised and a group of local people pushed ahead with plans to form a lifeboat station.

1995 The Portishead Lifeboat Trust was established, independently of the RNLI, with charity status, raising funds from donations and bequests. The organisation's mission was 'to save and protect the lives of the general public, in particular by the provision of a lifeboat in the Severn Estuary centred on Portishead'.

1996 On 6 October a purpose-built and fully funded lifeboat was launched on its first service call. It was based at a boathouse on Sugar Loaf Beach by the Yacht and Sailing Club, just down channel from Kilkenny Bay, about half way between Portishead Point and Black Nore Point. The lifeboat, a 6.5m Ribcraft rigid-inflatable, covered an area

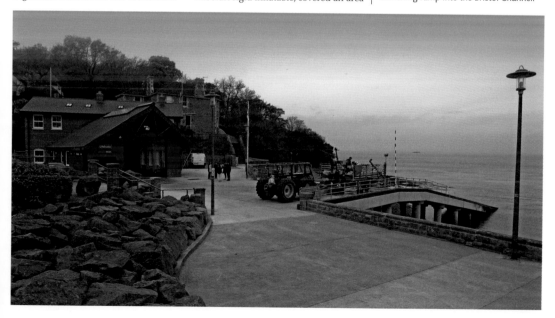

Portishead

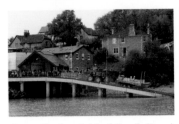

above Atlantic 75 Spirit of Clovelly (B-759) being launched down the launch ramp on 24 April 2015, the day the station was formally adopted by the RNLI.

right Atlantic 75 Spirit of Clovelly (B-759, on right) with Atlantic 85 My Lady Anne (B-884) in September 2015, when the latter took over from the former to become the first RNLI Portishead lifeboat.

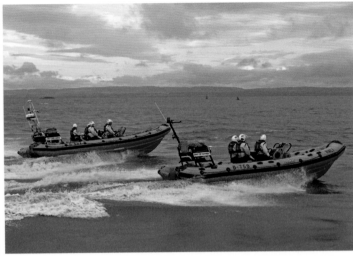

above Launch of Atlantic 85 My Lady Anne (B-884) using Talus MB764 tractor TW41 and do-do carriage.

below Atlantic 85 My Lady Anne speeds away from Portishead and into the Bristol Channel for a crew training exercise during the week she arrived on station.

on the south side of the Severn Estuary, between Avonmouth and Clevedon.

2003 A new 6.5m Ribcraft rigid-inflatable was placed on station in June; it was named *Denbar Sage* at the request of Barbara Palmer, who donated £30,000 towards the cost of the boat.

2011 The Portishead Lifeboat Trust approached the RNLI about being taken over by the national organisation; launching trials were carried out near Portishead Pier and Marina to establish the viability of a site for a proposed new RNLI lifeboat station. In March the relief Atlantic 75 *Rose West* (B-729) was leased from the RNLI by the Portishead

Lifeboat Trust, and continued to operate from the Sugarloaf Beach site.

2012 Up to 8 May the lifeboat had been called out on 321 occasions, saved thirteen lives, and rendered assistance to another 400 persons, who might otherwise have got into difficulty.

2013 Another RNLI relief Atlantic 75, *Brandy Hole* (B-733) originally stationed at Burnham-on-Crouch, was leased to the Trust by the RNLI in May.

2014-15 A new ILB house was constructed by the RNLI for an Atlantic ILB and launching tractor, by contractors Andrew Scott. The building was erected on the site of a former railway station, terminal for transatlantic crossings, and which was later used as a Masonic Lodge. The new building included crew and training facilities, as well as housing for the ILB.

2015 Following extensive crew training and launching trials, the station was formally adopted by the RNLI on 24 April, with relief Atlantic 75 *Spirit of Clovelly* (B-759) being declared operational at noon. The station was officially opened at a ceremony on 20 June. In September the station's own lifeboat, the Atlantic 85 *My Lady Anne*, was placed on station.

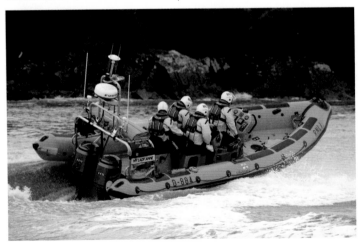

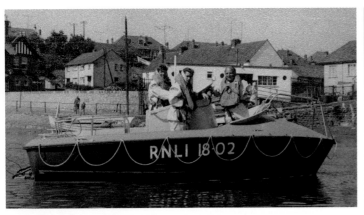

Key dates

Opened	1971
RNLI	1971
Inshore lifeboat	1971
Closed	1974

left The first ILB at Pill was the prototype McLachlan, 18-02, which is pictured on 8 July 1971, the day she arrived. The boat measured 20ft 6in overall by 8ft, with an overall depth of 7ft 3in. Originally fitted with an Evinrude 90hp stern drive engine, she could achieve a speed of twenty knots in calm water. The station's limits of operation were the Severn Bridge to the north and Clevedon to the west. (Pill photos by Grahame Farr/courtesy of the RNLI)

left The station's first lifeboat, McLachlan 18-02 was renumbered A-503 in 1972 in line with the RNLI's policy of classifying their inshore lifeboat as A, B, C and D classes. She is pictured with Betty Brown, a 27ft Cheverton boat built in 1969, which was the earlier Auxiliary Rescue Craft under the joint RNLI/CG scheme for rescue work in the Severn Estuary.

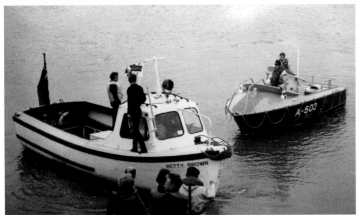

1971 An inshore lifeboat station was established at Pill, on the south bank of the Avon, in July, with the prototype McLachlan ILB 18-02 placed on service, operating from spare ferry mooring.

1973 Another 18ft 6in McLachlan ILB, A-510, was placed on station in March.

1974 The ILB was withdrawn as silting of the moorings in the river Avon, a lack of crew and the withdrawal of essential facilities when the Pill ferry closed made lifeboat operations inviable. In addition, a new rescue service had been established at Sugar Loaf Beach, Portishead, provided by the Portishead Yacht and Sailing Club.

below left A-503,on station 1971–73, on Pill Carnival Day on 30 May 1972.

below The second McLachlan to serve at Pill was A-510, which served from March 1973 to October 1974, when the station was closed. She is pictured on patrol in the River Avon, just off the Pill ferry slipway, with Shirehampton in the background. After service at Pill, the boat was transferred to Ramsgate in Kent.

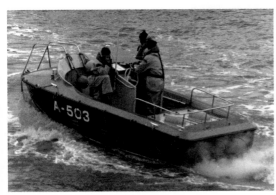

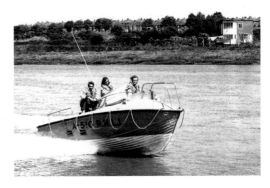

Appendix 1 • Bibliography

Cameron, Ian (2009): *Riders of the Storm: The Story of the Royal National Lifeboat Institution* (London).

Corin, John and Farr, Grahame (1983): *Penlee Lifeboat* (Penlee & Penzance Branch of the RNLI).

Cox, Barry (1998): *Lifeboat Gallantry* (Spink & Son Ltd, London).

Farr, Grahame (1982): *Papers on Life-boat History, No.1: William Plenty's Life-boats 1817-29, and James and Edward Pellow Plenty's Life Boat Model, 1851* (Bristol).

Leach, Nicholas (2005): *RNLI Motor Lifeboats* (Landmark Publishing, Ashbourne).

— (2009): *Devon's Lifeboat Heritage* (Twelveheads Press, Truro).

— (2009): *Fowey Lifeboats: 150 years of gallantry* (Foxglove Media, Lichfield).

— (2013): *Cornwall's Lifeboat Heritage* (Twelveheads Press, Truro, 3rd edition).

— (2013): *Sennen Cove Lifeboats: 150 Years of Lifesaving* (Tempus Publishing, Stroud, Gloucestershire).

Morris, Jeff (1987): *The Story of the Isles of Scilly Lifeboats*.

— (1989): *An Illustrated Guide to our Lifeboat Stations, Part 4: Swanage to Penlee*.

— (1990): *An Illustrated Guide to our Lifeboat Stations, Part 5: Isles of Scilly to Aberdovey*.

— (1995): *The Story of the Weston-super-Mare Lifeboats*.

Noall, Cyril and Farr, Grahame (1964): *Wreck and Rescue Round the Cornish Coast I: The Story of the North Coast Lifeboats* (D. Bradford Barton, Truro).

— (1965): *Wreck and Rescue Round the Cornish Coast II: The Story of the Land's End Lifeboats*. (D. Bradford Barton, Truro).

— (1965): *Wreck and Rescue Round the Cornish Coast III: The Story of the South Coast Lifeboats*. (D. Bradford Barton, Truro).

Wake-Walker, Edward (1007): *Break Through: How the inflatable rescue boat conquered the surf* (Granta Editions).

Appendix 2 • Lifeboats on display

A few historic restored lifeboats are on display in the south-west of England, with a restored pulling lifeboat based at Polperro actively in use as well as a former 48ft 6in Oakley class lifeboat at Land's End. This is a brief guide to the lifeboats on display in the south-west and where they can be seen.

below The 37ft Oakley Amelia (ON.979) on display at the Shipwreck and Heritage Centre in Charlestown.

Polperro

The former Looe pulling lifeboat *Ryder* (ON.489), built in 1902, has been restored to her original condition and is usually kept in Polperro harbour close to the Polperro Heritage Museum of Smuggling and Fishing. She has been taken round the country as an example of a pulling lifeboat, including in May 2015 to Courtmacsherry, Co Cork, to take part in the *Lusitania* centenary commemorations off Cork.

Fowey

Although no historic lifeboats are actually based at Fowey, the town has hosted an ex-lifeboat rally every year during the summer for the last twenty years. During a weekend in June or July, several privately owned former lifeboats, all restored and maintained in largely original condition, and usually including *Ryder*, are moored near the lifeboat station and open to the public. A parade of the boats rounds off the event, with sometimes ten or more former lifeboats in attendance.

Charlestown

The Charlestown Shipwreck and Heritage Centre not only has one of the largest collections of shipwreck artefacts and treasures in the country, it also has the former Scarborough 37ft Oakley *Amelia* (ON.979) on display outside. Built in 1964, the lifeboat served at Scarborough from 1978 to 1991 and was sold in March 1992 to the Shipwreck and Heritage Centre.

Land's End

The 48ft 6in Oakley lifeboat *James and Catherine MacFarlane* (ON.989), which served at Padstow and the Lizard, saving almost seventy lives in total, is on display outside the Land's End Visitor Centre, which has a number of attractions and various exhibitions including one on Air Sea Rescue. *James and Catherine Macfarlane* was built in 1967 and in 1988 was loaned to Peter de Savary for display at Land's End.

Lynmouth

The former Withernsea, Easington and Padstow No. 2 lifeboat *Docea Chapman* (ON.623), a 34ft Rubie self-righter, was on display at the Information Centre before being moved to the Power of Water Exhibition, Glen Lyn Gorge at Lynmouth. She is named *Louisa* and is part of an exhibition about the famous Overland Launch of 1899.

above The restored self-righting pulling lifeboat Ryder with a team of volunteer oarsmen about to get underway in the Fowey estuary.

below The gathering of former lifeboats at Fowey is an annual event, with owners able to exchange stories and views on maintaining their old lifeboats. At the July 2015, pictured, eleven former lifeboats were present, moored at Berrill's Yard pontoon with the operational lifeboat.

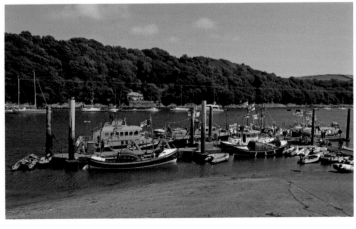

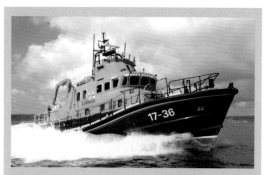

Severn

Introduced 1991, last built 2004, 46 built
Dimensions 17.3m (55ft 9in) x 5.5m (18ft) x 1.68m (5ft 6in)
Engines Twin 1,200hp Caterpillar, or twin 1,500hp MTU diesels
Stationed Falmouth, Penlee, St Mary's

Trent

Introduced 1991, last built 2004, 38 built
Dimensions 14.26m (46ft 9in) x 4.53m (14ft 10in) x 2.5m (8ft 4in)
Engines Twin 808bhp MAN D2840LXE diesels, speed 25 knots
Stationed Fowey

Tamar

Introduced 2005, last built 2013, 27 built
Dimensions 16m (45ft 11in) x 5m (14ft 10in) x 1.35m (4ft 3in),
Engines Twin 1,015hp (746 bkW) Cat C18 diesels, 25 knots
Stationed Appledore, Lizard, Padstow, Sennen Cove

Shannon

Introduced 2013, more than 50 planned
Dimensions 13.6m x 4.5m x 1m　　**Engines** Twin 13-litre 650hp
Scania D13 engines, twin Hamilton HJ364 waterjets, 25 knots
Stationed Ilfracombe, St Ives

Atlantic 75

Introduced 1972, built 1993-2003
Dimensions 24ft x 8ft 8in
Engines 2x70hp outboards, speed 35 knots
Stationed Burnham-on-Sea, Falmouth, Looe, Penlee, Weston-s-Mare

Atlantic 85

Introduced 1972, Atlantic 85 2004
Dimensions 8.3m x 2.8m
Engines 2x115hp outboards, speed 35 knots
Stationed Appledore, Clovelly, Minehead, Newquay, Portishead

D class inflatable

Introduced 1963, IB1 type in 2003
Specifications 16ft 3in x 6ft 7in, crew two to four, 50hp outboard
Stationed Looe, Fowey, St Ives, St Agnes, Newquay, Rock, Bude, Ilfracombe, Minehead, Burnham-on-Sea, Weston-super-Mare

Arancia inshore rescue boat

Introduced 2001 (with RNLI); 2009 (to lifeboat stations)
Dimensions 3.88m x 1.73m, crew two
Engines Single 30hp outboard, speed twenty-six knots
Stationed Used on beaches by RNLI Lifeguards

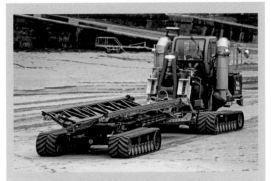

Launch vehicle: Supacat L&RS

Introduced 2013
Technical Scania DC13 12.7 litre 450bhp turbo-charged diesel engine
Stationed Ilfracombe, St Ives

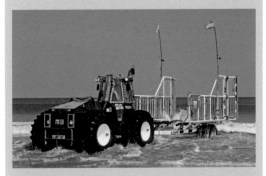

Launch vehicle: Talus MB-4H

Introduced 1982, 32 built
Technical Length 4.48m, width 2.66m, 105hp diesel engine
Stationed Burnham, Looe, Newquay, Minehead (Case tractor at Clovelly)

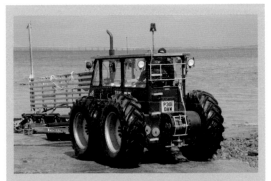

ILB launch vehicles: Talus MB764

Introduced 1974, 30 built
Technical 67hp Lombardini four-cylinder turbo diesel engine
Stationed Appledore, Portishead, Weston-super-Mare

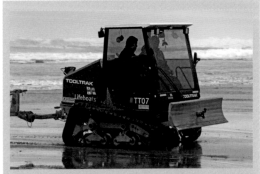

ILB launch vehicle: Tooltrak

Introduced 2010, 22 built to 2013
Technical 67hp Lombardini four-cylinder turbo diesel engine
Stationed Bude, Ilfracombe, Minehead, Sennen Cove, St Ives

Index